n4

AUGUSTE RODIN

PHAIDON

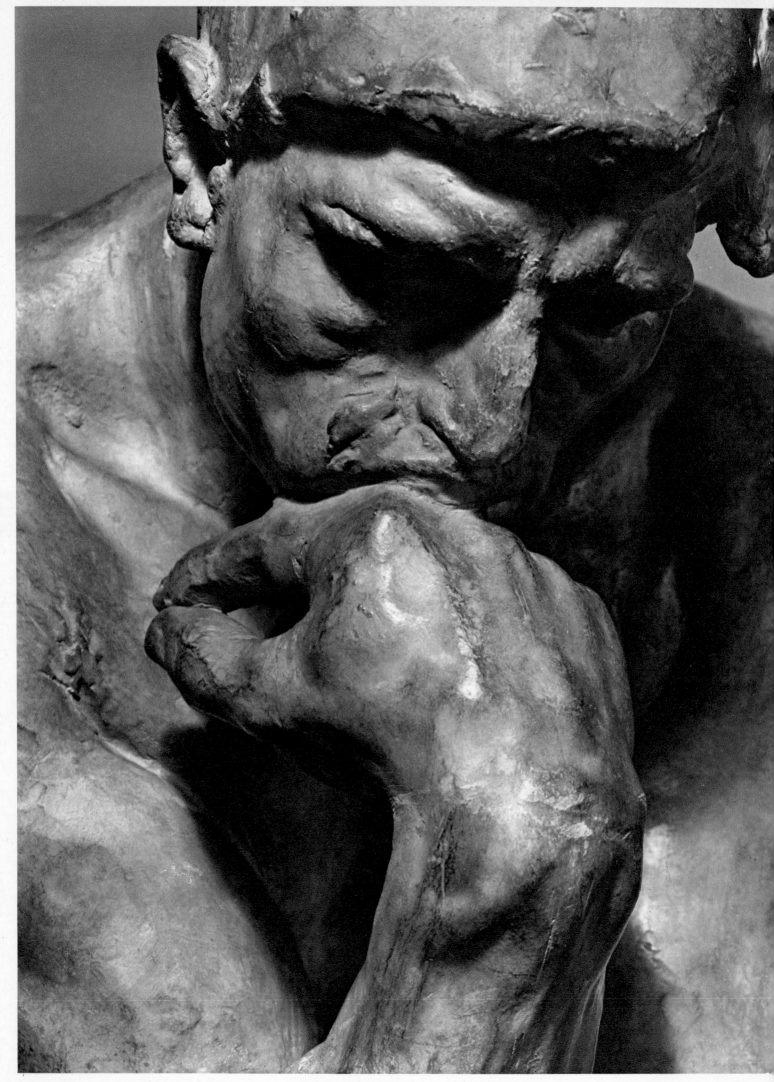

THE THINKER. DETAIL OF PLATE 16.

RODIN
SCULPTURES

SELECTED BY LUDWIG GOLDSCHEIDER
PHOTOGRAPHS BY ILSE SCHNEIDER-LENGYEL
INTRODUCTION BY SOMMERVILLE STORY

WITH NINETY-FIVE ILLUSTRATIONS

PHAIDON PRESS

COPYRIGHT BY PHAIDON PRESS LTD
5 CROMWELL PLACE · LONDON · SW7

MADE IN GREAT BRITAIN 1966
TEXT PRINTED BY GEO. GIBBONS LTD · LEICESTER
PLATES PRINTED BY CLARKE & SHERWELL LTD · NORTHAMPTON

AUGUSTE RODIN AND HIS WORK

EVERY GREAT THINKER is a mystery and a puzzle to his contemporaries. Auguste Rodin was not only the greatest sculptor since Michelangelo, but he was the greatest thinker in stone of modern times, perhaps ever since the prehistoric age when men first began to think it possible to shape in stone the presentments of living things. Who will venture to contemplate his wonderful collection of groups, figures and busts, and not require some guidance in the master's meaning? There is the great art and the technique, than which none are more remarkable, and behind these there is the soul in his work. How are we to read that soul?

The Burghers of Calais, for instance. This is not merely a group of six men marching off to execution, but every man in the group is alive with character and with a meaning which those who will may read. The St. John has a significance different from the mystical figures of the Prophet with which centuries of religious art have familiarized us. So with his Venuses, his allegorical figures, his Naiads, his studies of men (and one is struck with how much more frequently, in comparison with some other sculptors, he depicts the force of man rather than the grace of woman). And his Balzac—was it without deep thought that such a man represented the author of the 'Comédie Humaine' as he did, in a way that set all the critics and dilettantes agog? Rodin himself realized that his meaning was sometimes hard to fathom. "I am," he said once, "like the Roman singer who replied to the yells of the populace, 'Equitibus cano'—I only sing for the knights" (that is, for the select few). All great thinkers and artists have felt this at times. Yet Rodin contradicted this, as he was right to do, when he left all his work to the nation with a view to helping others to attain education in art. He knew that nothing great and durable can really be for the few, either in art or in any other manifestation of human activity, and Rodin is for the world, as he wished to be.

RODIN'S LIFE

AUGUSTE RODIN was a Parisian, born in a working-class quarter, close to the Latin Quarter—No. 3, rue de l'Arbalète—on November 12, 1840. His father, Jean-Baptiste Rodin, a native of Normandy, born at Yvetot, a modest office employee at the time his son was born, later became an inspector at the Prefecture of Police. His mother, Marie Cheffer, was from Lorraine. The family seems to have been very united and highly religious. Rodin was the younger of two children. His sister, who was two years older than he, became a nun, but died in 1862 after a short illness. He had been

greatly attached to her, and her death caused him much grief and suffering. In spite of the modesty of the family's position, the two children were brought up and educated with great care, the girl Marie at a convent and Auguste first at the friars' school in the Val-de-Grâce quarter and afterwards at Beauvais, at a school founded by his uncle, a man of considerable culture who had taken up teaching as a profession and succeeded in making an interesting position for himself. Auguste remained with his uncle until his fourteenth year.

The child's taste for drawing was already so pronounced that his father placed him then at the school of drawing and mathematics in the Rue de l'École de Médecine. This institution was known as the 'little school', to distinguish it from the official Fine Arts School; it was especially intended for the education of young artisans going in for artistic industries. No higher future was thought of for the boy at that time. The director of this school was a man named Belloc, but there was also a professor, Lecocq de Boisbaudran, who has left behind him a great name not as artist but as teacher, for he created a remarkable system of teaching drawing by the training of the memory, and thus helped to form a number of famous artists. Among his pupils were Fantin-Latour, Cazin, Legros, Lhermitte, the sculptor Dalou and the medallist Chaplain. There was another professor, a sculptor named Fort, who also had great influence over young Rodin, who in fact in later years declared that he owed his vocation to him. The youth also studied at the Gobelins school, where there was a professor named Lucas, for whom he expressed almost equal gratitude. These men all doubtless discovered in the studious and earnest young fellow the qualities that form an artist. As his bent became evident, it was decided to consult a sculptor named Maindron, who then enjoyed a considerable reputation. His verdict being favourable, young Rodin gave in his name at the École des Beaux-Arts. He was rejected three times.

Then for some years he earned money by exercising various crafts more or less allied to the sculptor's profession—moulder, ornamenter, goldsmith, and so on, all the time gathering valuable experience for his career of an artist. At the age of twenty-three Rodin, impelled by grief at the death of his beloved sister, took religious vows and entered the monastery of the Eudistes, in the Faubourg St. Jacques. This devotional impulse, however, did not last long, and five or six months afterwards he returned home. A little later he united his life to Rose Beuret, the faithful companion who was by his side for fifty years and only predeceased him by a few months.

In 1864 Rodin started to follow the lessons of Barye, the animal sculptor (1795–1875), who was an admirable and powerful artist, but as a teacher is said to have lacked enthusiasm. Then he entered the studio of Carrier-Belleuse (1824–87), another sculptor of great talent, a pupil of David d'Angers, and remained as assistant to him more or less for six years. But although Rodin called himself the pupil of both these artists, in order to conform to the rules of the Salon, he only followed the public

lectures of the one and was the employee of the other. Up to that time, the known works by Rodin are very few, except several commercial orders, which were commissioned, such as the Caryatids of the Gobelins theatre, the chimney piece of the Gaîté Theatre, decorative reliefs in the Long Gallery of the Louvre Museum (Salle de Rubens), etc. There is a bust of his father, which according to a legend in the family was made when he was seventeen, but which Rodin himself said dated from a year or two before his next work—the bust of Father Eymard, the superior of the Societas Sanctissimi Sacramenti, to whom the young man became greatly attached during his short stay at the monastery. The date of this work was 1863. It is not surprising that this excellent priest, for whose memory Rodin always felt a great veneration, soon felt that the young man's true vocation was not the cloister. He arranged a studio for him, and after a while gently urged him to change his views and go home. This bust shows great powers of observation, fidelity to and comprehension of nature. The third work known is the famous 'Man with the broken nose', which he sent to the Salon and which was refused.

During the siege of Paris Rodin remained in the city and shouldered a gun as a National Guard. But in February 1871, having been judged unfit for military service, he went with Carrier-Belleuse to Belgium, with the idea of continuing to work beside him. But a dispute or misunderstanding arose, and Rodin left him and joined the Belgian sculptor Van Rasbourg, who continued the decoration of the Stock Exchange at Brussels begun by the French artist, and also worked on the Palais des Académies. He did work also on his own account, and in 1875 (a year in which he made a first timid appearance at the Salon with two busts), having put by a little money, he carried out a long nurtured ambition to go to Italy and study the works of Donatello and of Michelangelo. But his resources, naturally, were modest and he did not stay long. Most of his time was spent at Florence and Rome, but he also visited Venice and Naples. He came back enthusiastic and filled with the influence of the two great masters.

His next work shows the influence of Donatello, although it was sufficiently original to make the young sculptor immediately famous and to arouse a remarkable controversy. This was the statue first called 'Man awakening to Nature', now known as the 'Bronze Age'. Some of his confrères and critics professed to see in this work an imposture, and accused him of taking a mould from Nature. It led to the first scandal of Rodin's career (it was followed by numerous others), and the young sculptor was defended in a collective protest signed by a number of sculptors and painters. The State soon afterwards repaired the offence by acquiring the bronze of the incriminated statue, and a third-class medal was awarded to the sculptor. A little later, too, the State acquired his St. John the Baptist, which was placed in the Luxembourg. The appearance of these two works brought him a great many new friends in the artistic and intellectual worlds. About this time Rodin was working at the decoration of the

Trocadéro Palace, Paris (now demolished in view of the International Exhibition of 1937), with the sculptor Legrain, and he modelled a number of terracotta busts in the style and manner of the eighteenth century. Then the Under-Secretary for Fine Arts, as an *amende honorable* for the aspersions that had been cast on him, offered him the choice of a State command. Rodin, still burning with enthusiasm from his Italian studies, asked to be allowed to execute a door for the future Museum of Decorative Arts, and, inspired by Dante, chose for his subject 'The Gate of Hell'.

In 1877 Rodin returned to Paris, where he settled definitely after making a tour of France to visit the Cathedrals. It was the first of several such tours, for, like his great predecessor, Michelangelo, Rodin was intensely interested in cathedral and other architecture. He dreamed at one time indeed of being an architect, and during his various journeys was fond of studying architectural details, sketching and taking notes. (In the year 1910 his book 'Les Cathédrales de France' was published, illustrated with drawings by him.) Like some of his great predecessors, he touched various branches of art and shone in all—portraiture, landscape, etching, and even ceramics; for when he was employed for a time at the State Porcelain Manufactory at Sèvres (1879–82, with his old chief Carrier-Belleuse) he made several highly creditable vases. His journeys in France, therefore, like his trip to Italy, left a deep impression on him. On the occasion of a visit he made to Marseilles to work on the Fine Arts Palace, with an artist named Fourquet, he was greatly struck with the Greek type of beauty of the women in the Provençal towns.

The order for the 'Gate of Hell' was confirmed in 1880, and Rodin started work on it. This enormous task occupied and fascinated him for over twenty years, and on it he expended all the varied sides of his stupendous genius. As with all his other work, its chief characteristic is life in movement. It contains some 186 virile or graceful figures in all the phases of anguish, terror or voluptuousness. The famous statue of 'The Thinker' (which at first he called 'The Poet') was to command and contemplate all these varied scenes. For a long time this was the work on which Rodin concentrated all his best energies; he made hundreds of drawings and models for it. Later on he seemed to tire of it or at any rate, he criticized his own conceptions; and for some years he used it as a sort of reservoir from which to evoke the varied forms of his work. It may be said indeed that nearly all his passionate figures came from the Gate. But in later years again he returned to this great work and set about the task of getting it definitely fixed in marble and bronze. It was never, however, completely finished.

About 1882 a studio was placed at Rodin's disposal free of charge by the Government in the State marble repository in the Rue de l'Université. During these years numbers of his works were shown at the Salon—for instance, St. John preaching, the Creation of Man, Ugolino, and the busts of J. P. Laurens, Legros, Dalou, Victor Hugo and others. It was in these years that the sculptor came to know some of the leading

literary men of the age, such as Alphonse Daudet and the Goncourts. In 1880 he competed for the monument of the National Defence to be erected at Courbevoie, at the gates of Paris, where a great stand of the French had taken place in 1871, when they were defeated. The work he sent in, 'The Genius of War', was not selected, as it was judged to be 'too ferocious'. This monument was chosen in 1916 by a Dutch committee who wished to offer a monument to the city of Verdun to commemorate the heroic defence of that place, which had gone far towards crushing the attempt made against the liberties of humanity. Rodin presented the work to the committee, and they accepted it with enthusiasm. In 1883 he received an order for an equestrian statue of General Lynch for South America. In 1884 the town of Calais opened a competition for a monument in memory of Eustache de St. Pierre, the historic burgher who had delivered the keys of the town to the English King. Rodin competed, and instead of a single figure he showed the hero accompanied by five of his companions in misfortune. He obtained the order for the work, though not without difficulty, and devoted ten years of study and labour to it. The monument was inaugurated in 1895, and again it aroused criticism and discussion.

All or nearly all Rodin's greater works led to intense and often bitter controversies. Such were the Claude Lorrain, executed for Nancy in 1889, and erected in 1892; the Victor Hugo, which was refused by the commission because the sculptor had made a seated figure instead of an erect one, as was required for the architectural ensemble. The seated statue was, however, placed in the Luxembourg and the Minister of the day ordered a Victor Hugo erect for the Panthéon. It was the same with the monument he made of President Sarmiento, of the Argentine Republic, for Buenos Aires. But the most bitter controversy of all was over the famous Balzac monument, which was ordered by the Société des Gens de Lettres and was exhibited at the Salon of 1898. The society refused the work. The president, the poet Jean Aicard, in disgust at this decision, resigned; the statue was returned to the artist's studio at Meudon, and the order was passed on to Falguière. In London again the committee who had ordered from Rodin a monument to Whistler did not accept it.

Nevertheless there were those who recognized and acclaimed the genius of the artist, and these, whether French or foreign, were enthusiastic. Among other valuable testimonies to his worth about this time, a group of admirers contributed in 1886 for the casting of 'The Kiss'. Critics like Gustave Geffroy and Octave Mirbeau supported him with their pens during this most difficult period. His portraits, as the late Léonce Bénédite, curator of the Rodin museum in Paris, remarked, would alone have brought fame to any other artist—such works as the busts of Madame Rodin, Carrier-Belleuse, Dalou, Puvis de Chavannes, Henri Rochefort.

For England he did the busts of Henley, the poet, who was then editor of the 'Magazine of Art', George Wyndham, Bernard Shaw, Lord Howard de Walden,

Mrs. Hunter, Lady Sackville, Lady Warwick, and Miss Fairfax. For America his busts included those of Mr. Harriman, Mrs. Simpson, Mrs. Potter Palmer, Mr. Kay and Mr. Ryan. It was owing to the last-named gentleman's initiative and generosity that the Rodin collection at the Metropolitan Museum in New York was inaugurated.

The monument to Bastien Lepage was erected at Damvilliers (Meuse) in 1889. In this year during the Universal Exibition, a number of his works were shown at the Georges Petit gallery in Paris. These included the Perseus and Gorgon and the Danaid, among his most recently completed subjects (besides the Galatea, Walkyrie, the Fall of a Soul into Hades, Perseus, St. George, Bellona, St. John, the Burghers of Calais, the Thinker, Bastien Lepage, and others). The result was highly satisfactory for the sculptor. In the same year the foundation of the Société Nationale des Beaux-Arts, in which he occupied a prominent position, assured Rodin's status as the chief of a school. An exhibition held in a special pavilion in the Place de l'Alma in 1900 constituted a veritable triumph for him. Tardy fame had now begun to catch him up. His 'Thinker' was made the object of a subscription among his admirers, who offered it to the people of Paris, and it was placed, in 1906, in front of the Panthéon. Four reliefs made for the villa of Baron Vitta at Evian were shown at the Luxembourg museum in 1905. Altogether forty-two of his works were shown at the Luxembourg.

The one great passion which filled the career of this man of great genius was work, and his life was filled with it. It was indeed scarcely interrupted except for a few journeys to Belgium, England and Rome. In 1903 he went to Prague to attend an exhibition of his work. Temptations were held out to induce him to go to America, but he could never make up his mind. In later years he regretted that he had never been to Greece. Among his latest works were busts of the Duc de Rohan and Georges Clemenceau (1911), and of Pope Benedict XV, done at Rome in 1915. The last work of all was the bust of M. Etienne Clémentel, then Minister of Commerce. In 1916 the sculptor was struck down by illness and had to take to his bed. He recovered slowly, but had to give up all work. He then began to set his artistic property in order and to occupy himself with the Rodin Museum. His beloved wife died on February 13, 1917, and, never recovering from this blow, Rodin himself succumbed on November 17, 1917. He was buried in the garden of his villa at Meudon, with a replica of the 'Thinker' watching over the grave.

All that last summer he scarcely left his villa at Meudon, where he lived surrounded by two lady cousins who looked after him, by M. Léonce Bénédite, and one or two other devoted friends. Occasionally, but with increasing rarity, he would go to the Hôtel Biron (the Rodin Museum) or make up a little party with one or two friends. He showed himself affectionate and gay, and grateful for all attentions, his old combative spirit seeming to have left him.

Rodin was singularly indifferent to worldly honours, the only distinction he desired

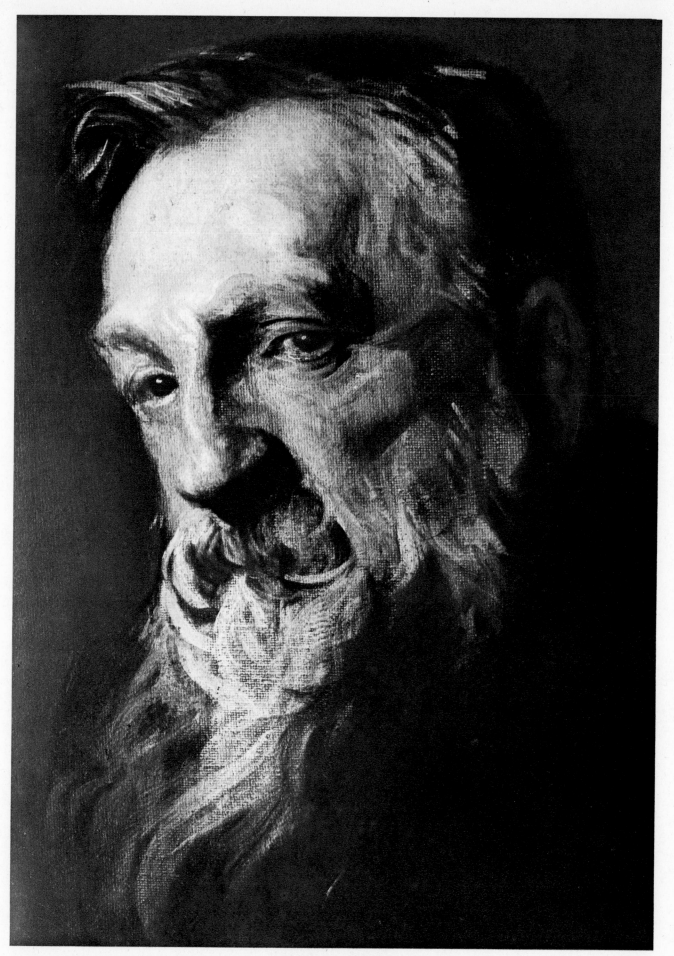

AUGUSTE RODIN

DETAIL FROM A PORTRAIT BY JACQUES-EMILE BLANCHE

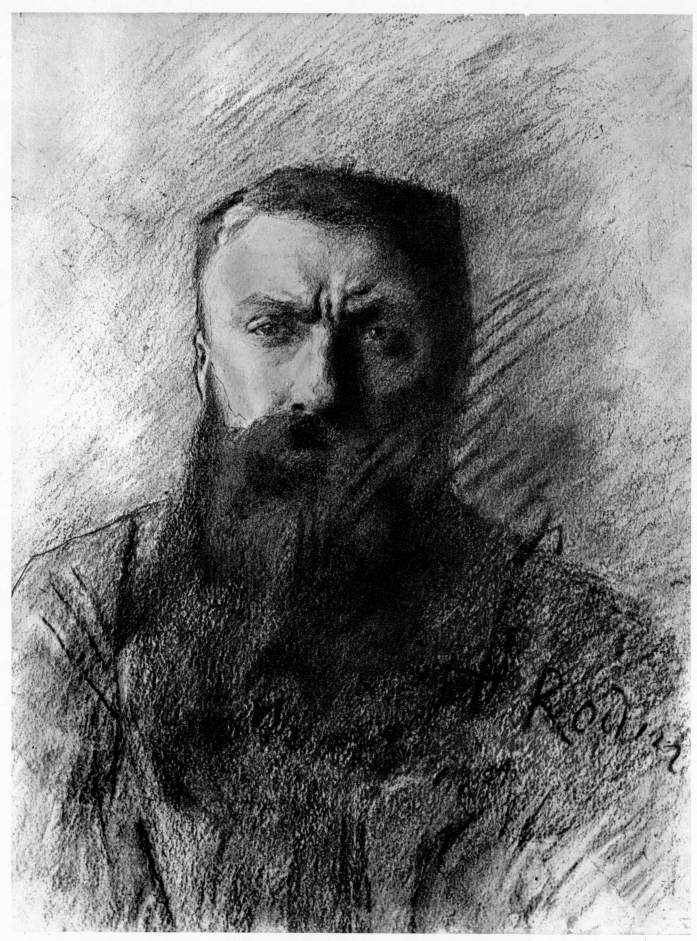

SELF-PORTRAIT OF RODIN. DRAWING

being the recognition of his work. Academical honours he never sought, but he keenly appreciated the approval of his foreign admirers, and the distinctions conferred on him by foreign bodies, such as the doctorate *honoris causa* given him by Oxford.

Rodin, as his friend Camille Mauclair described him, was of medium stature, with an enormous head on a massive trunk; prominent nose, flowing grey beard, and small bright eyes, in which there was the appearance of shortsightedness with a gentle irony. The impression of power in the man was emphasized by the rolling gait from his haunches, the 'rocky' aspect of the troubled brow under rough bushy hair, the bony aquiline nose and ample beard. This impression, however, was partly contradicted by the reticent fold of the mouth, the quick regard, which was at once penetrating, malicious and naive ("one of the most complex I have ever seen", adds M. Mauclair), and above all by the husky voice, modulated with difficulty and mixed with grave inflexions. He appeared simple, precise, reserved, courteous and cordial without excess. By degrees his timidity would give place to a tranquil and simple authority. He showed neither over-emphasis nor awkwardness, and his general manner was rather sad than inspired. An immense energy seemed to issue from his sober and measured gestures. The slowness and apparent embarrassment of his speech and the pauses in his conversation gave it particular significance.

In the presence of one of his works Rodin had a way of explaining it which was elliptical but clear. He said what was essential, finishing his words with a gesture. He used to contemplate his creations lovingly, and sometimes even seemed to be astonished and contemplative at the idea of having created them, speaking as if they existed apart from himself. Gradually under Rodin's simplicity were discovered qualities that had at first been hidden; he was ironical, sensual, nervous and proud. In himself were found *in posse* all the passions he expressed with such troubled magnificence, and one began to understand the secret bonds between this calm man and the art he revealed. He was the companion of these white mute creatures of his, he loved them and entered into their abstract lives, and had moral obligations towards them. They were his sole preoccupation. He was restrained in the expression of his ideas and opinions and rather summary in his dealings with people. His cordiality gave the impression that he wished to have done quickly with social duties. Very capable of friendship, he limited it to a tacit understanding on the essential subjects of thought; he had less faith in individuals than in general ideas. Devoted to his work as he was, he only tolerated other things with polite boredom, and had a horror of discussions or of being disturbed.

As to bad artists, he took no notice of them—he did not criticize them. He endured all the violent discussions and all the unjust criticism heaped on his own works without saying anything, for he was too proud to discuss the matter. At the time of the Balzac quarrel, his friends advised him to fight, since the terms of his contract were

entirely to his advantage. But he thanked them for the advice and withdrew his statue without saying a word.

This was not weakness, for Rodin's life had been a hard one. It arose from the dignity of his inner being and indifference to the passing phases of life. He cared for few things, but those few he was much attached to. Reading but little, he was intense in his admiration of certain authors. One of these was Baudelaire. He was passionately fond of music, especially Gluck, but rarely talked of it.

He simplified all things in his life and disliked all that was unessential. When one knew him well it was impossible to separate him from his work. His statues were the states of his soul. Just as Rodin seemed to break the fragments around the statue away from the block in which it had been concealed, so he himself seemed to be a sort of rock hiding various forms and crystallized growths. For him work lovingly accomplished was the secret of happiness, and to love life and natural forms, and do nothing to outrage Nature's laws, was all his morality. He seemed to be isolated in his time by his genius as well as by the character of his artistic conception, but in reality this isolation was only apparent. After his years of hard struggle and neglect or contumely he had become a master to whom young artists looked up. As the artist Pierre Roche expressed it, he had 'opened a vast window in the pale house of modern statuary, and had made of sculpture, which had been a timid, compromised art, one that was audacious and full of hope'.

RODIN'S WORK

WORK WAS THE LAW of Rodin's life, and his career was one long-sustained effort. No man ever worked harder, and there are few who have any idea of his vast output over a long life. With the passion of genius and an insatiable desire to create, he had the patience of a monk of the Middle Ages. Towards the end of his life he declared that he was only just beginning to understand the laws of sculpture. He was often criticized or ridiculed on account of the length of time he took over his work, but this arose from excessive conscientiousness. "A work even when finished is never perfect," he would say. He spent five years in modelling the two female statues that represent the Muses in his Victor Hugo statue. Over the 'Balzac' he spent seven years, and as it was leaving his studio he regretted that he could not keep it with him still a while so as to add touches which he thought would help to perfect it. He warned youthful workers against believing in inspiration and told them they would achieve nothing except by hard work, In later years he was, in fact, apt to underrate the rôle of inspiration in artistic work, and would contemptuously call such talk 'a dream'. Work was to him the true religion. But inspiration represented something else to

Rodin; and he liked to keep a work by him so that he could, as he contemplated it long after others might have considered it finished, make touches here and there suggested by sudden ideas of improvement. He has been compared to one of those nameless artificers of the Middle Ages who spent all their lives in chiselling the figures round a cathedral; but in the general breadth of his character and his sympathies he was a descendant of the Greeks, with the naturalism of the Greeks allied to deep religious sentiment.

No artist ever understood the conditions of matter or the laws of plastic like Rodin. For long he oscillated, as he himself said, between the influence of Michelangelo and that of Phidias, the Christian and the pagan—the expressive and the plastic. Finally his allegiance lay between the Greeks and the Gothic. Follow nature, was his watchword all through his life. He was intensely imbued with the mystery of Nature and the freshness of the art of the ancients.

He would not admit the existence of ugliness in nature. "That which one commonly calls ugliness in nature may in art become great beauty," he would say. "As it is simply the power of character which makes beauty in art," he explained on one occasion, "it often happens that the more a creature is ugly in nature, the more it is beautiful in art. In art only those things that are characterless are ugly—such as have no beauty without or within. For the artist worthy of the name all is beautiful in nature, because his eyes boldly accepting all truth shown outwardly, read the inner truth as in an open book. That which is ugly in art is that which is false and artificial—that which aims at being pretty or even beautiful instead of being expressive"—in other words, that which is mannered, all parade, without soul and without truth. To disguise or attenuate the facts of Nature in order to please the undiscerning was for him the work of an inferior artist. One sees in works like the 'St. John' (a simple peasant, though an illuminated one, as it were, with his mouth open) and the 'Burghers of Calais' (simple rough men, nude under their 'sack' shirts, and with nothing heroic about them either in face or posture) how implacably he insists upon the absolute interpretation of nature, refusing to sacrifice anything to conventional ideas of beauty. No sculptor understood better than he all the possibilities of the nude. He used to draw comparisons between the modelling of a body and that of a landscape.

Up to his thirtieth year Rodin was almost exclusively engaged in helping to carry out the work of others. But he was all the time learning, and those long years of apprenticeship were invaluable in giving him varied experience in the study of effects in grouping and dexterity in the use of the sculptor's tools, while they afforded him endless opportunities for the criticism of defects. In his Brussels experiences he had the advantage of doing work on a large scale out of doors, and of observing the effects of climate on sculpture, and how each figure appeared under the changing aspects of the day. He early realized that the spontaneous attitudes of the living model are the only

ones that should be represented in statuary, and that any attempt to dictate gesture or pose must destroy the harmonious relation existing between the various parts of the body. In the observance of this law primarily resided the superiority of antique over modern sculpture. Another of his discoveries was that as, under the suggestion of successive impulses, the outlines of the body are continually changing—muscles swelling or relaxing in a sort of rhythmic flow or ripple—the sculptor has ample opportunity of choosing the reliefs and curves that most faithfully and most effectively interpret the pose they accompany.

Rodin's method of working, writes Paul Gsell, was singular. He had in his studio a number of nude models, men and women, in movement or reposing. Rodin paid them to supply him constantly with the picture of nudity in various attitudes and with all the liberty of ordinary life. He was constantly looking at them, and thus was always familiar with the spectacle of muscles in movement. Thus the nude, which to-day people rarely see, and which even sculptors only see during the short period of the pose, was for Rodin an ordinary spectacle. Thus he acquired that knowledge of the human body unclothed which was common to the Greeks through constant exercise in sports and games, and learned to read the expression of feeling in all parts of the body. The face is usually regarded as the only mirror of the soul, and mobility of features is supposed to be the only exteriorization of spiritual life. But in reality there is not a muscle of the body which does not reveal thoughts and feeling.

So when Rodin caught a pose that pleased him and that seemed expressive—the delicate grace of a woman raising her arms to arrange her hair or inclining the bust to lift something, or the nervous vigour of a man walking—he wanted the pose kept, then quickly he seized his implements and a model was made, and then just as swiftly he passed to another. Herein is shown the difference between Rodin's method in watching for the attitudes of nature and that of so many of his contemporaries, who pose their models on pedestals and arrange the positions they wish them to assume as if they were lay figures. It was never his habit, as we have seen, to undertake a work, complete it, and have done with it. He always had by him a number of ideas and thoughts on which he meditated patiently for years as they ripened in his mind.

It was after 1900, when his reputation was firmly established, that Rodin conceived the daring idea of exhibiting human figures (such as 'Meditation', 'The Walking Man', etc.) deprived of a head, legs or arms, which at first shock the beholder, but on examination are found to be so well balanced and so perfectly harmonized that one can only find beauty in them. And his reason for this is artistically profound, though it might be thought that it was pushing the 'religion of art' to extremes. In the development of a leading idea—of thought, of meditation, of the action of walking, his desire was to eliminate all that might counteract or draw attention from this central thought. "As to polishing nails or ringlets of hair, that has no interest for me," he said; "it

detracts attention from the leading lines and the soul which I wish to interpret."
Nevertheless he did not by any means underestimate the technique of his art. Though
he regarded it as only a means to an end, he said the artist who neglects it will never
attain his object, which is the interpretation of feelings and ideas. "One must have a
consummate sense of technique," he said, "to hide what one knows."

On one occasion he told Paul Gsell of a valuable lesson in the science of modelling
which he had received from a certain Constant, who worked in the studio where he
started as a sculptor. He was one day watching him modelling a capital with foliage
in clay, and said, "Rodin, you are going about that badly. All your leaves look flat—
that's why they don't seem real. Make them so that some of them will be shooting
their points out at you. Then on seeing them one will have the sense of depth. Never
look at forms in extent but in depth. Never consider a surface except as the end of a
volume, and the more or less broad point which it directs towards you." He followed
this valuable advice and discovered later that the ancients had practised exactly this
method of modelling; hence the vigour and suppleness of their works.

The influence of Michelangelo on Rodin was great, as we have seen. He made copies
at one time of some of Rubens' pictures from memory, so deeply had he studied them.
He also declared that from Rembrandt he had learned much in the way of chiaroscuro
in sculpture. Later he was interested in Japanese art, which the Goncourt brothers did
so much to popularize in France; the attitudes of some of his models are said to have
been suggested by Japanese paintings. But all forms of art interested him—Egyptian,
Aztec, Far Eastern, or French eighteenth century, and he was always learning. He used
to say that a visit to the Louvre affected him like beautiful music or a deep emotion and
incited him to renewed efforts. Rodin was particularly interested in the depiction of
elemental natures. His mind harked back to the origins of things, and over and over
again he represented beings that were blossoming into humanity from primitive or
elemental conditions, creatures that are not very distant from the nature in which they
have grown—part animal, part human, or such as have sprung from trees, fountains
and the material of elemental life. For him, as for the early Greeks, all Nature was
teeming with semi-human form: he saw dryads in the woods and nereids in the streams
and their physical natures and aspect differed but little from the elements that gave
them birth. Numbers of his creatures are issuing from matter, others are assimilated
with trees, with rocks or the earth itself. Nature being the source of all life, it seems as
if he could hardly conceive of life removed from this source of energy.

PLATES

All the sculptures reproduced in this volume are exhibited in the Rodin Museum in Paris, with the exception of Plate 49, which is in the Tate Gallery, London.

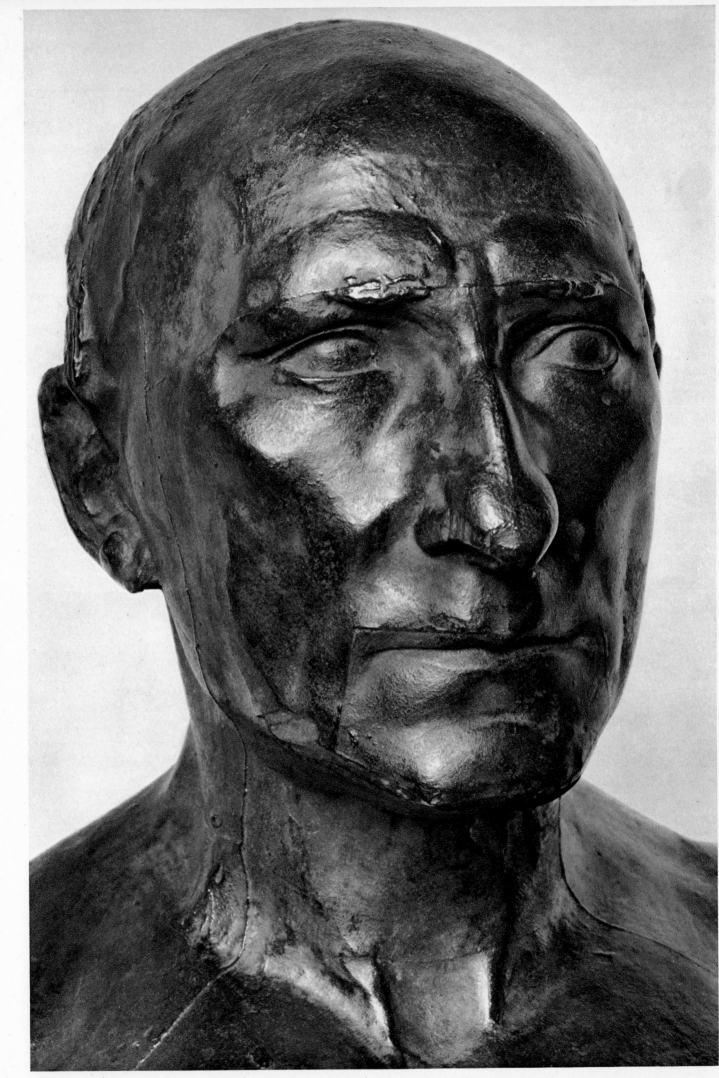

1. JEAN-BAPTISTE RODIN, THE SCULPTOR'S FATHER. BRONZE. 1860.

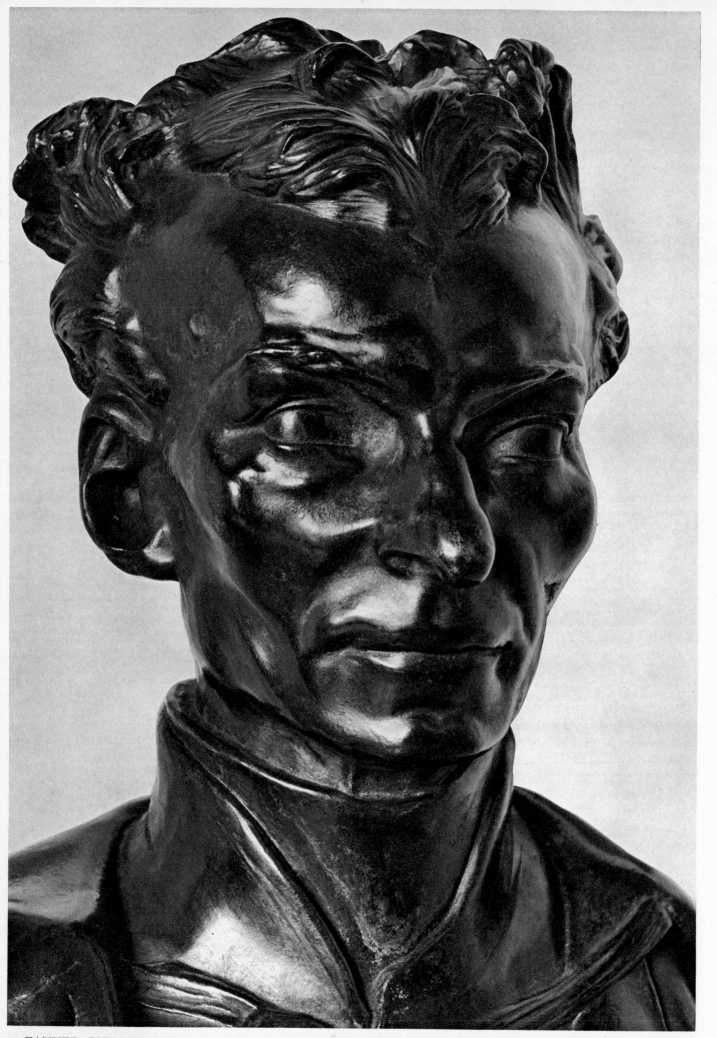

2. FATHER PIERRE-JULIEN EYMARD. BRONZE. 1863.

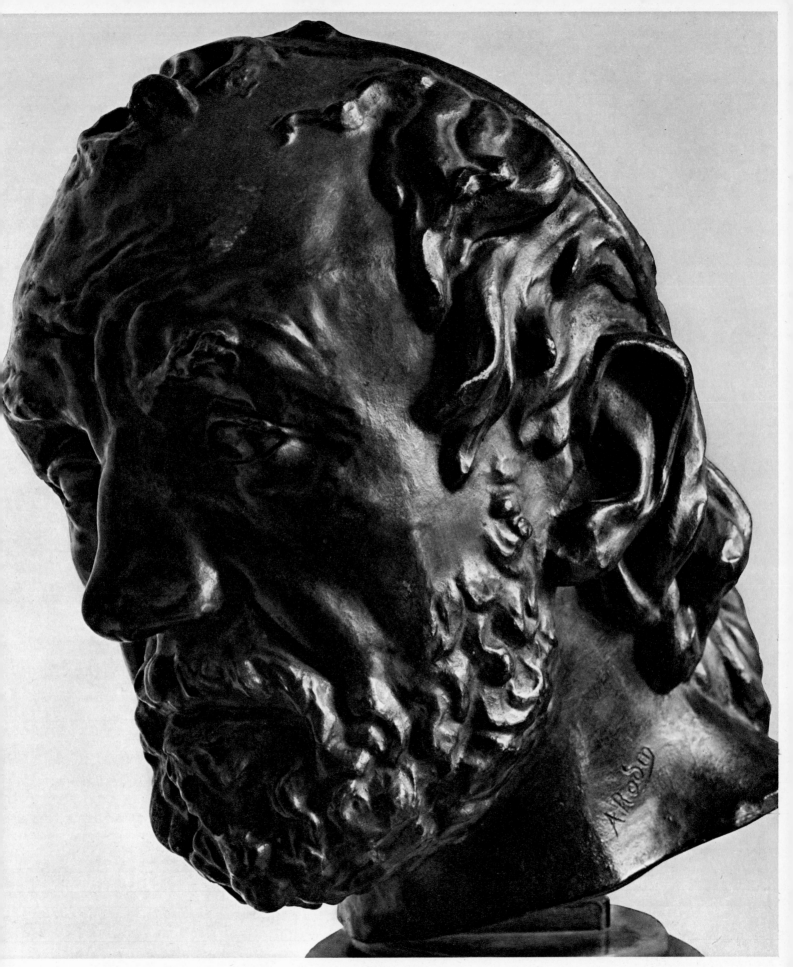

THE MAN WITH THE BROKEN NOSE. BRONZE MASK. 1864.

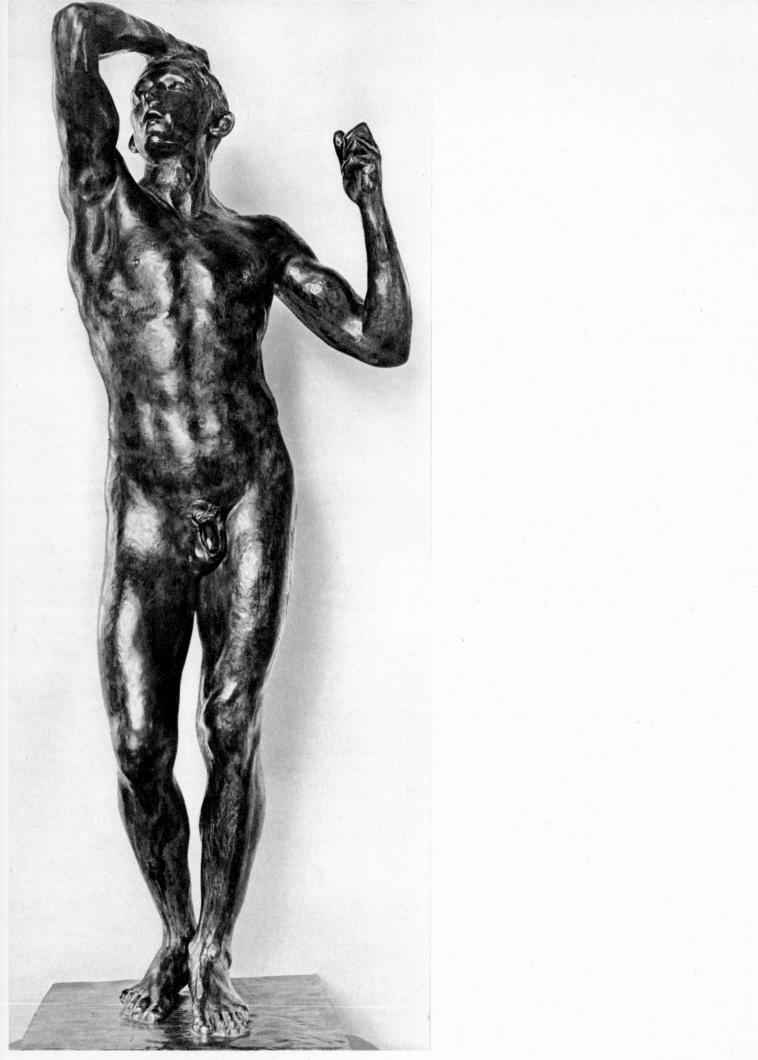

4. THE AGE OF BRASS. BRONZE. 1876.

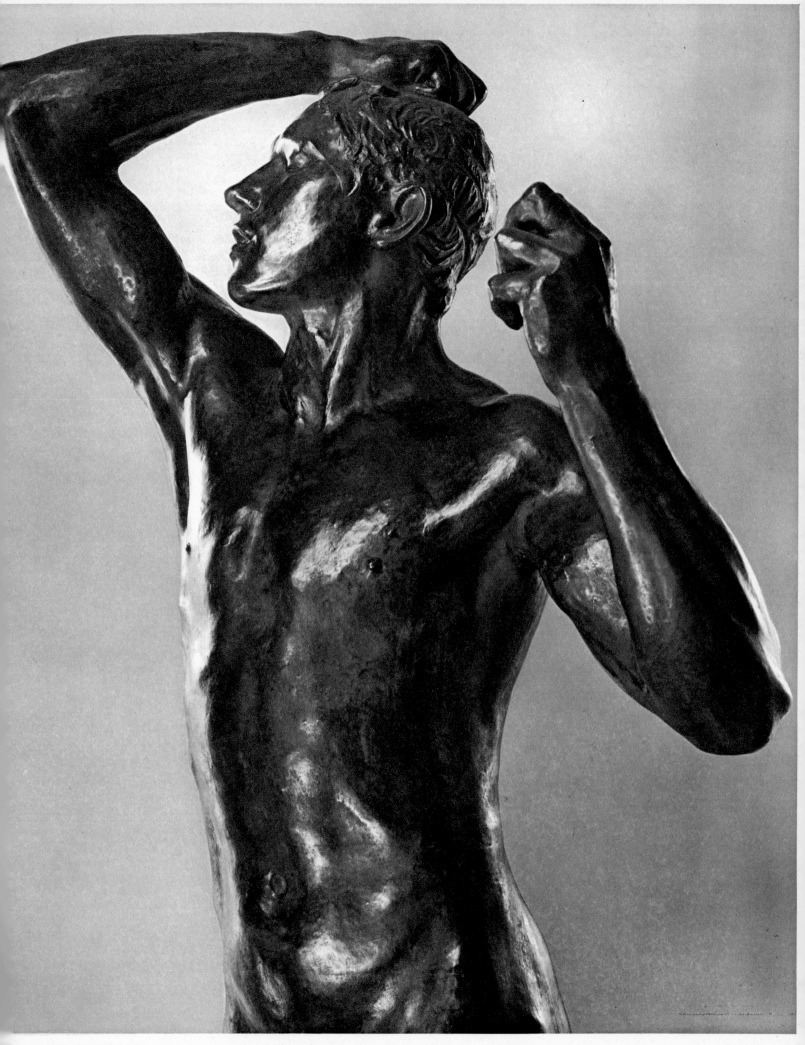

IE AGE OF BRASS. DETAIL.

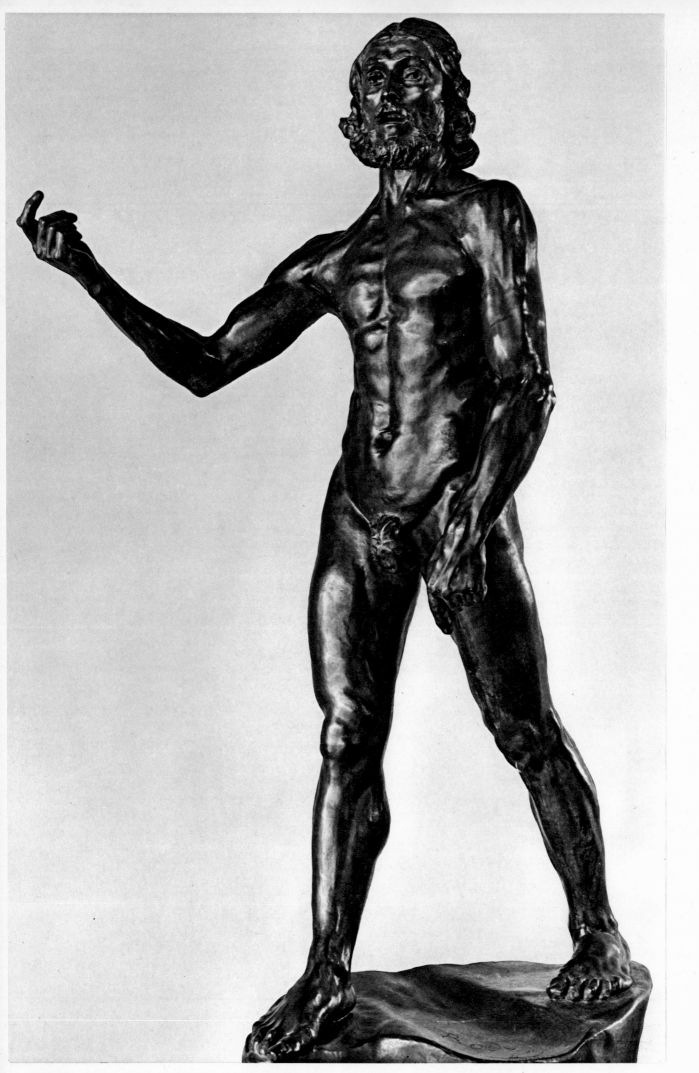

6. SAINT JOHN THE BAPTIST PREACHING. BRONZE. 1878.

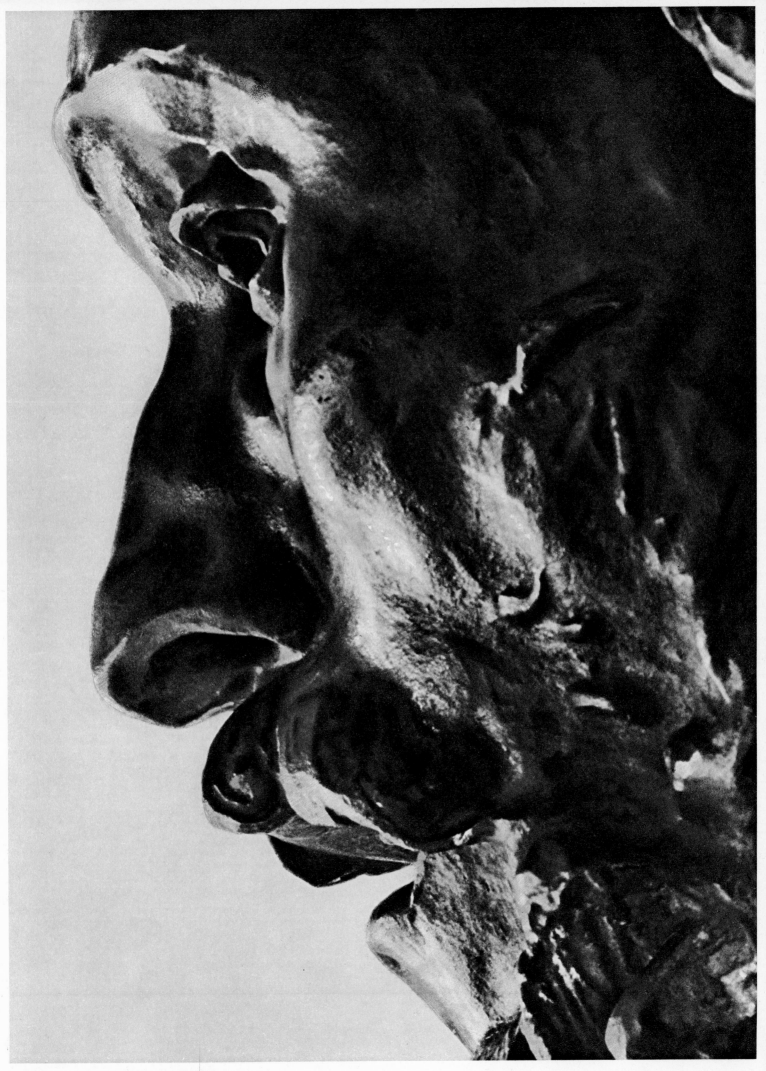

7. SAINT JOHN THE BAPTIST. DETAIL.

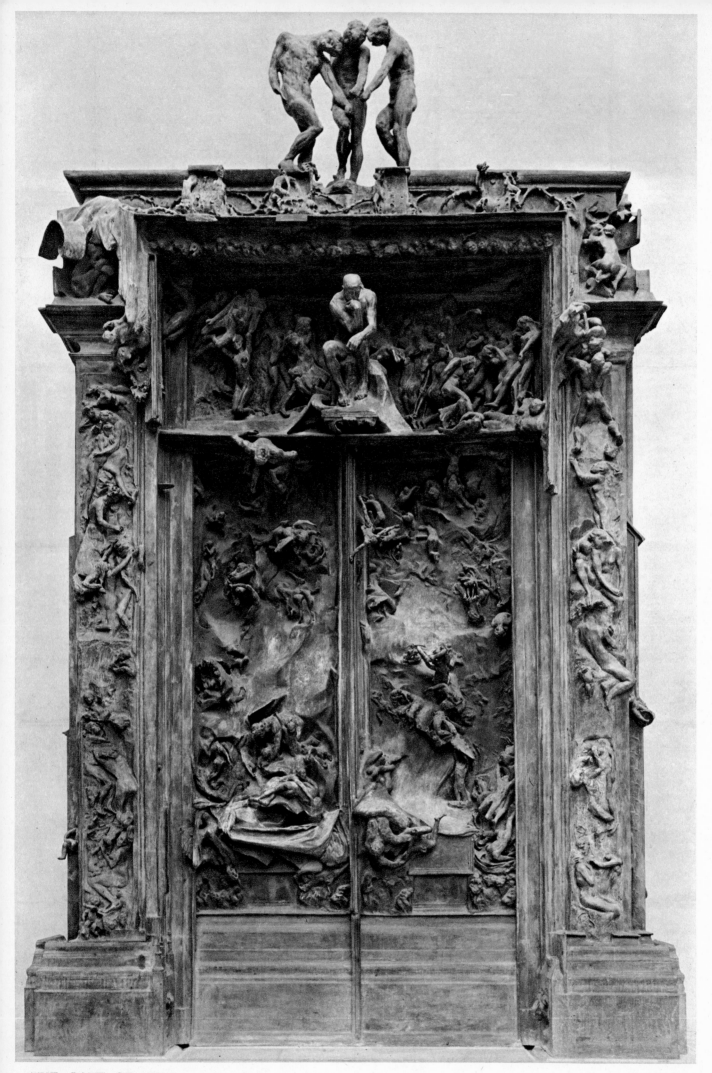

8. THE GATE OF HELL. BRONZE. 1880-1917.

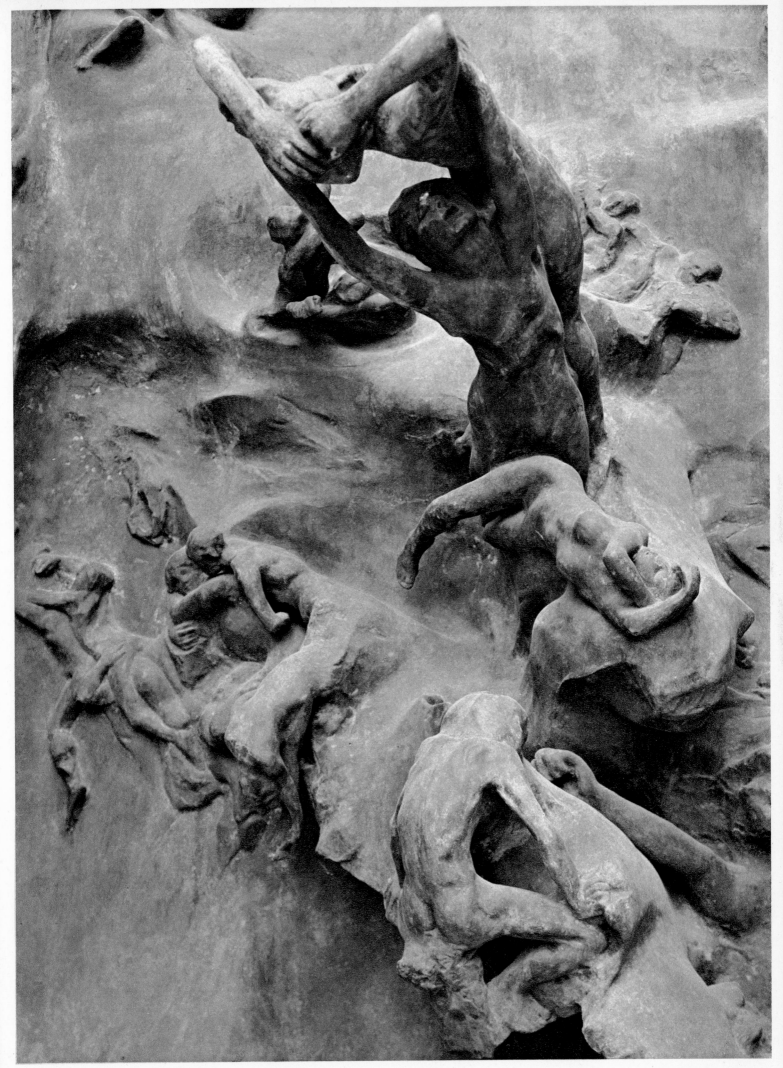

9. THE GATE OF HELL. DETAIL.

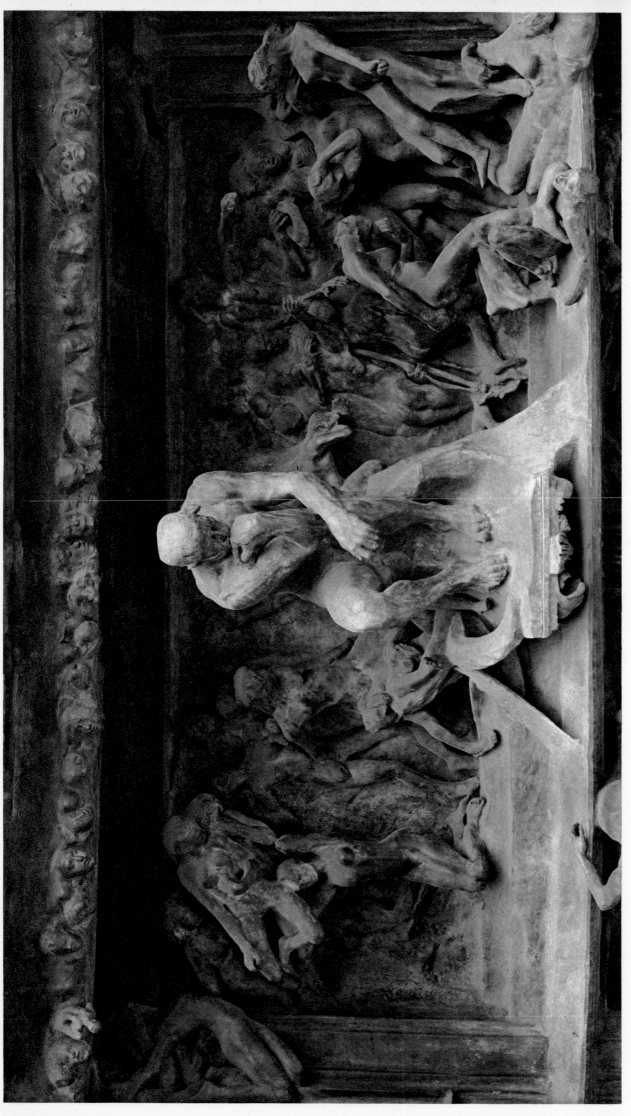

10. THE GATE OF HELL. DETAIL.

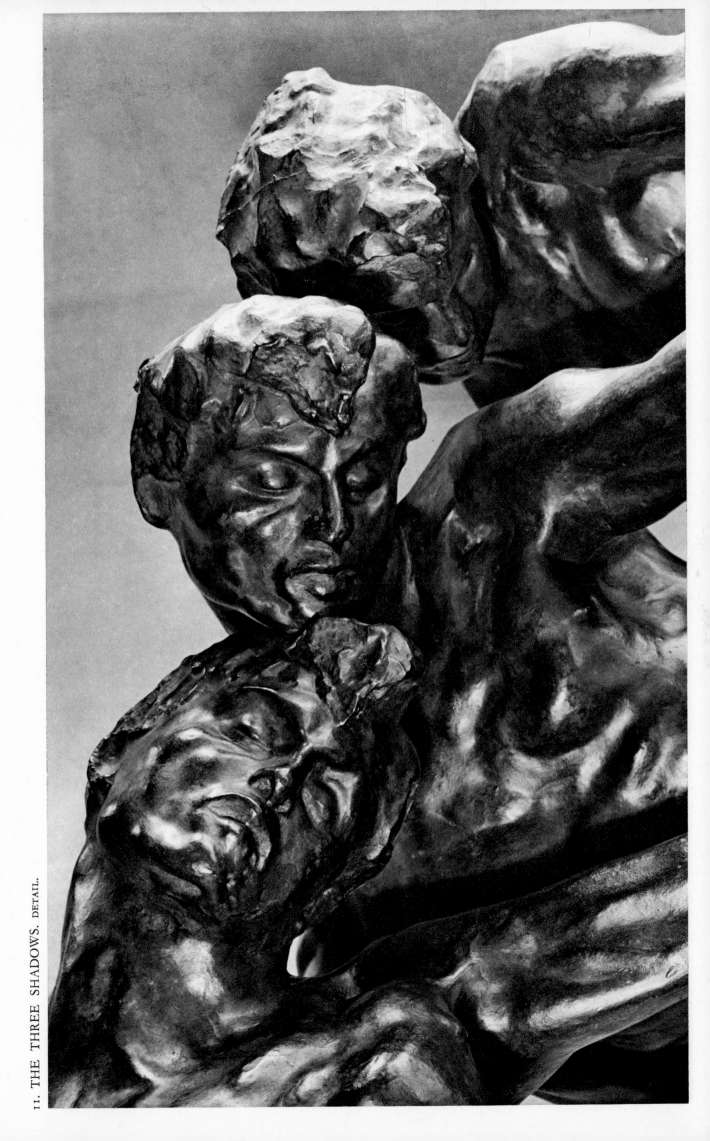

11. THE THREE SHADOWS. DETAIL.

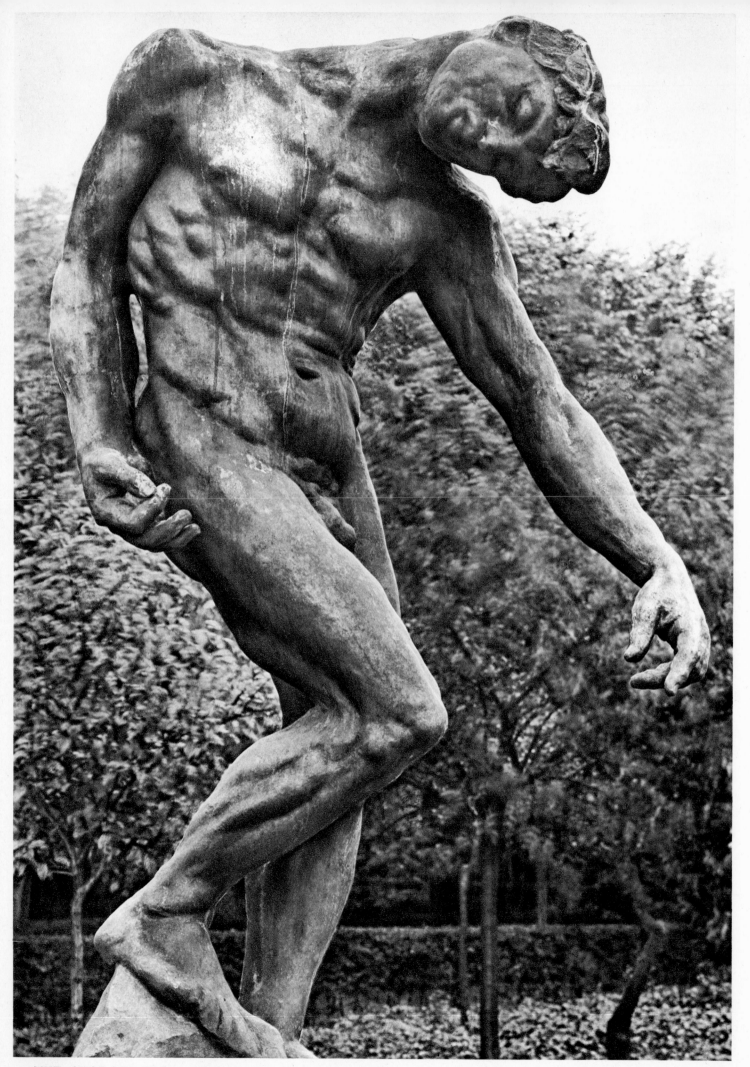

12. THE SHADOW. FROM "THE GATE OF HELL". BRONZE. 1880.

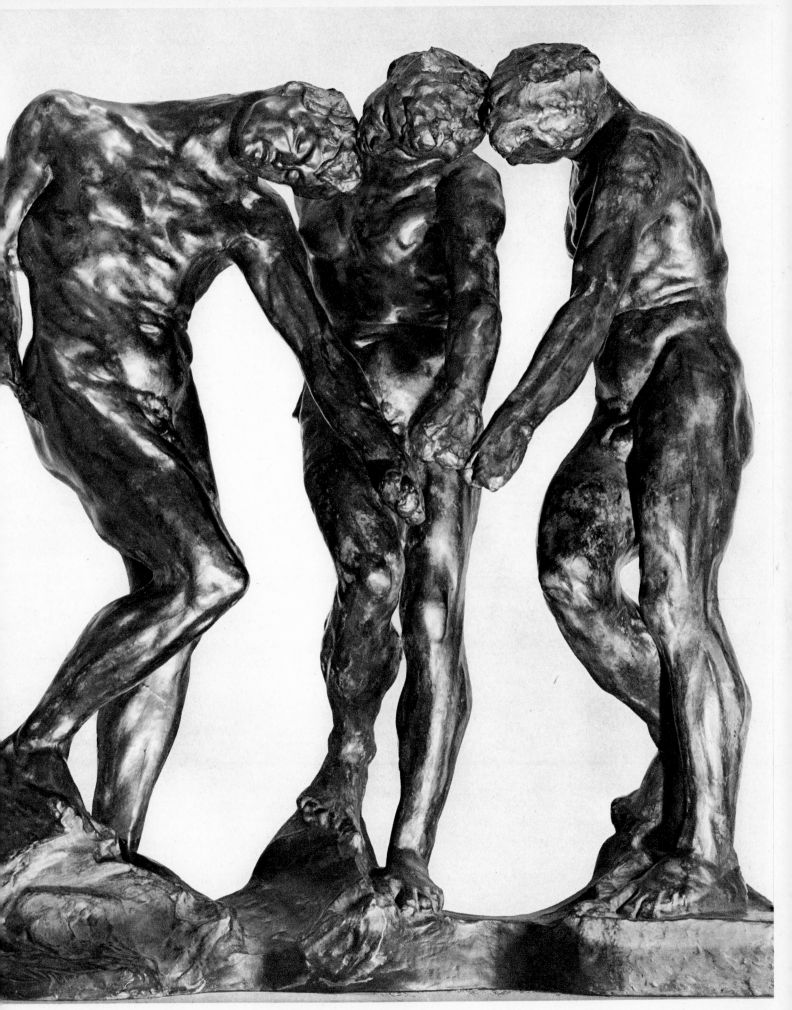

THE THREE SHADOWS. FROM "THE GATE OF HELL". BRONZE. 1880.

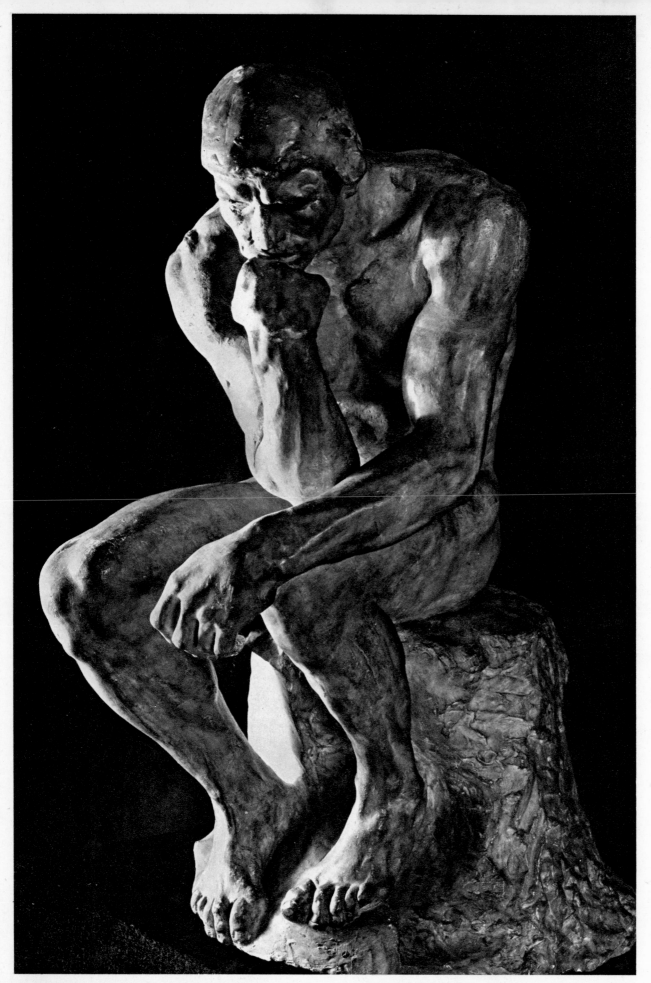

14. THE THINKER. PLASTER MODEL. 1879–1880.

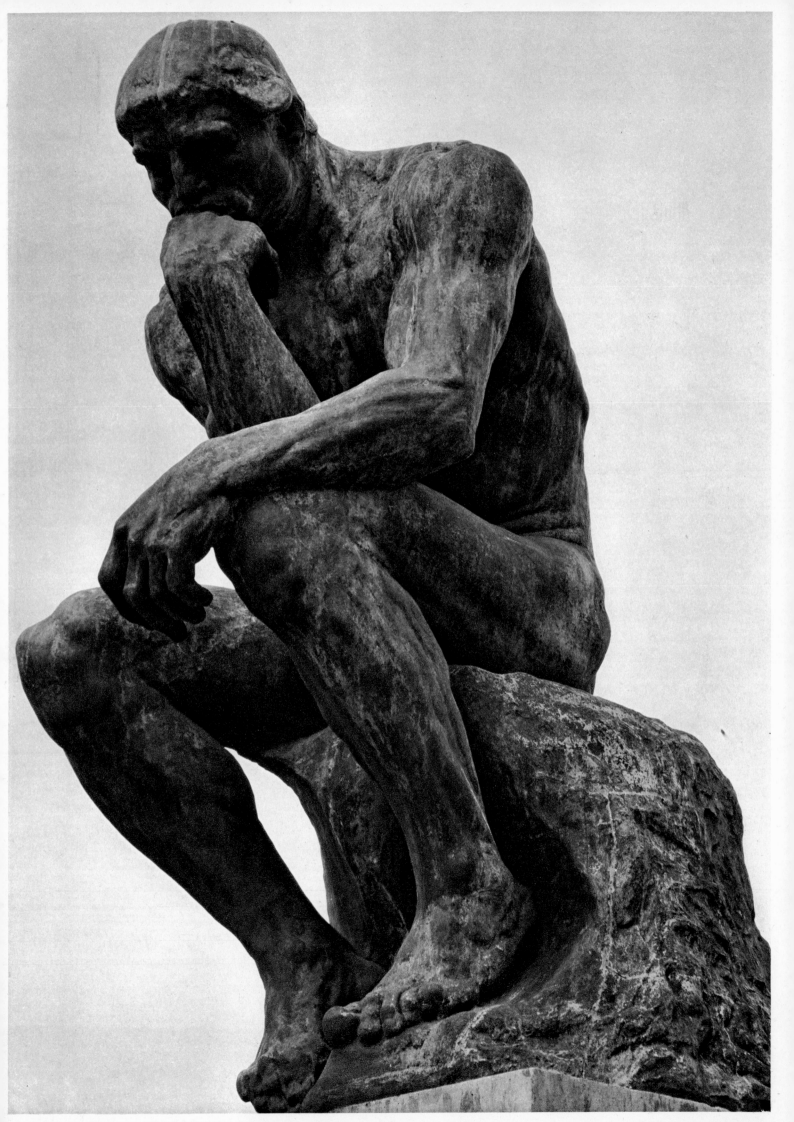

15. THE THINKER. FROM "THE GATE OF HELL". BRONZE. 1880-1900.

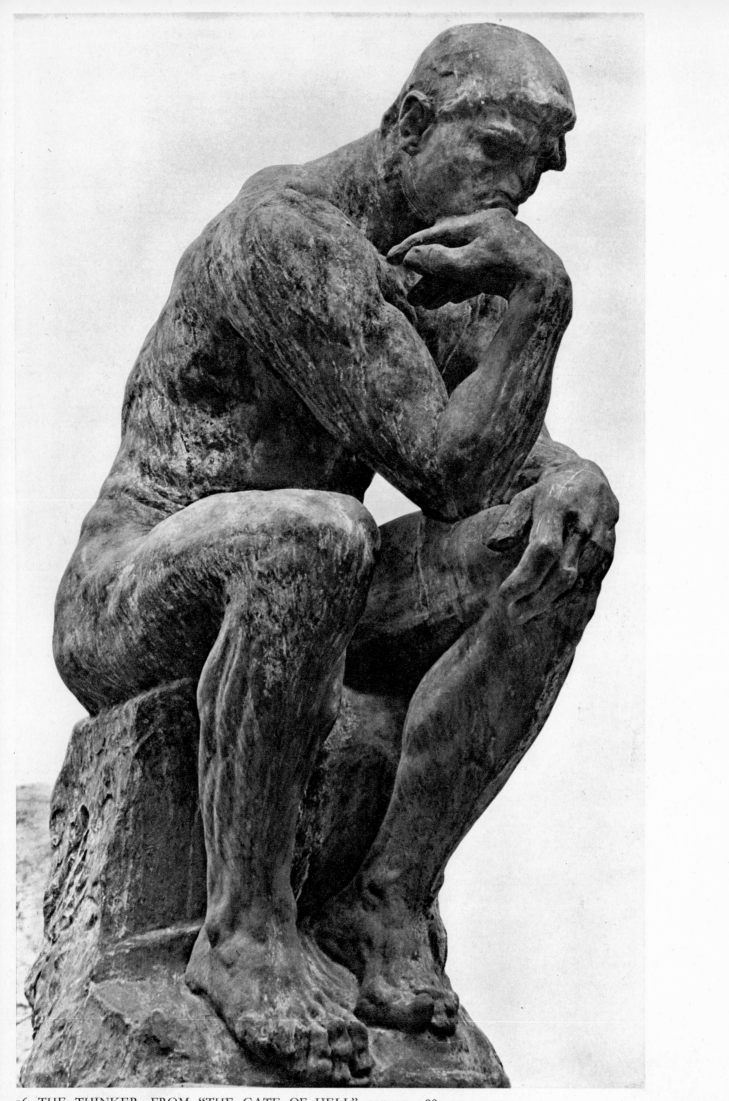

16. THE THINKER. FROM "THE GATE OF HELL". BRONZE. 1880–1900.

17. BUST OF THE PAINTER ALPHONSE LEGROS. BRONZE. 1881.

18. BUST OF THE PAINTER JEAN-PAUL LAURENS. BRONZE. 1881.

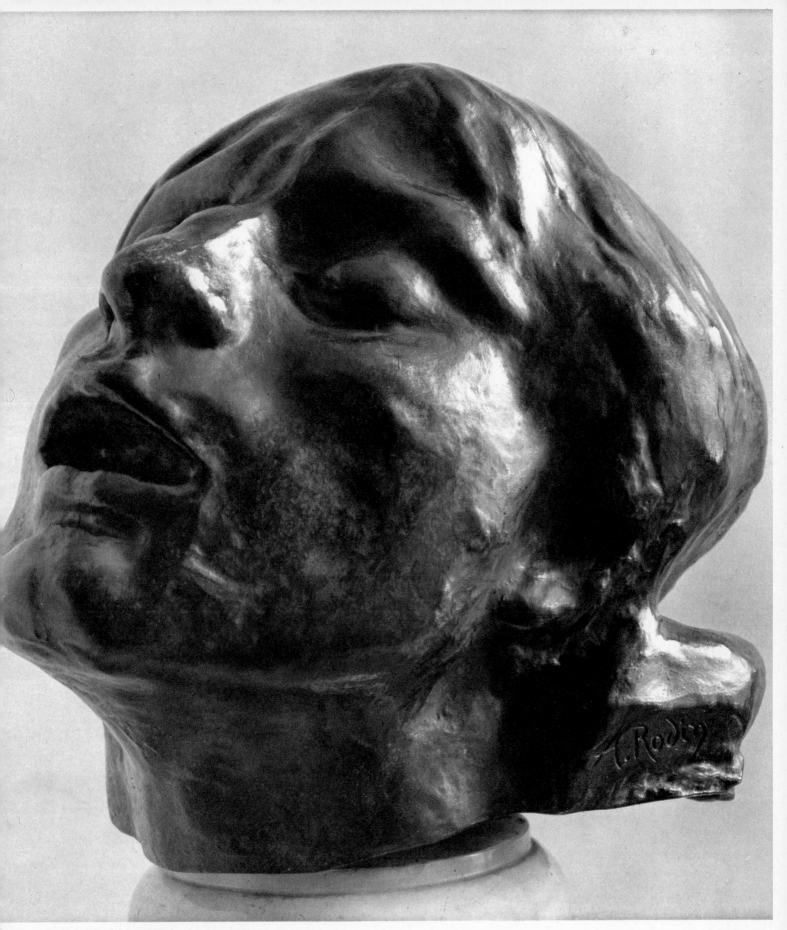

THE HEAD OF SORROW. BRONZE. 1882.

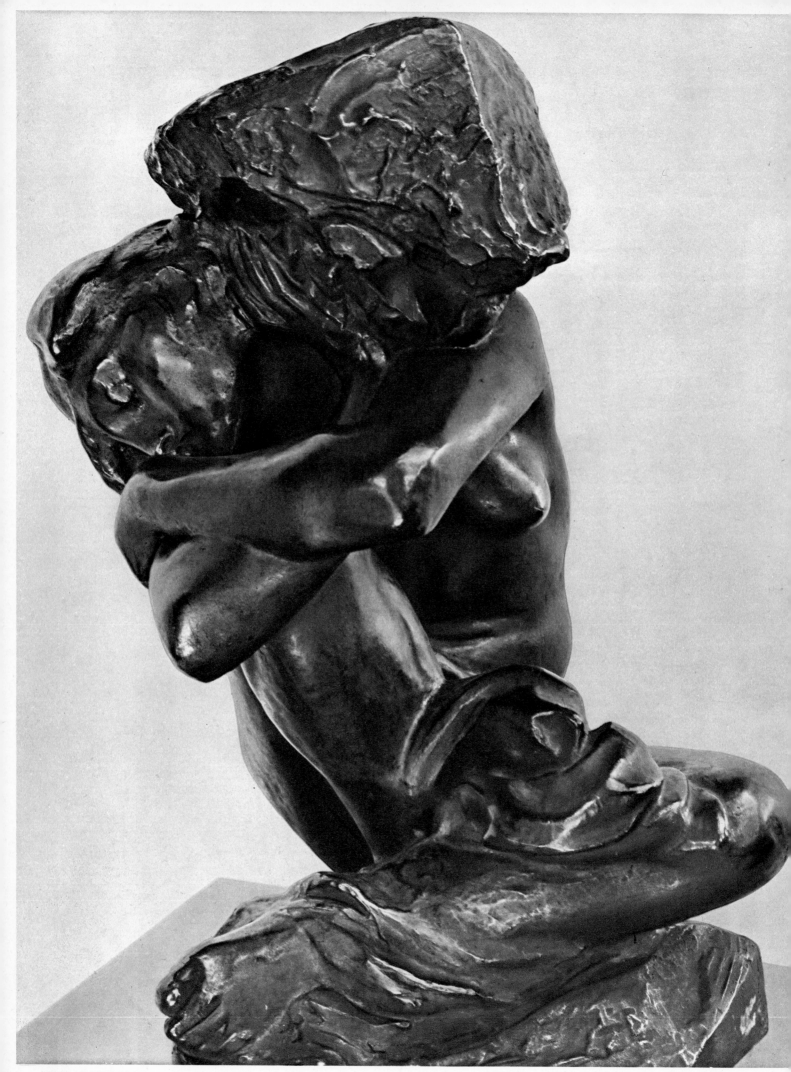

20. THE CARYATID. BRONZE. 1880–1.

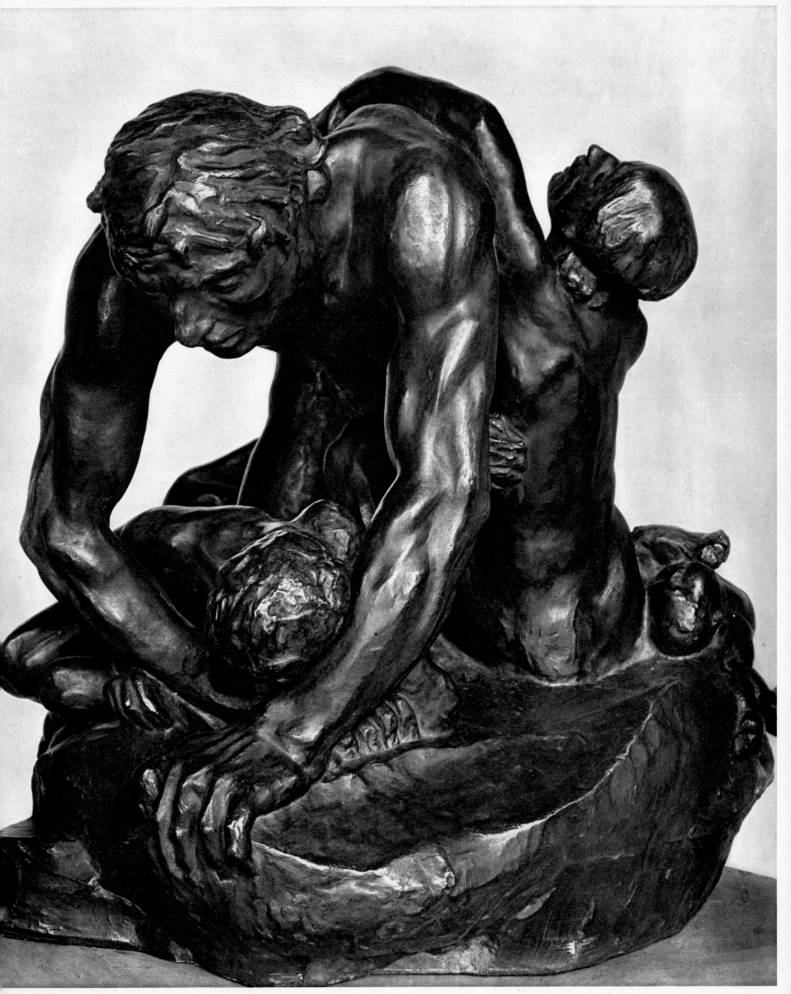

UGOLINO. BRONZE. 1882.

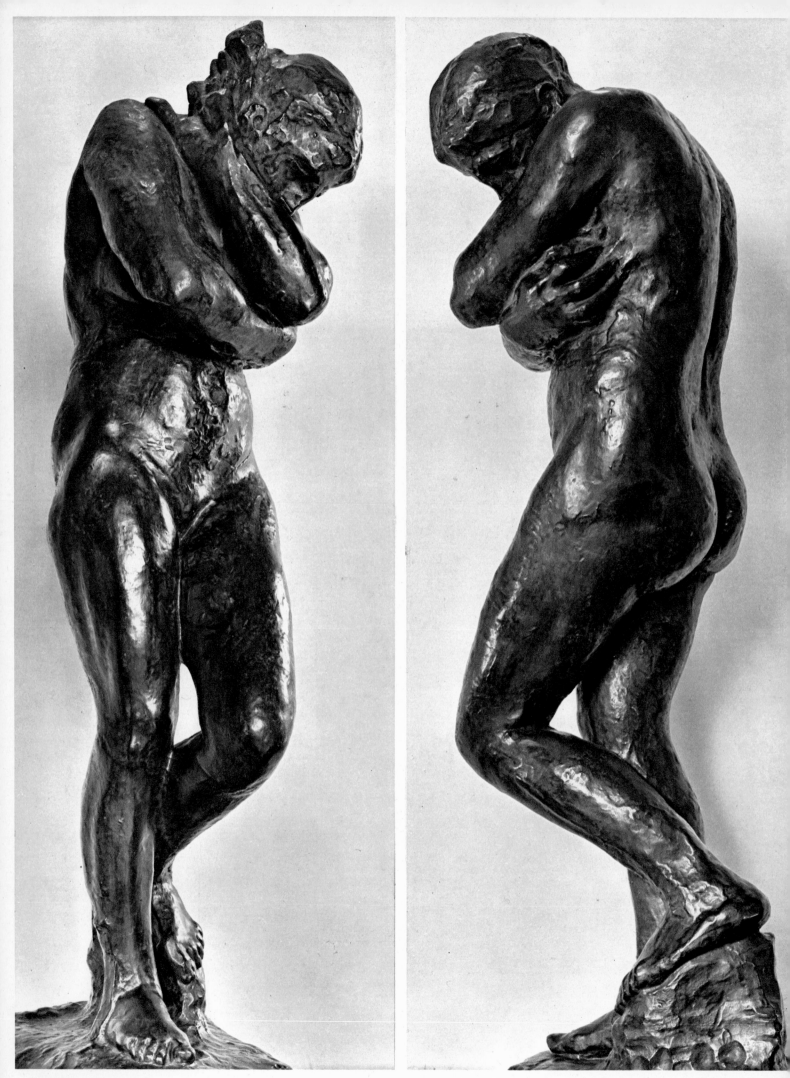

22. EVE. BRONZE. 1881.

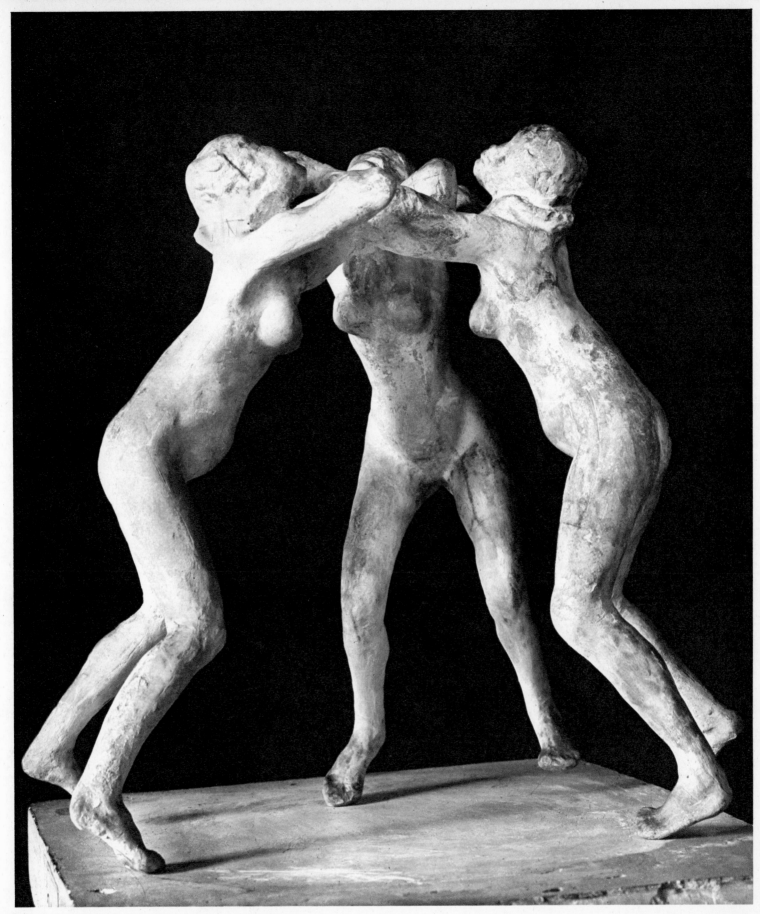

23. THE THREE FAUNS. PLASTER. 1882.

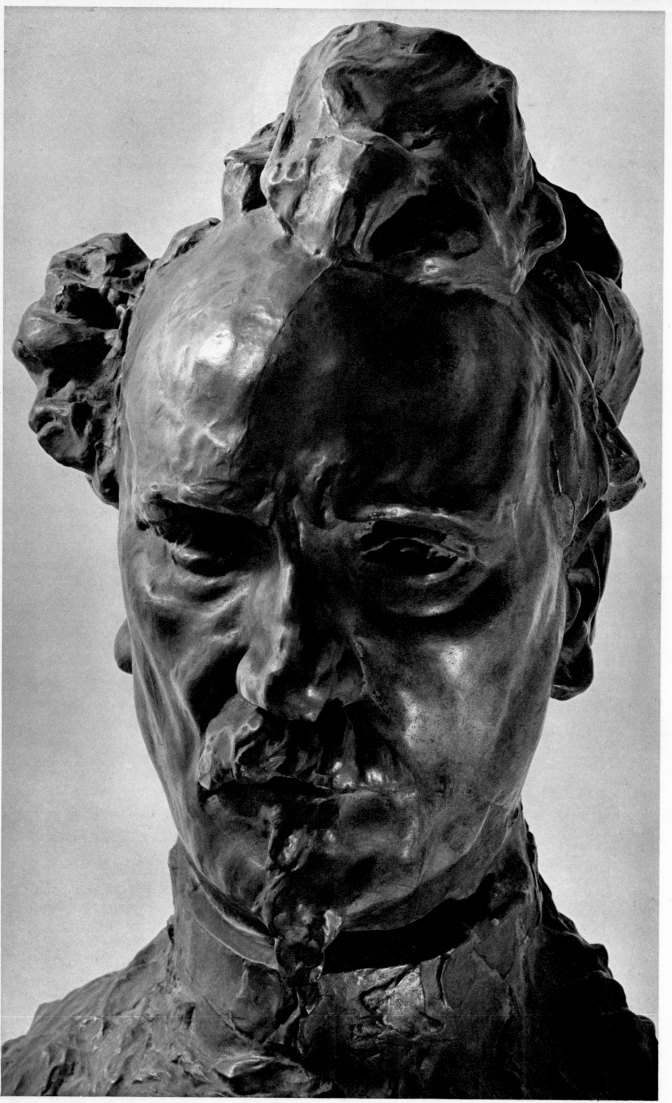

24. BUST OF HENRI ROCHEFORT. BRONZE. 1897.

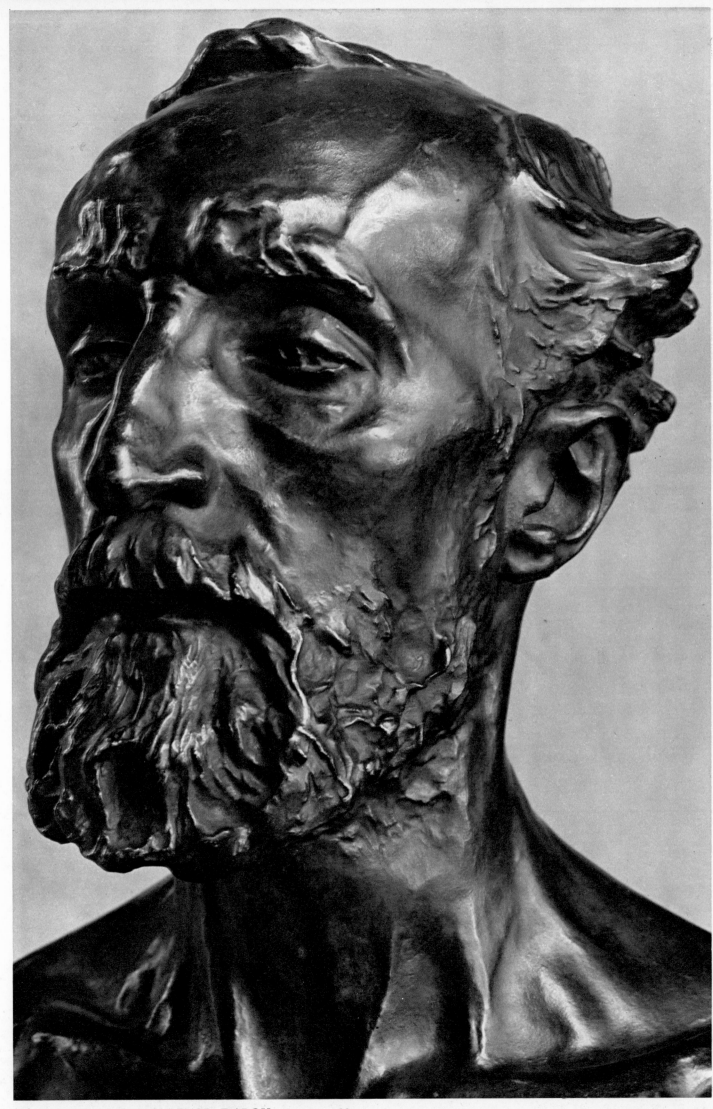

25. BUST OF THE SCULPTOR DALOU. BRONZE. 1883.

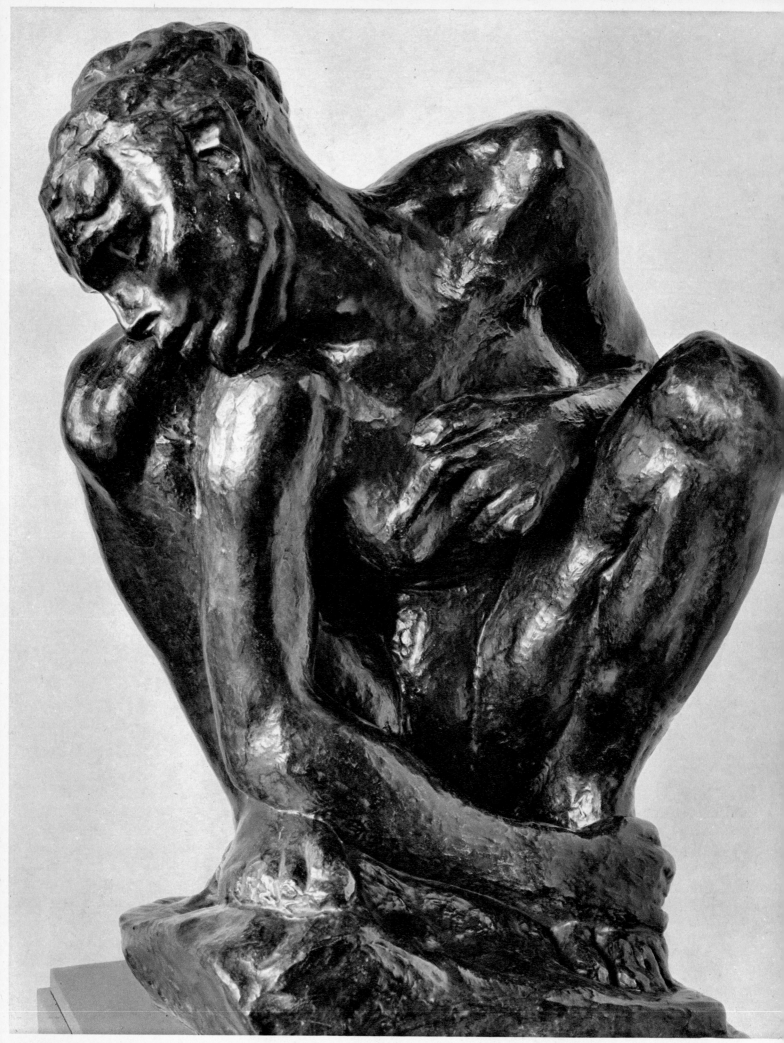

26. THE CROUCHING WOMAN. BRONZE. 1882.

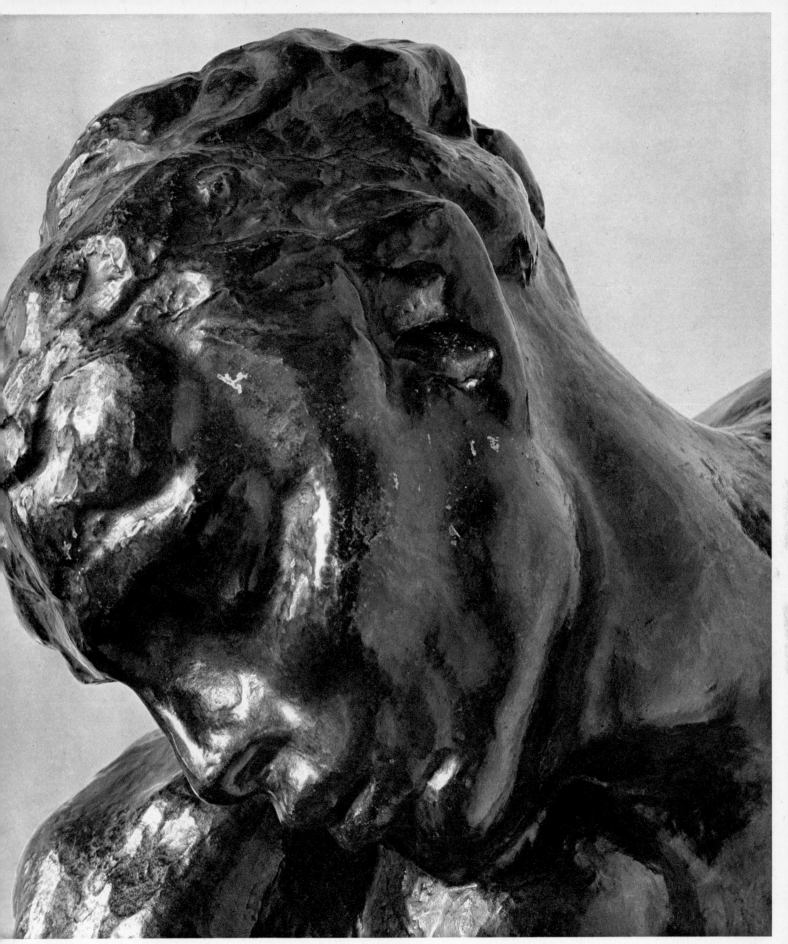

THE CROUCHING WOMAN. DETAIL.

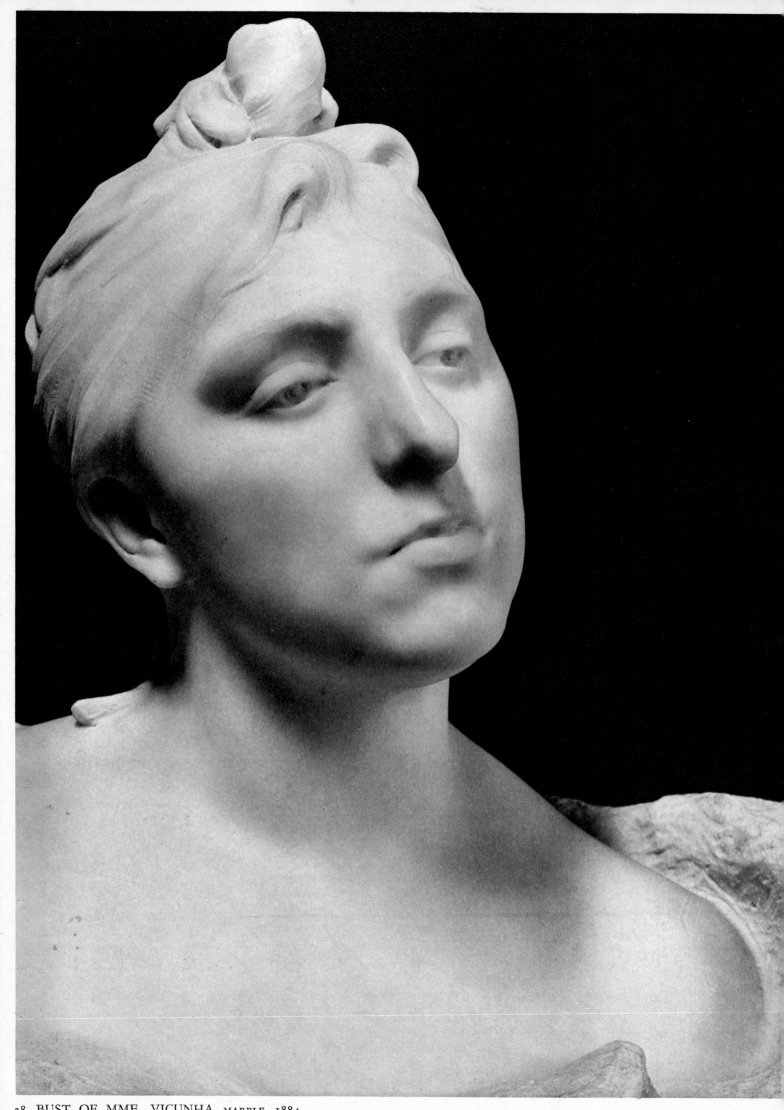

28. BUST OF MME. VICUNHA. MARBLE. 1884.

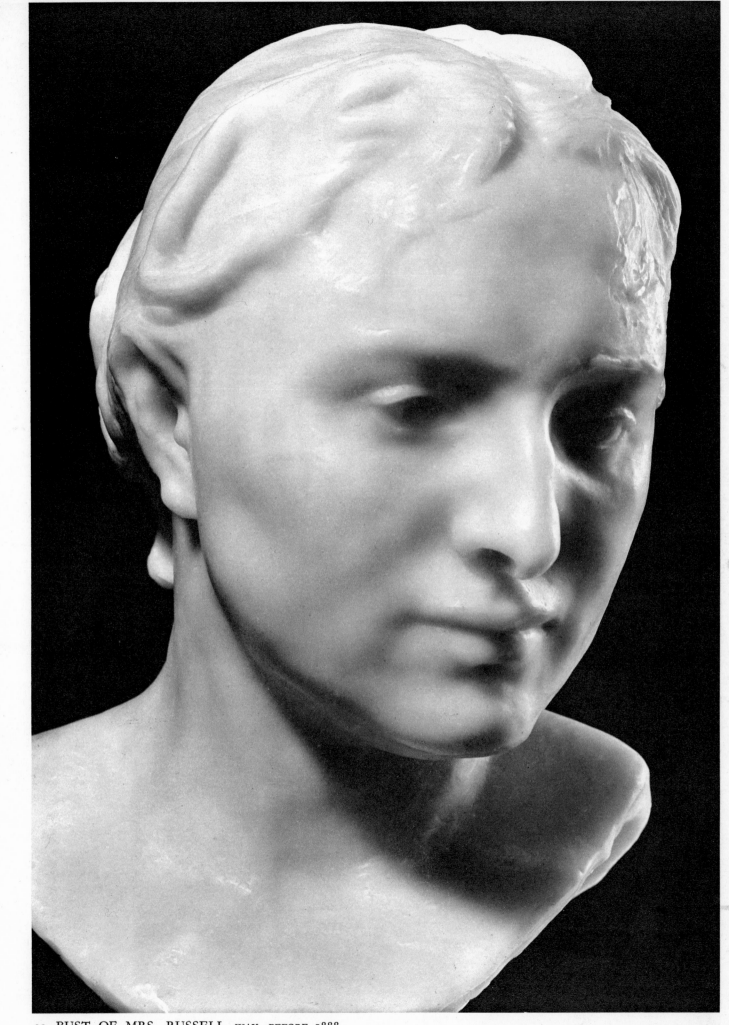

29. BUST OF MRS. RUSSELL. WAX. BEFORE 1888.

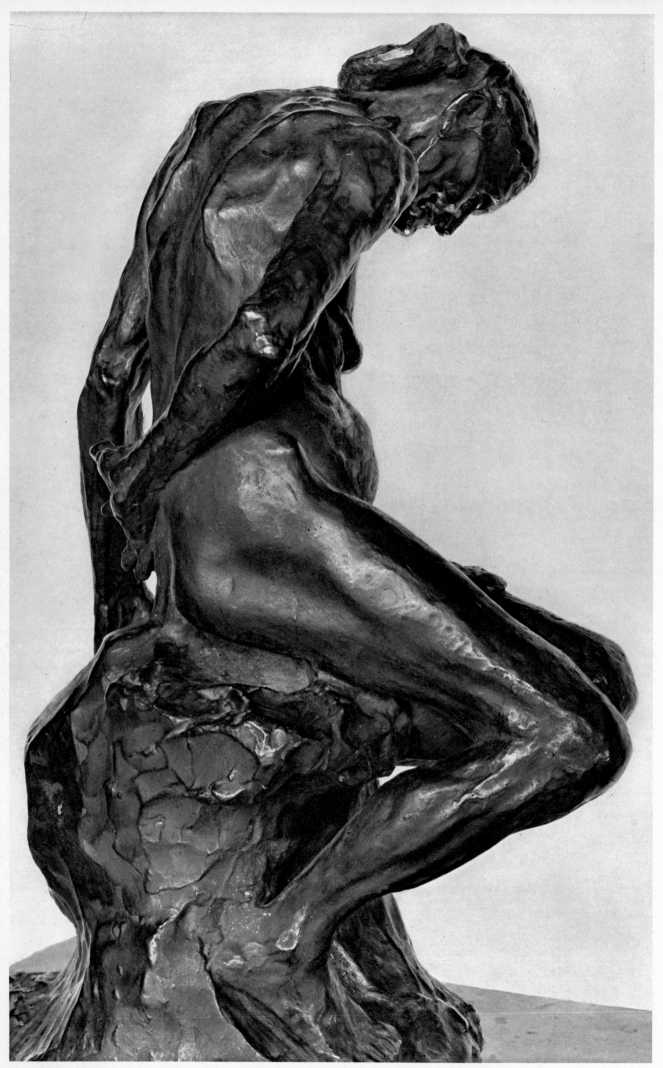

30. "SHE WHO ONCE WAS THE HELMET-MAKER'S BEAUTIFUL WIFE". BRONZE. BEFORE 1885.

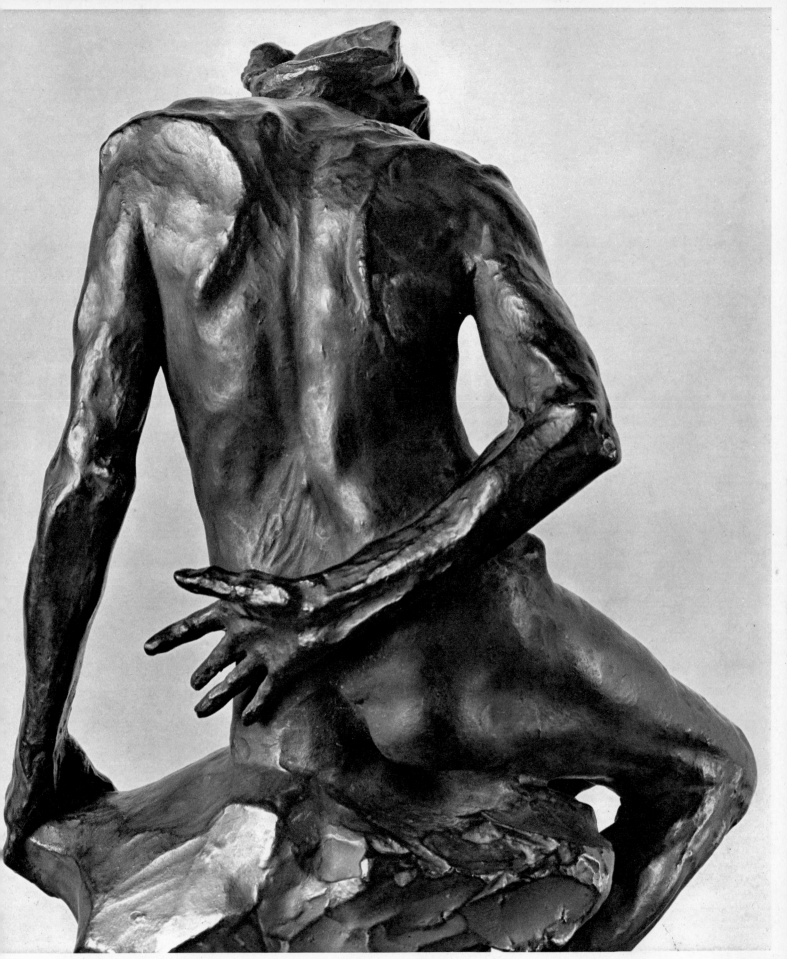

"THE HELMET-MAKER'S WIFE". BACK VIEW.

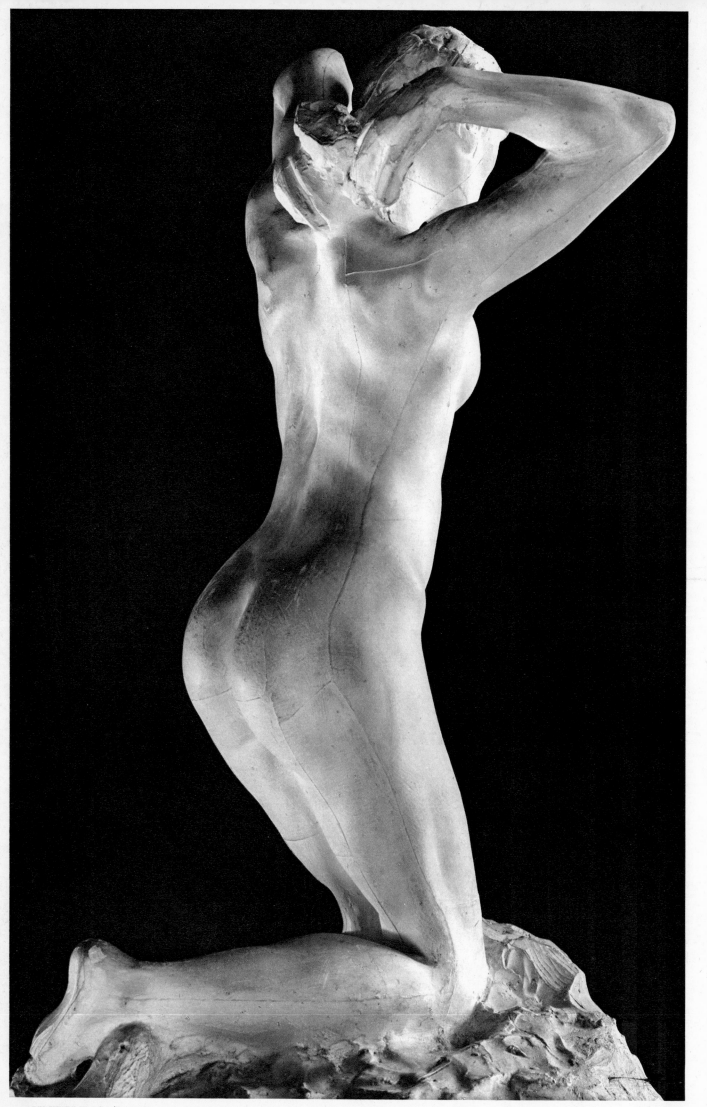

32. KNEELING FAUN. PLASTER. 1884.

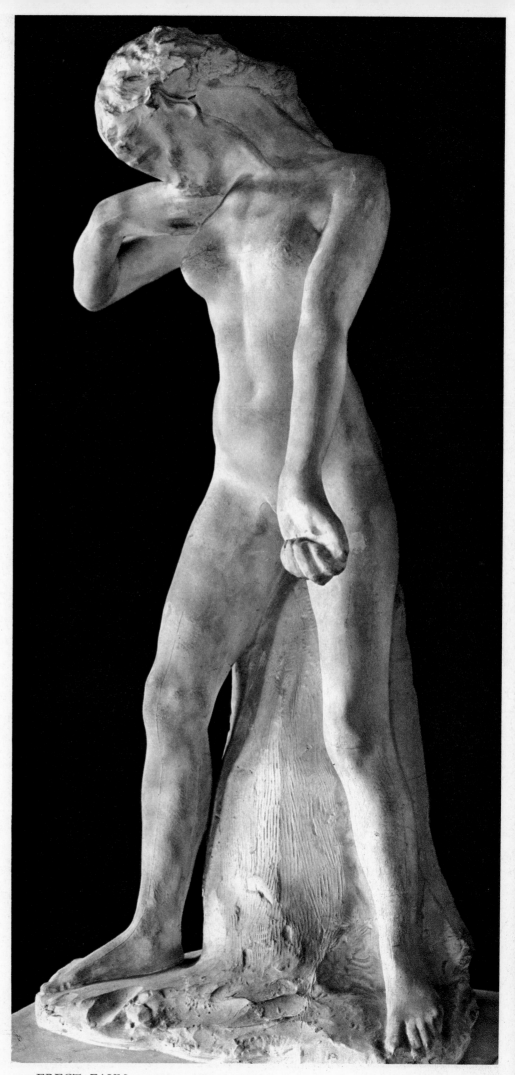

33. ERECT FAUN. PLASTER. 1884.

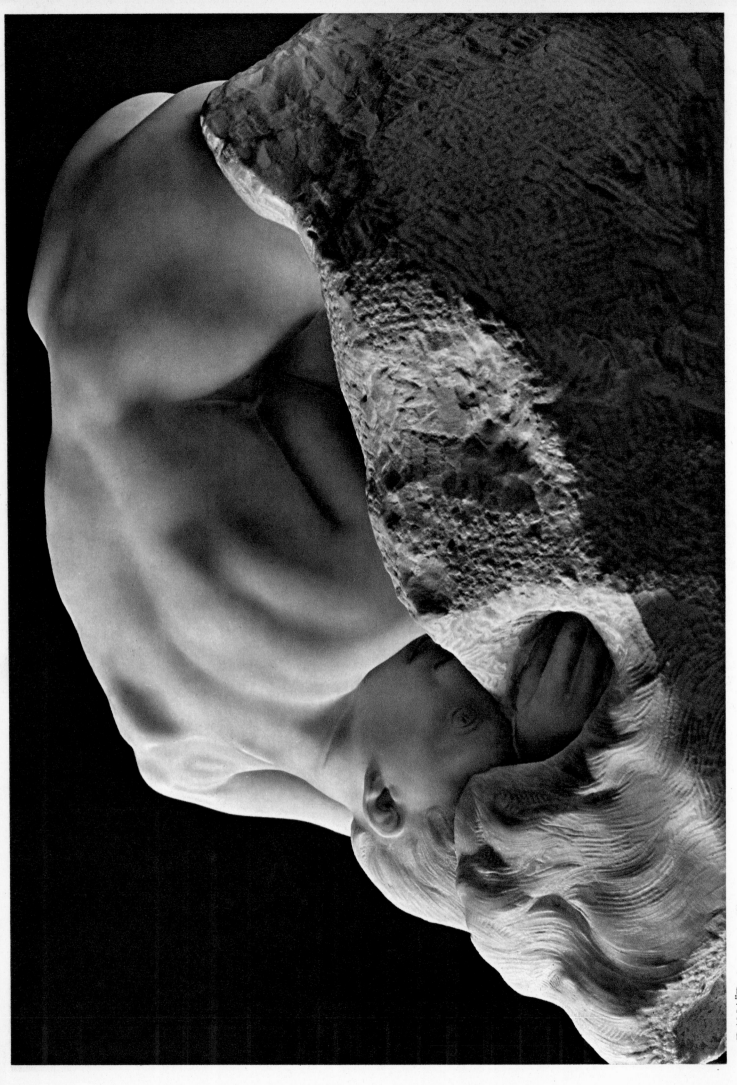

34. DANAÏD. MARBLE. 1885.

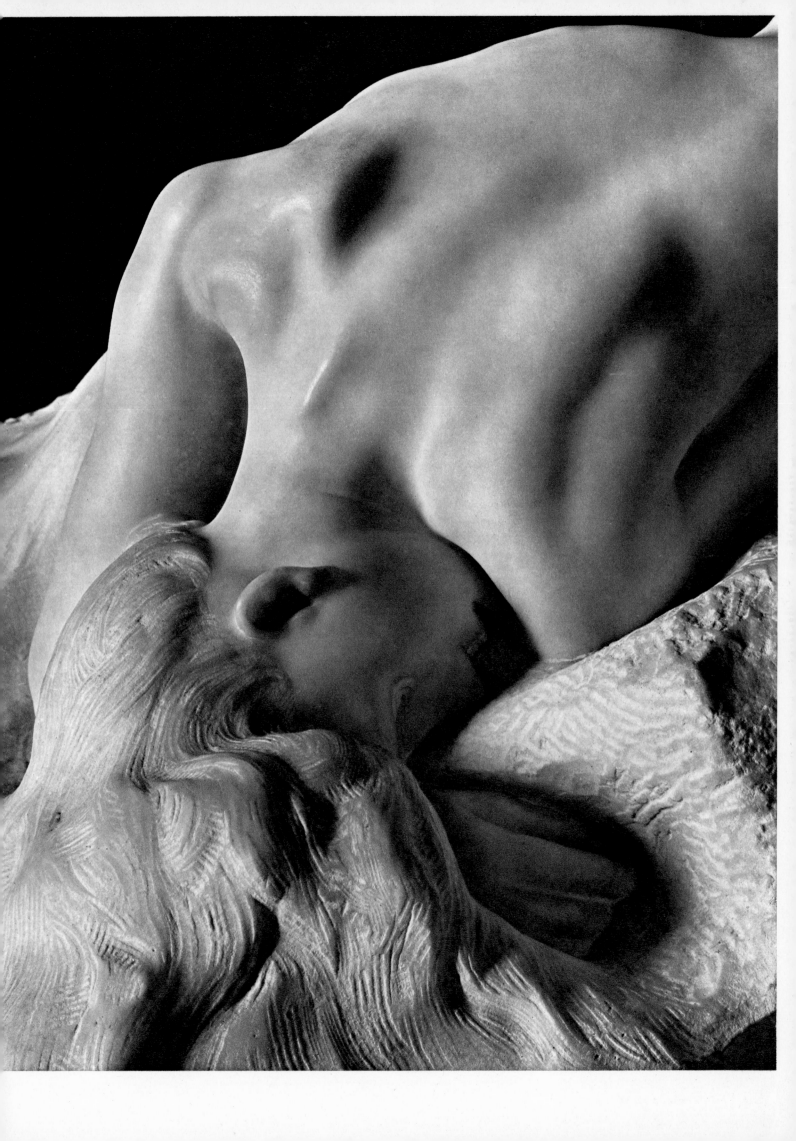

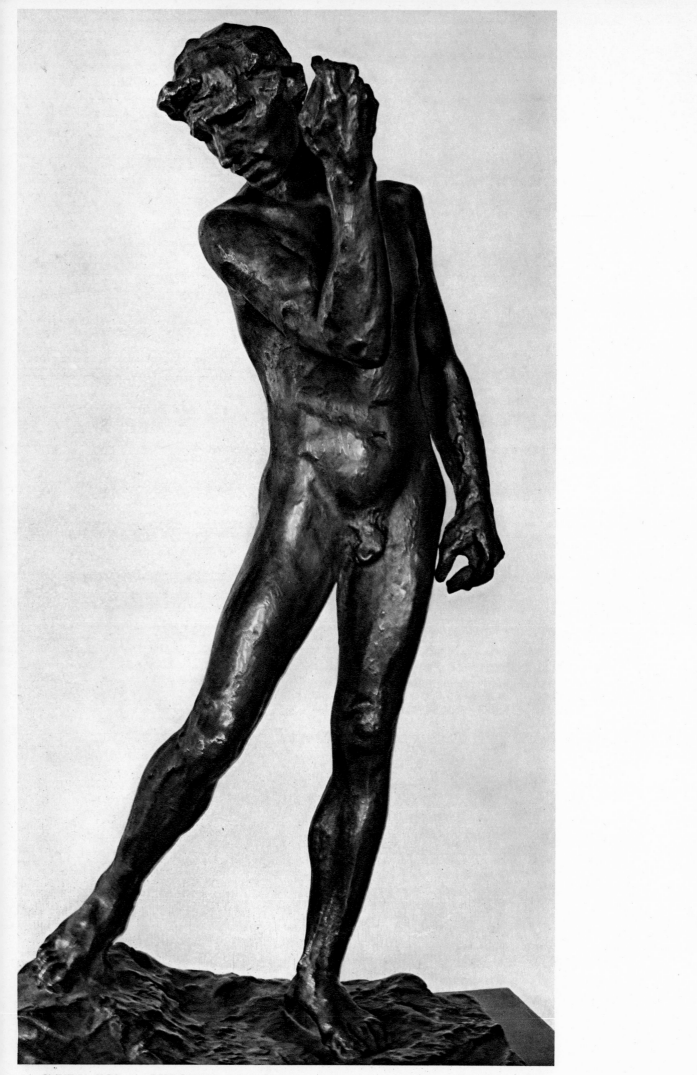

36. STUDY FOR A BURGHER OF CALAIS. BRONZE.

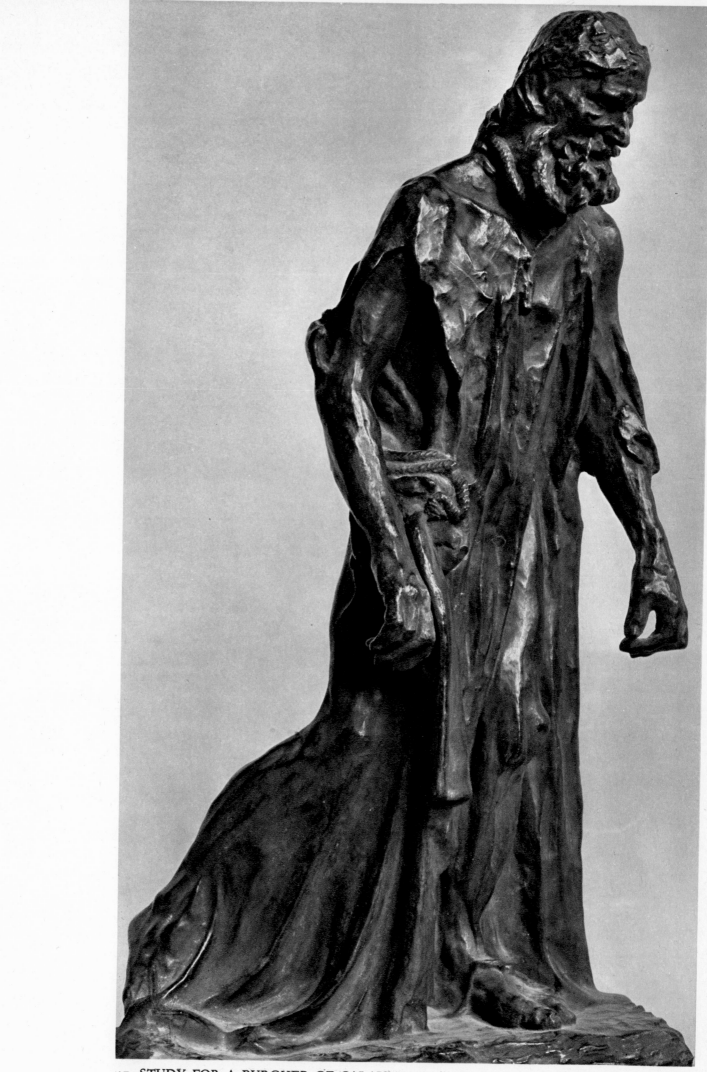

37. STUDY FOR A BURGHER OF CALAIS. BRONZE. 1884.

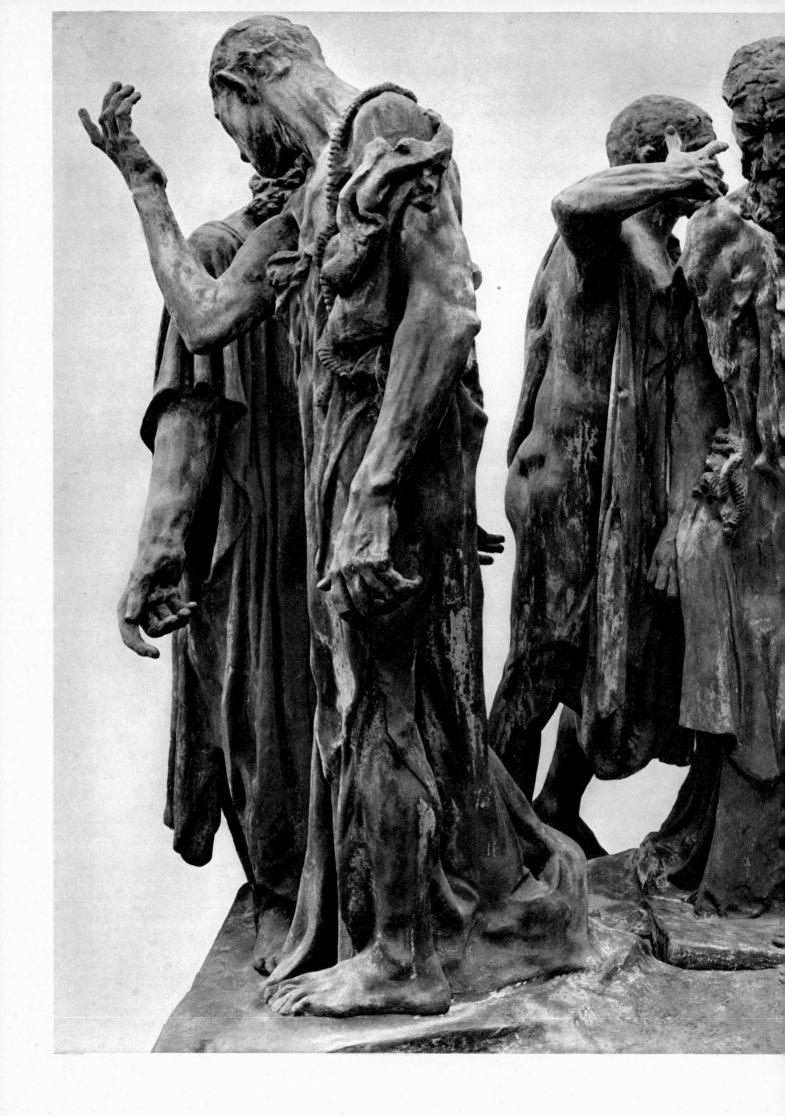

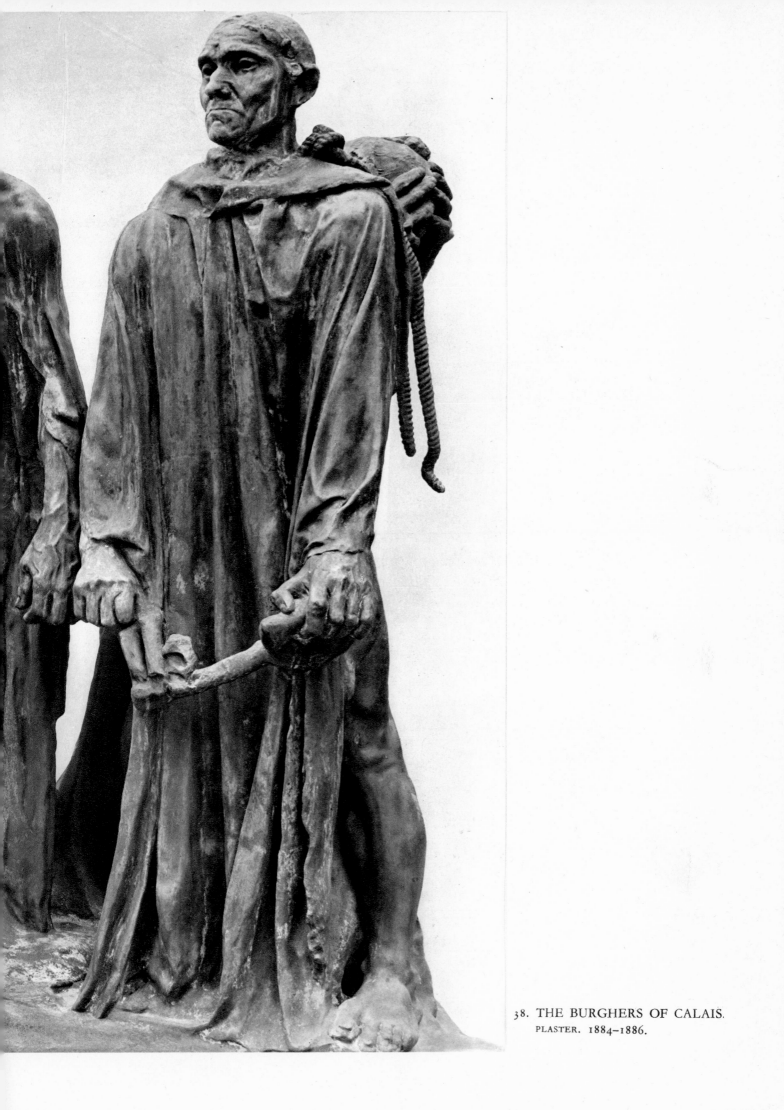

38. THE BURGHERS OF CALAIS.
PLASTER. 1884–1886.

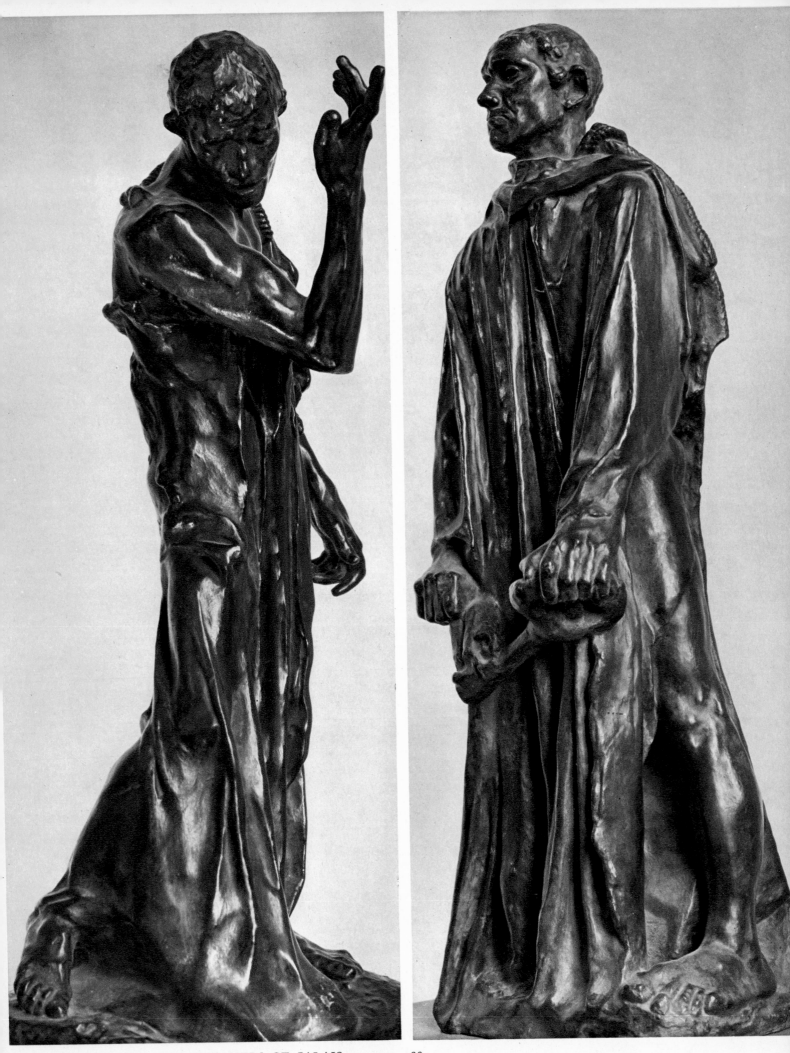

39—40. STUDIES FOR THE BURGHERS OF CALAIS. BRONZE. 1884.

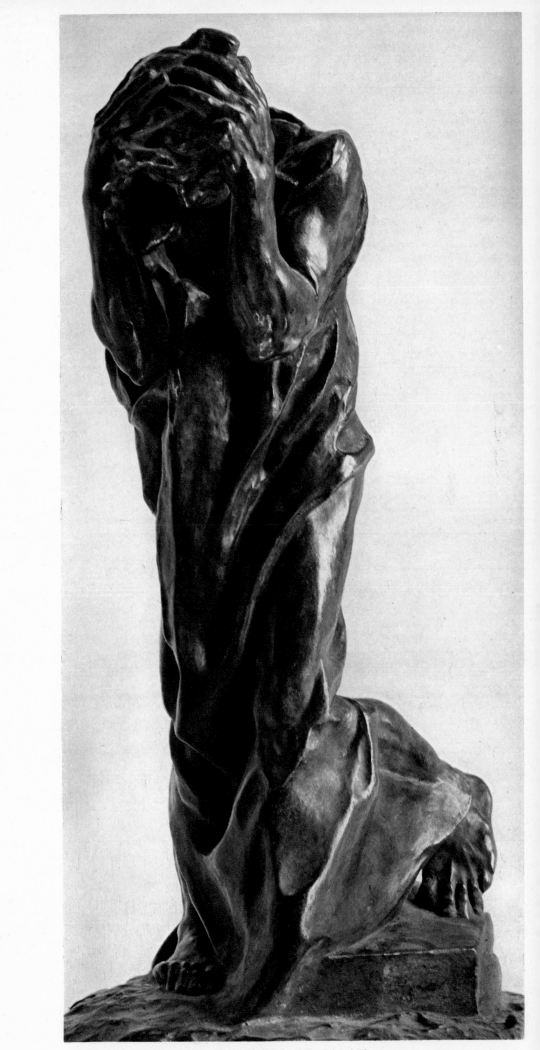

41. STUDY FOR THE BURGHERS OF CALAIS. BRONZE. 1884.

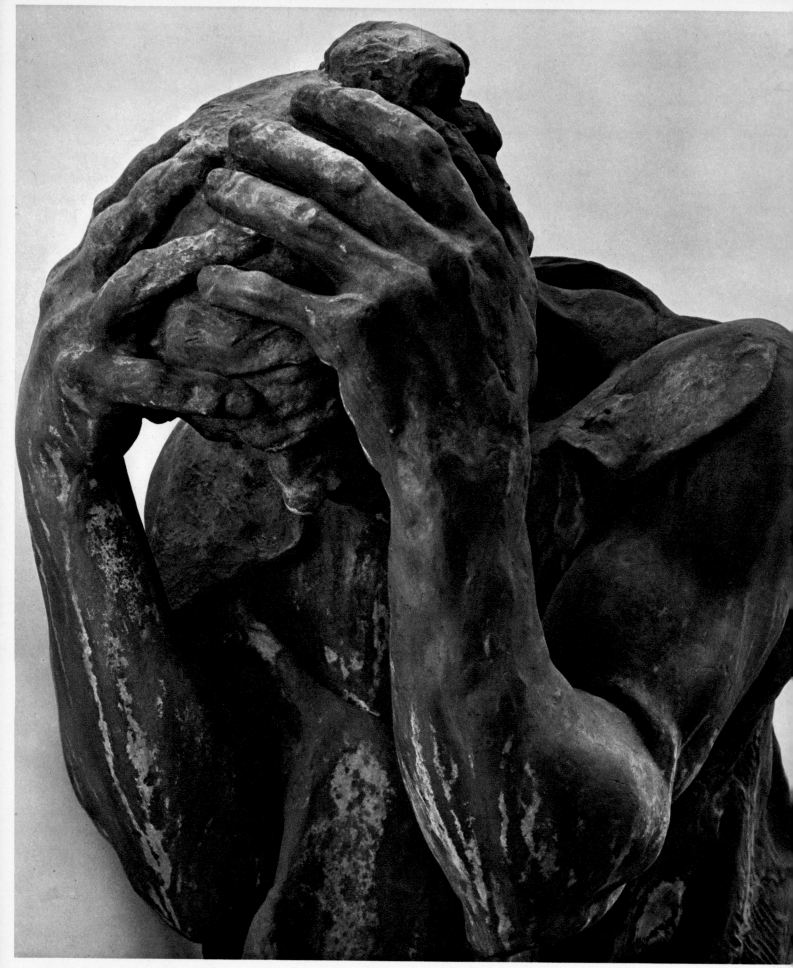

42. THE BURGHERS OF CALAIS. DETAIL.

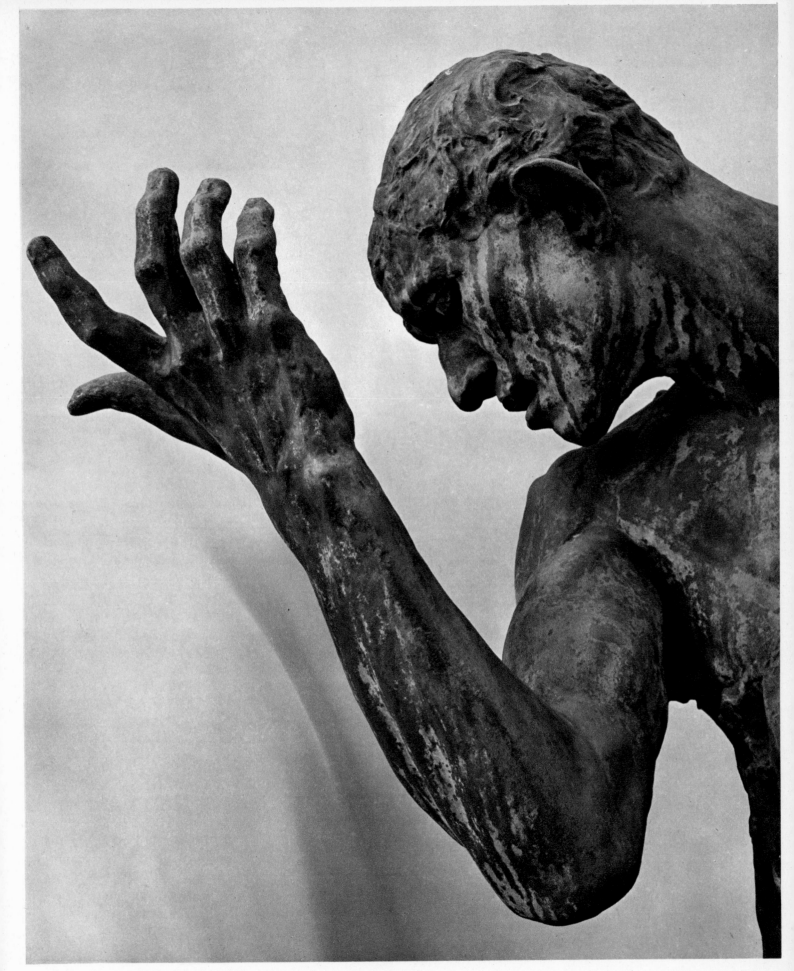

43. THE BURGHERS OF CALAIS. DETAIL.

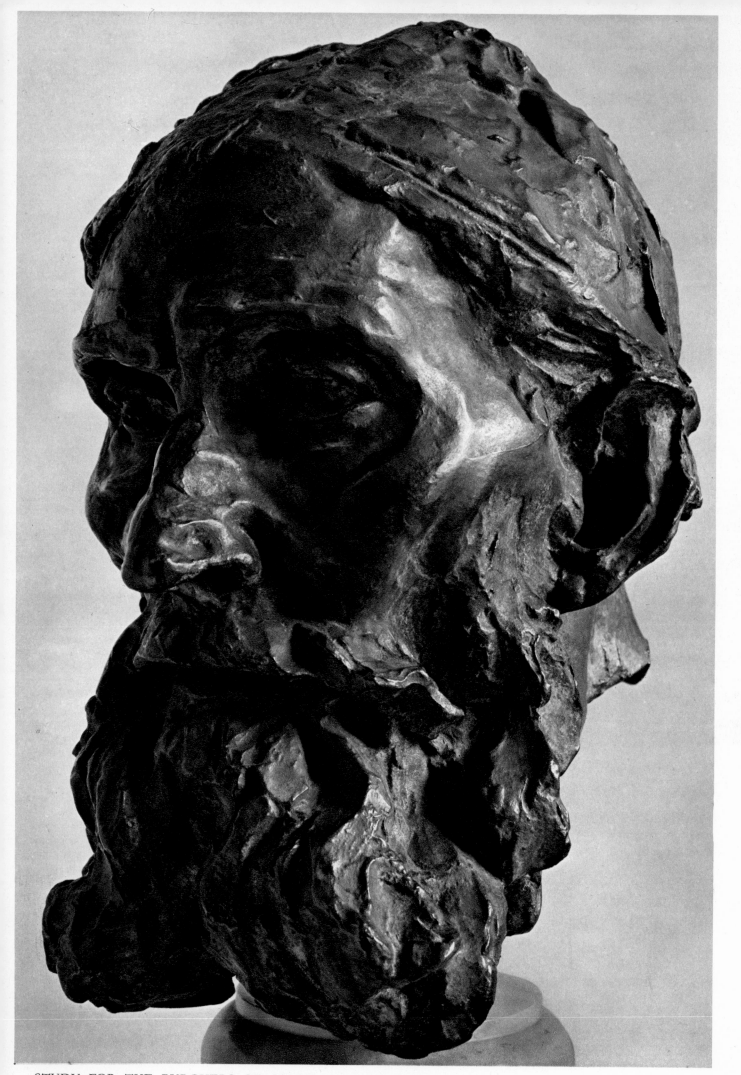

44. STUDY FOR THE BURGHERS OF CALAIS. BRONZE. 1884.

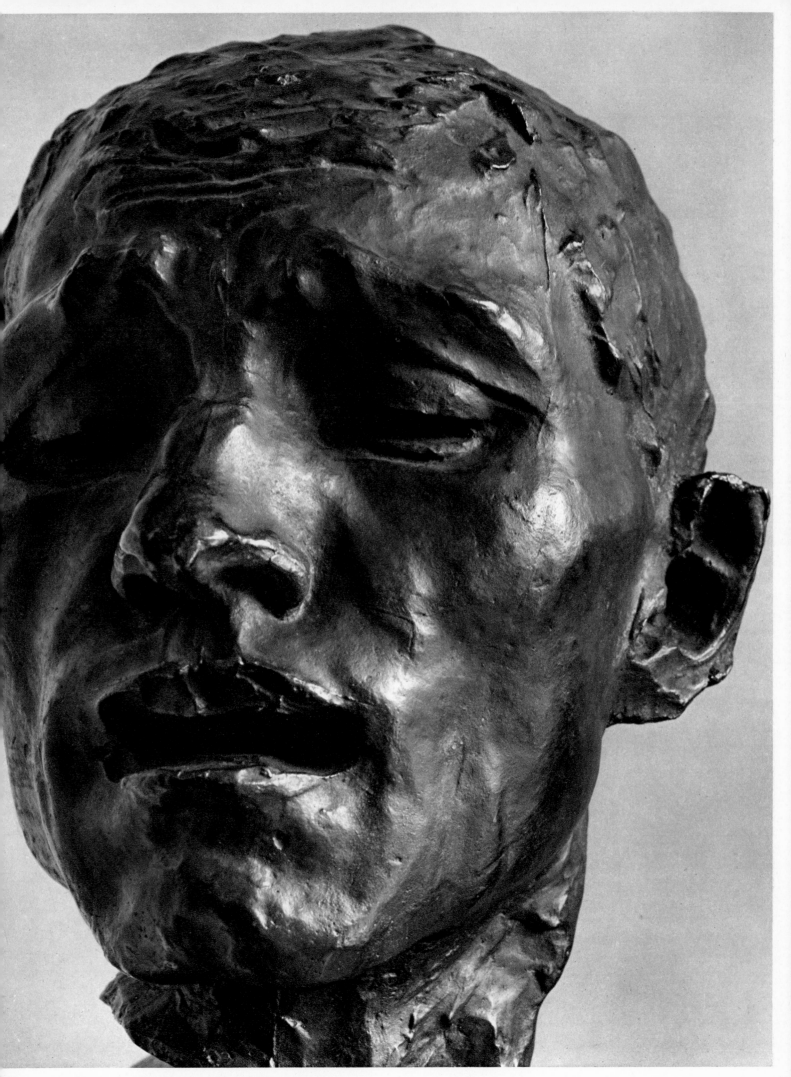

UDY FOR THE BURGHERS OF CALAIS. BRONZE. 1884.

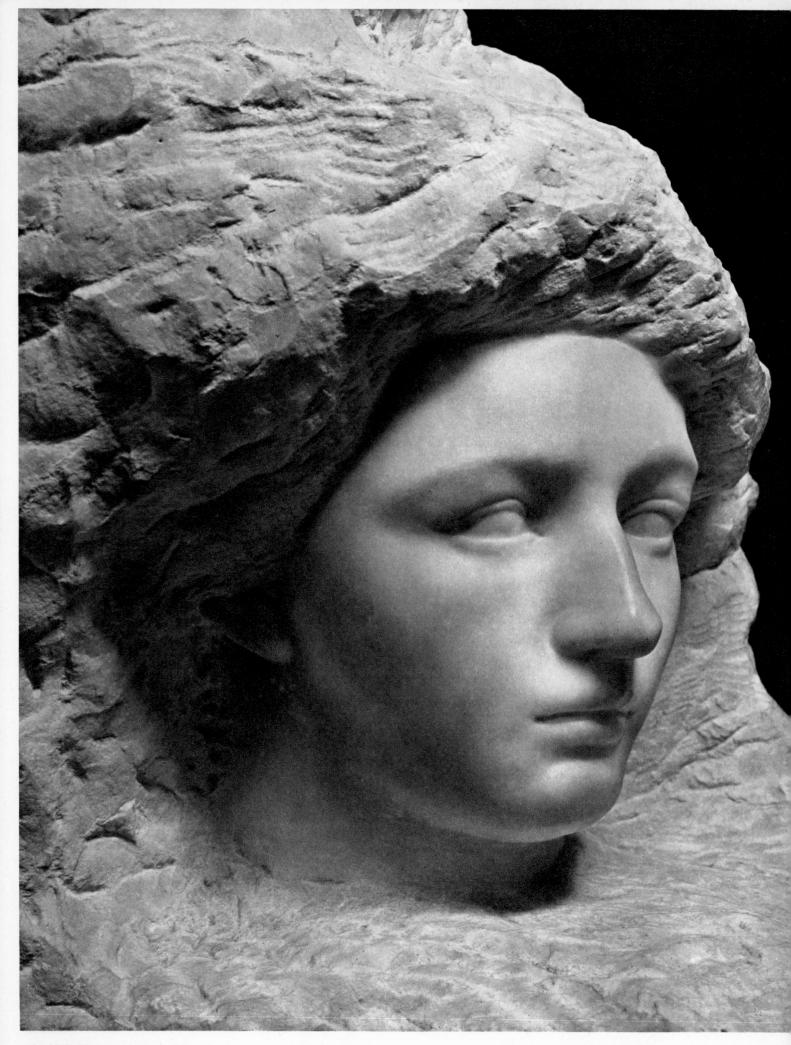

46. AURORA. MARBLE. 1885.

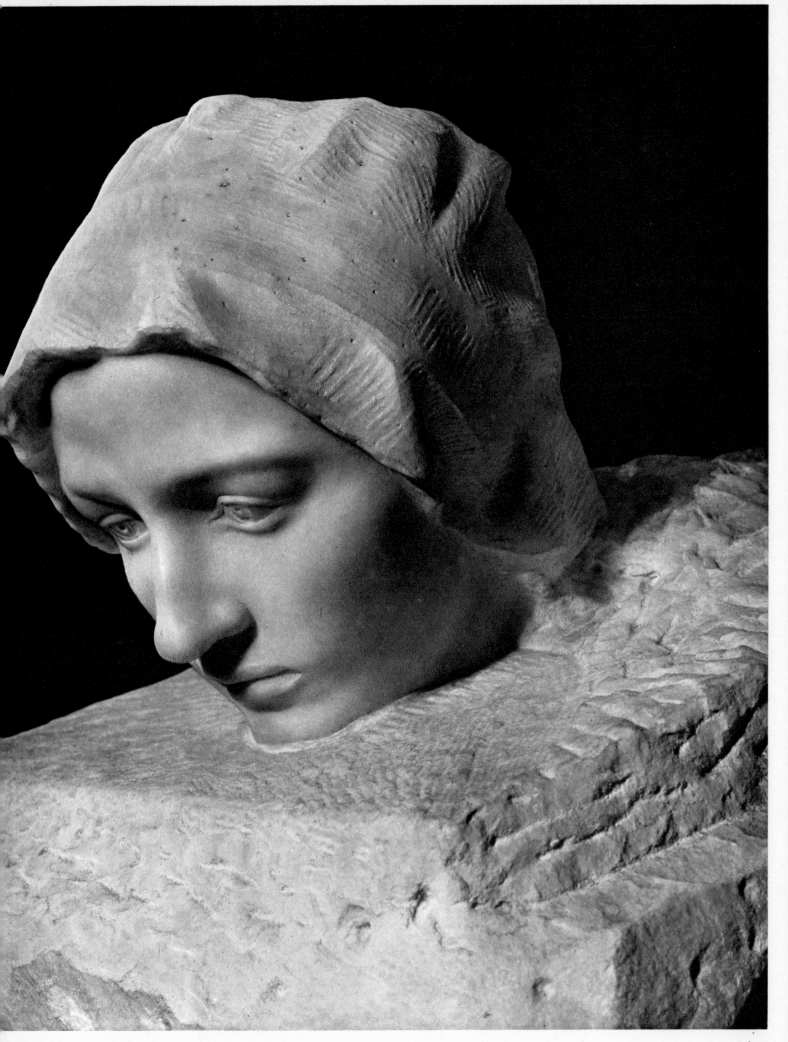

THOUGHT. MARBLE. 1886.

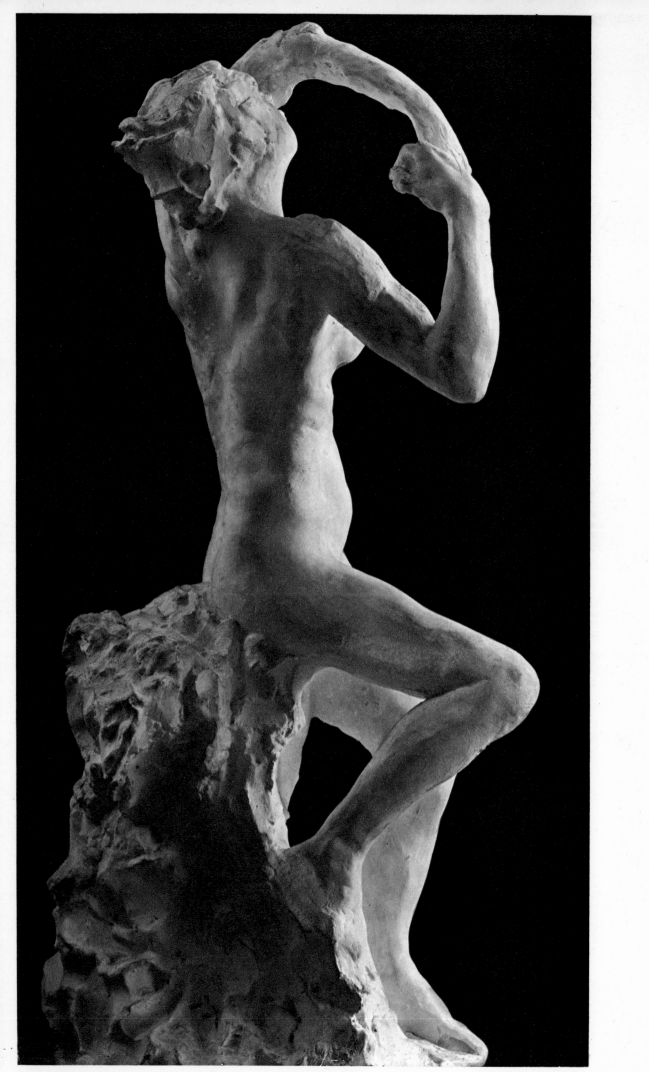

48. INVOCATION. PLASTER. 1886.

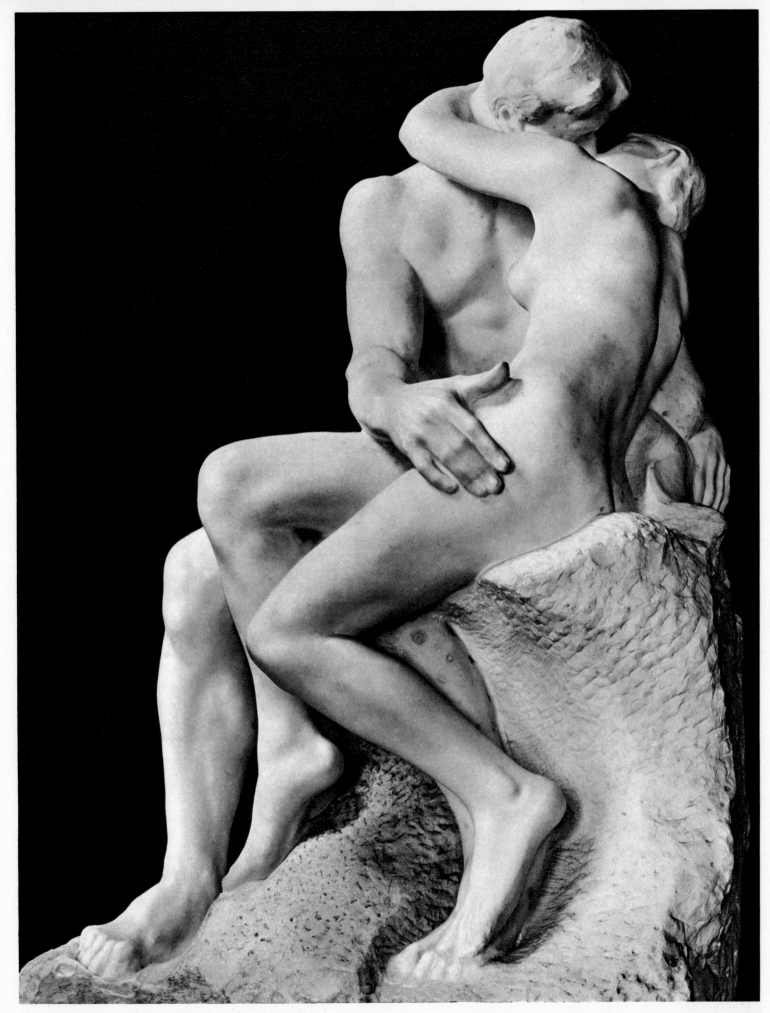

49. THE KISS. MARBLE. 1886.

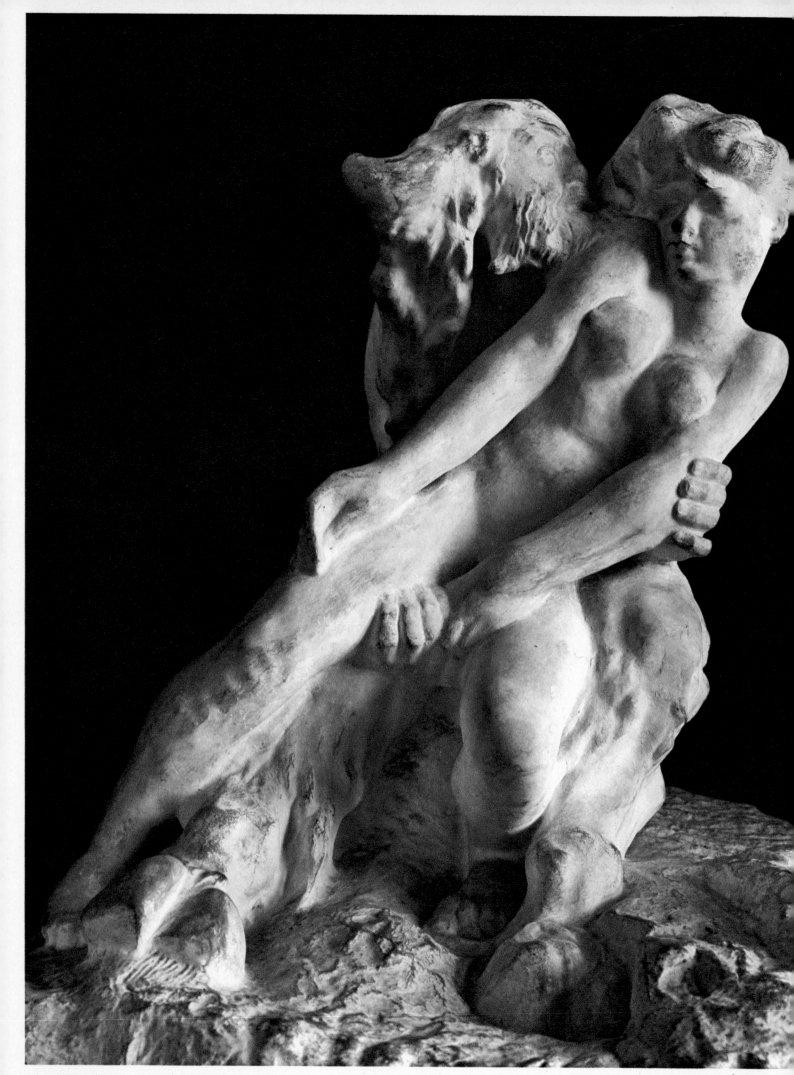

50. FAUN AND NYMPH. (THE MINOTAUR.) PLASTER. BEFORE 1886.

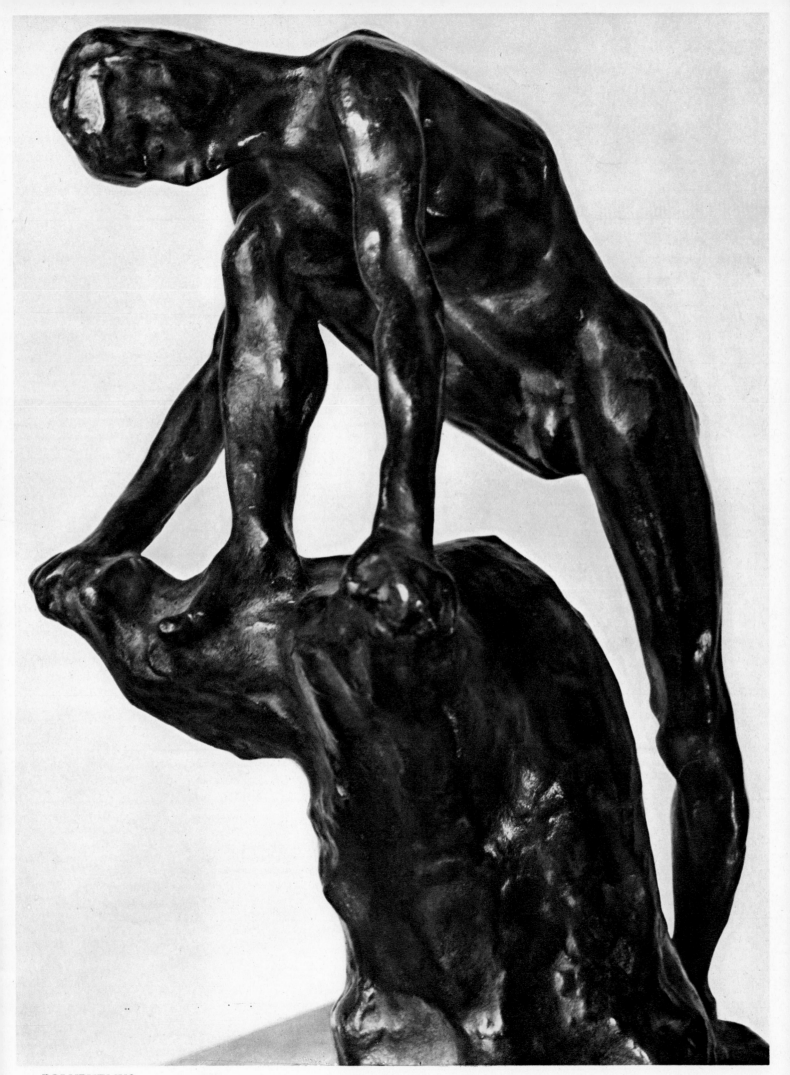

51. POLYPHEMUS. BRONZE. 1888.

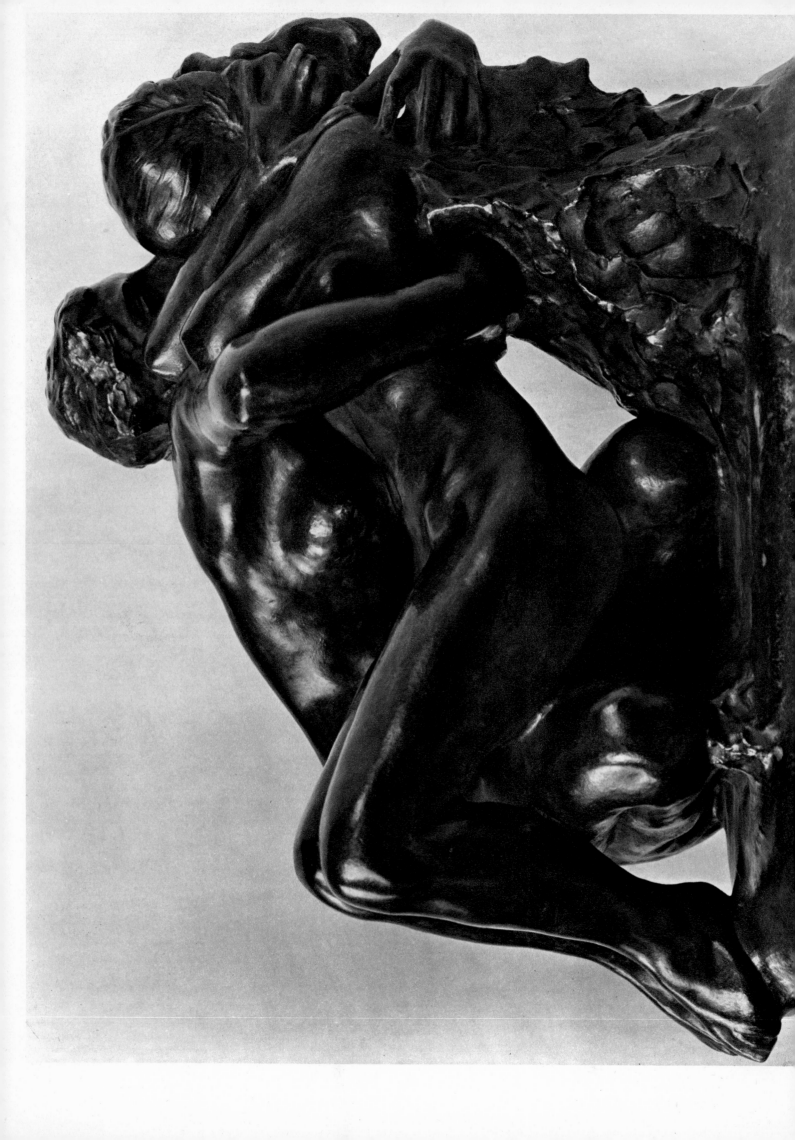

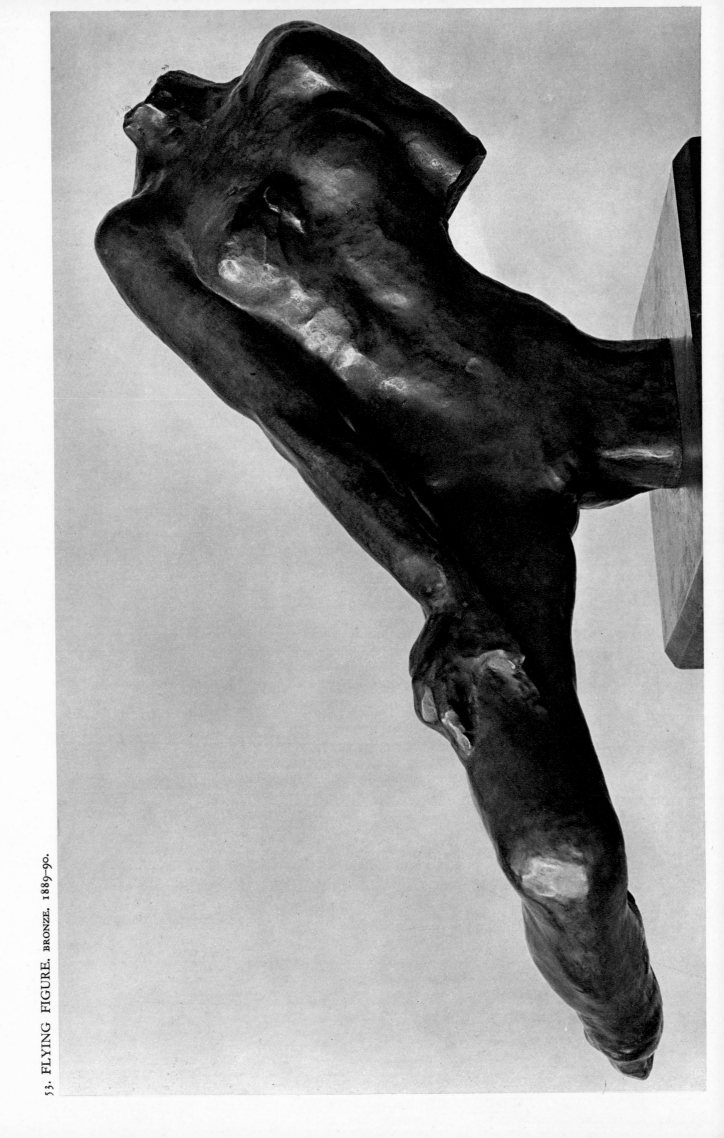

53. FLYING FIGURE. BRONZE. 1889-90.

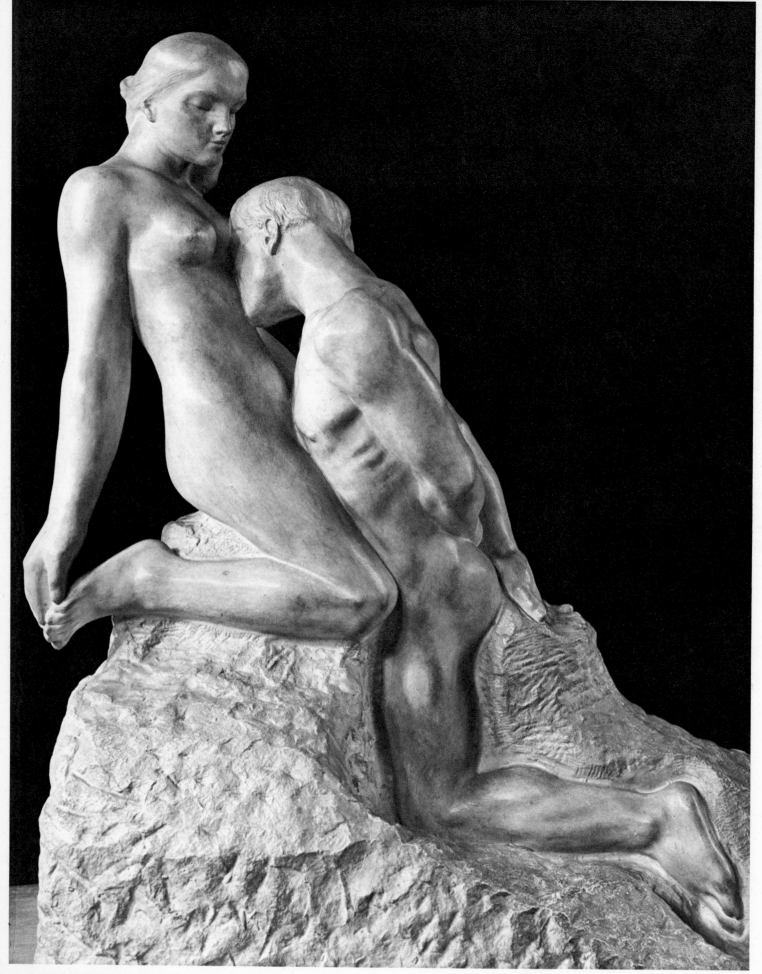

54. THE ETERNAL IDOL. PLASTER. 1889.

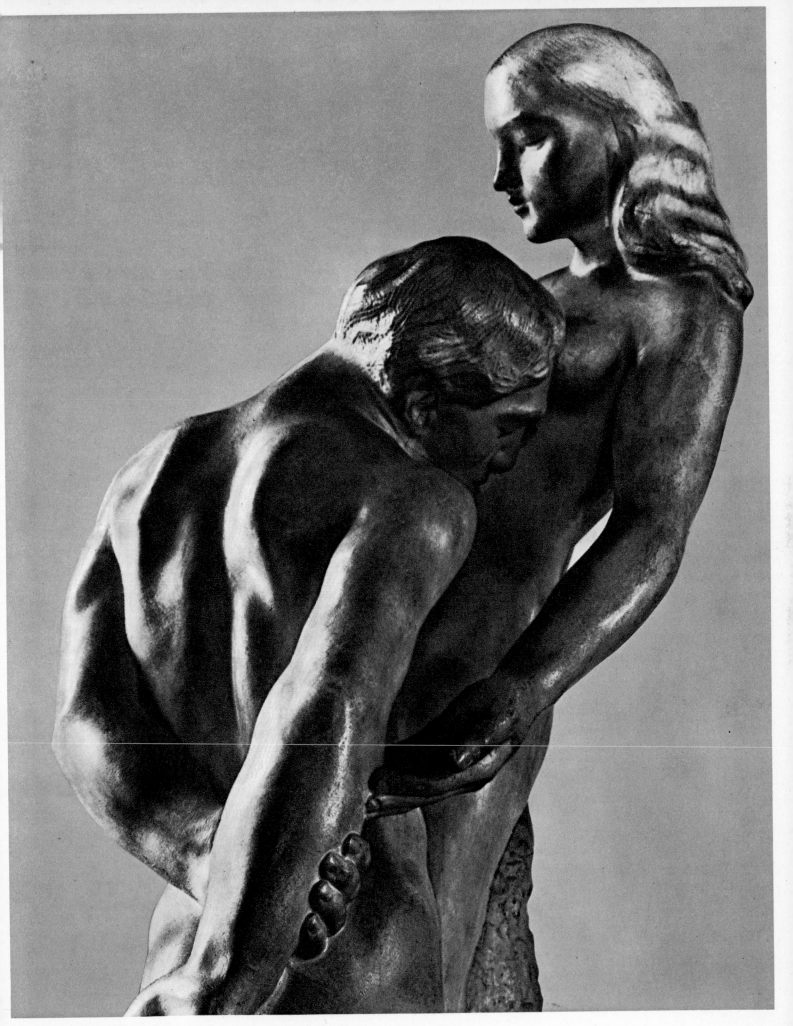

55. THE ETERNAL IDOL. DETAIL OF THE BRONZE. 1889.

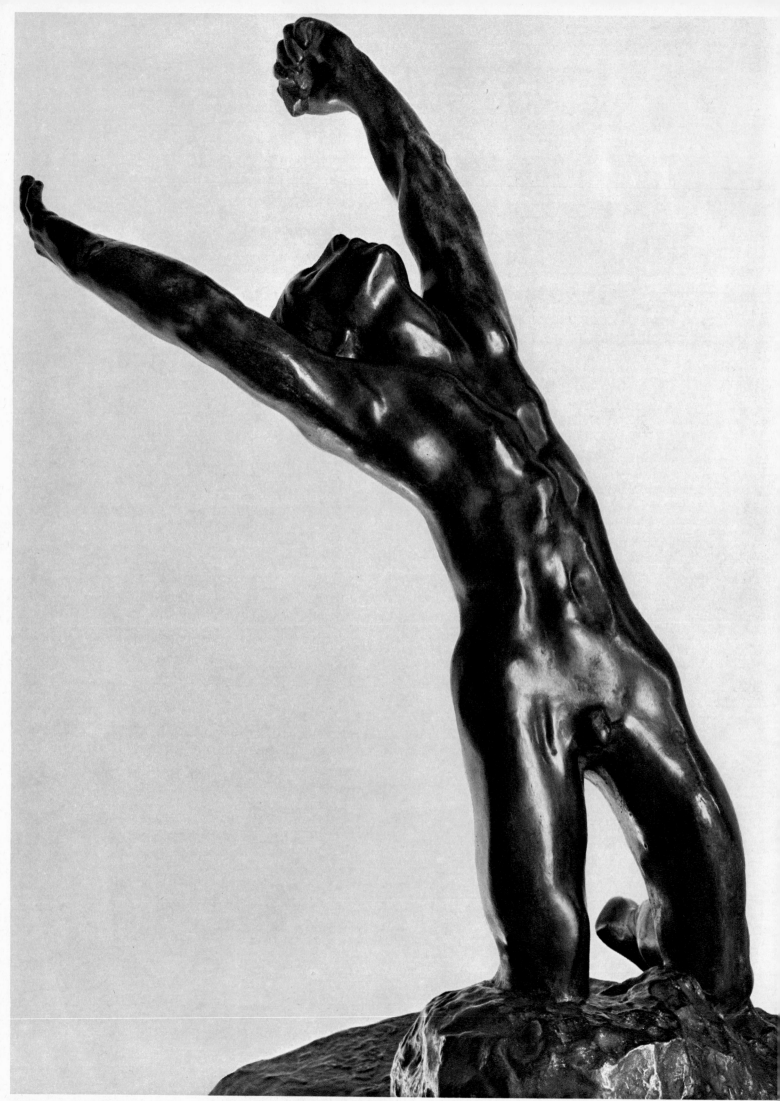

56. THE PRODIGAL SON. BRONZE. BEFORE 1889.

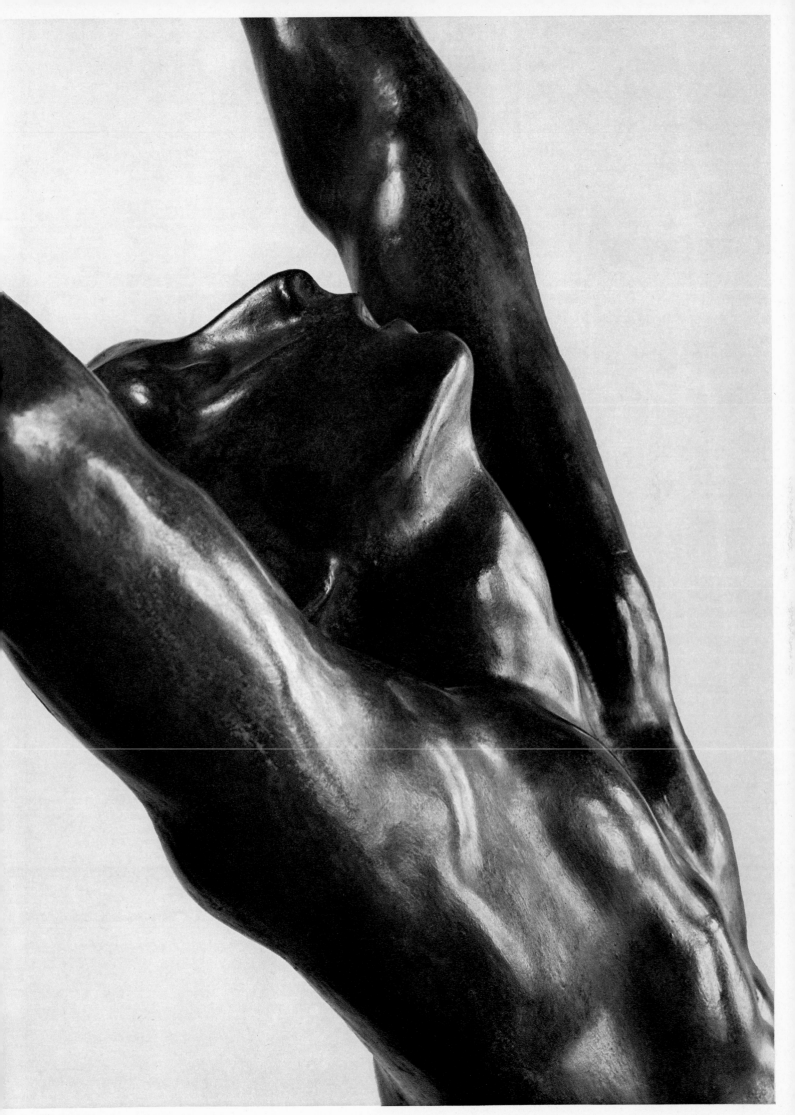

57. THE PRODIGAL SON. DETAIL.

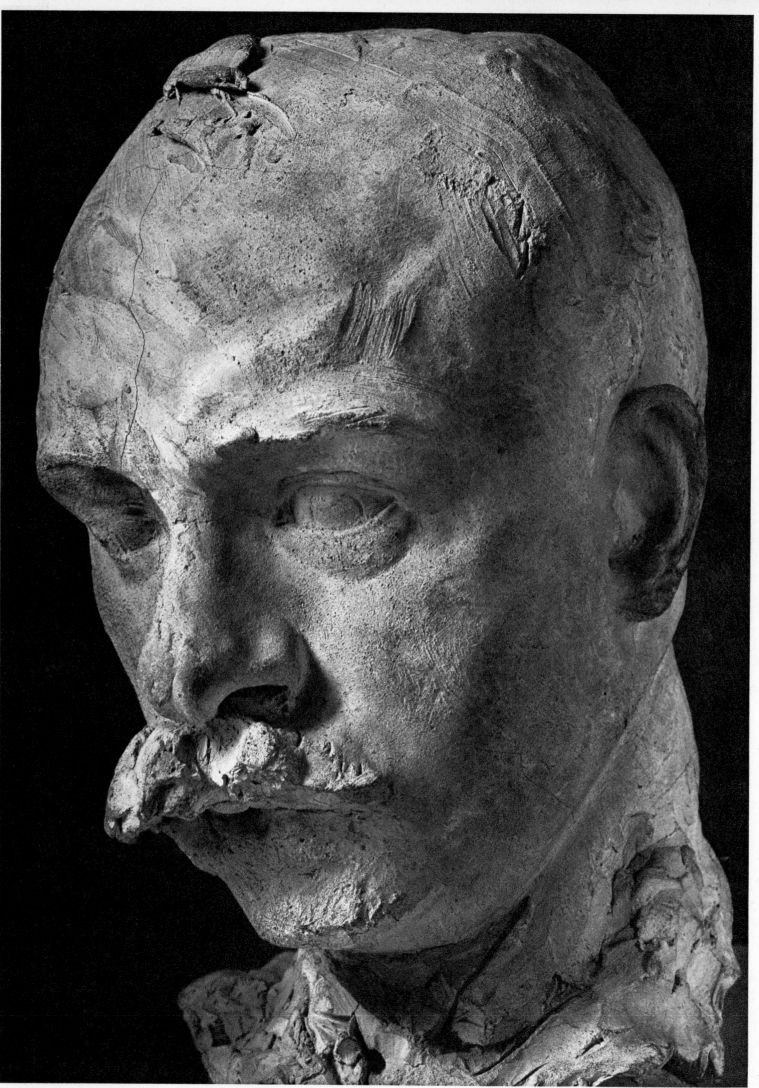

58. OCTAVE MIRBEAU. TERRACOTTA. 1889.

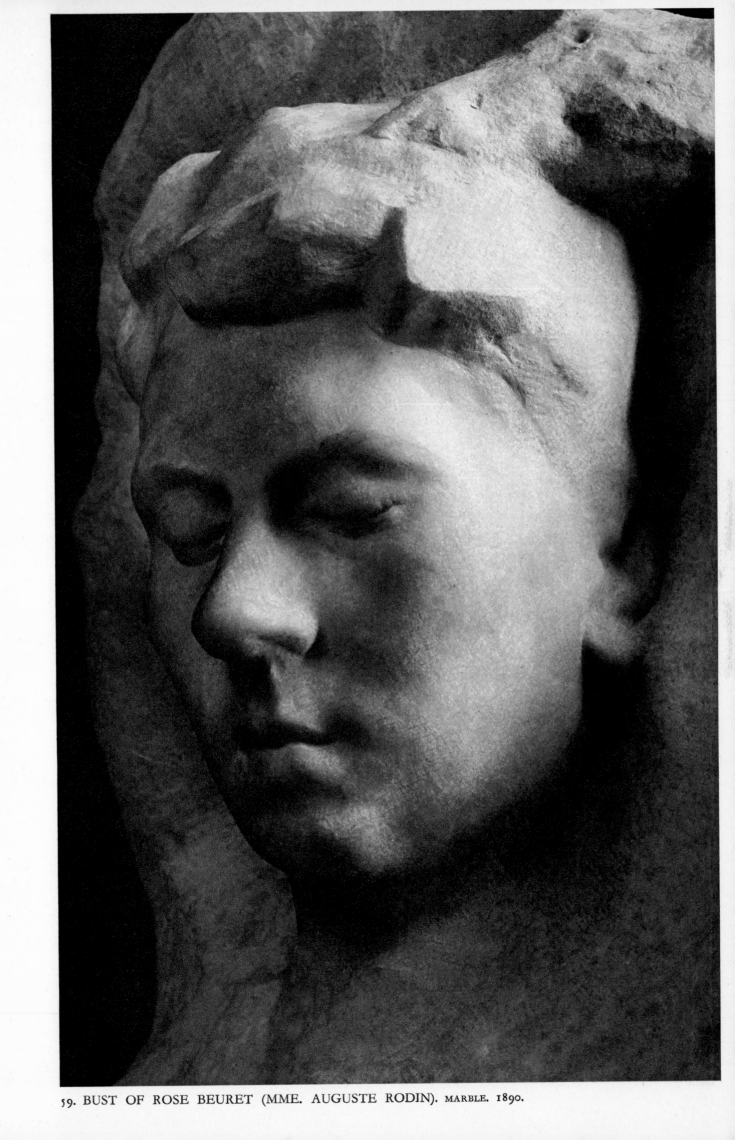

59. BUST OF ROSE BEURET (MME. AUGUSTE RODIN). MARBLE. 1890.

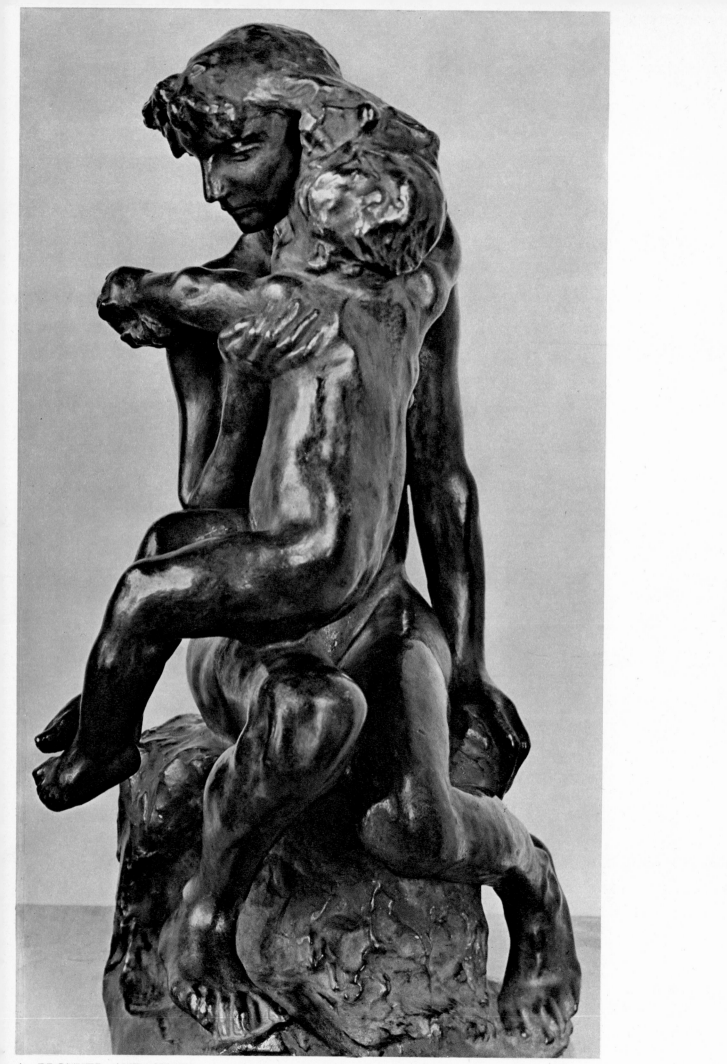

60. BROTHER AND SISTER. BRONZE. 1890.

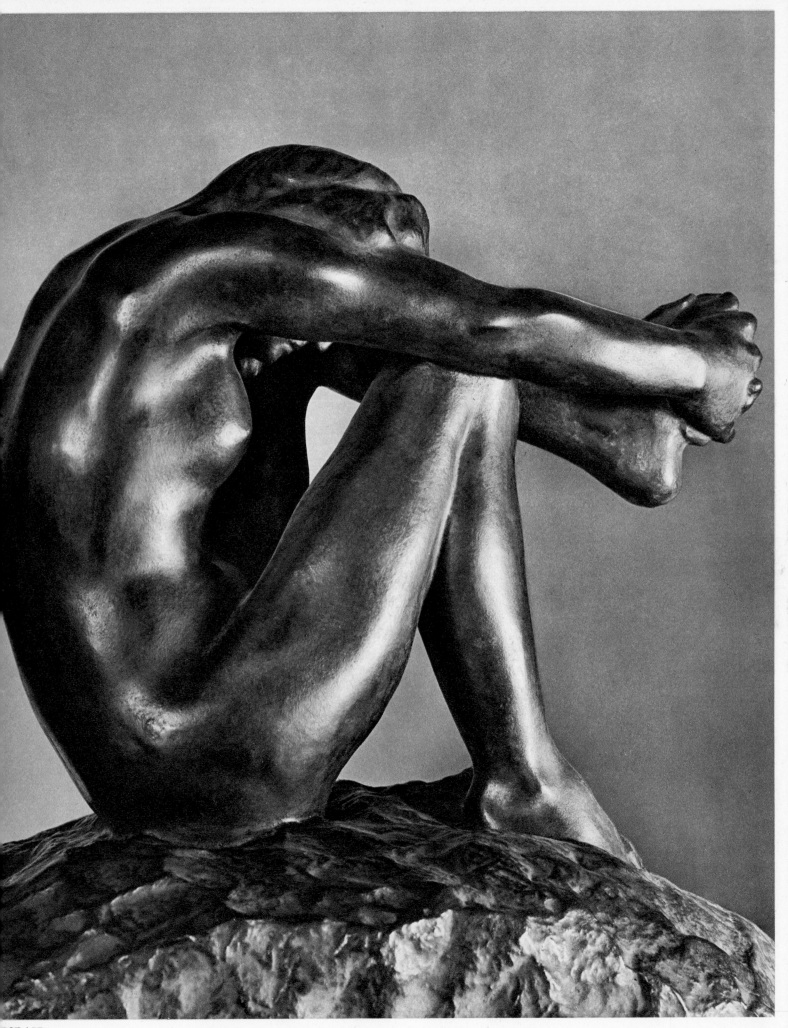

DESPAIR. BRONZE. 1890.

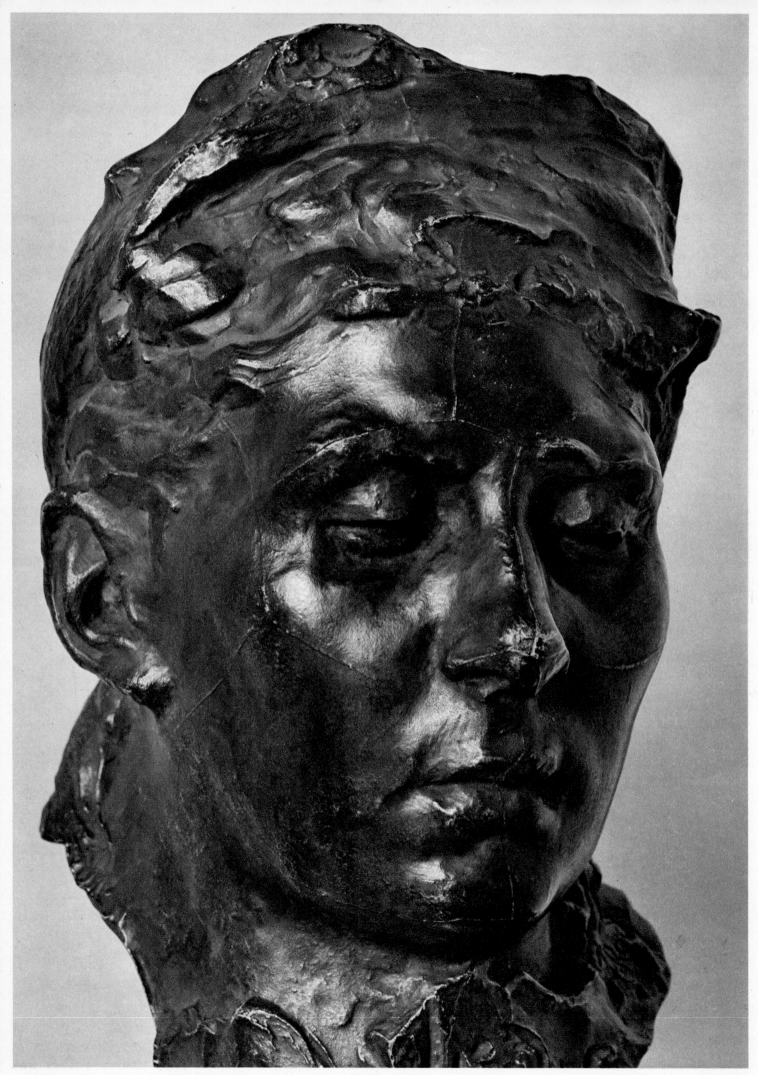

62. BUST OF ROSE BEURET (MME. AUGUSTE RODIN). BRONZE MASK. 1890.

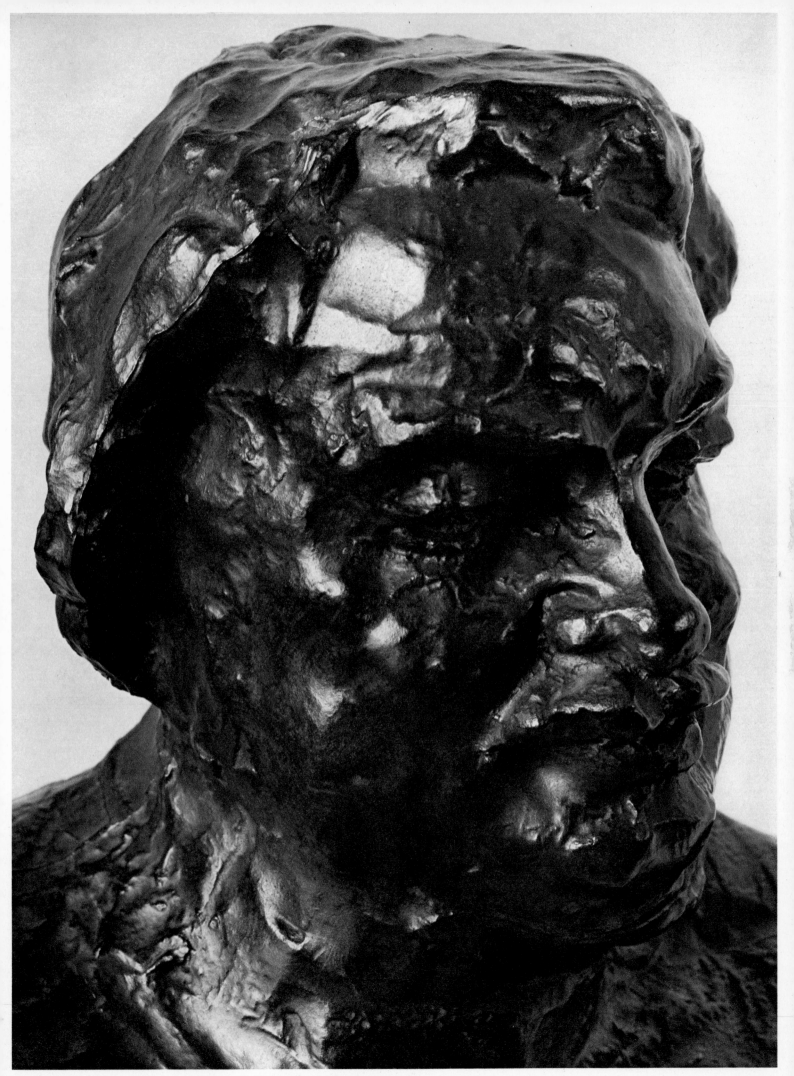

63. STUDY FOR THE MONUMENT TO BALZAC. BRONZE. 1893.

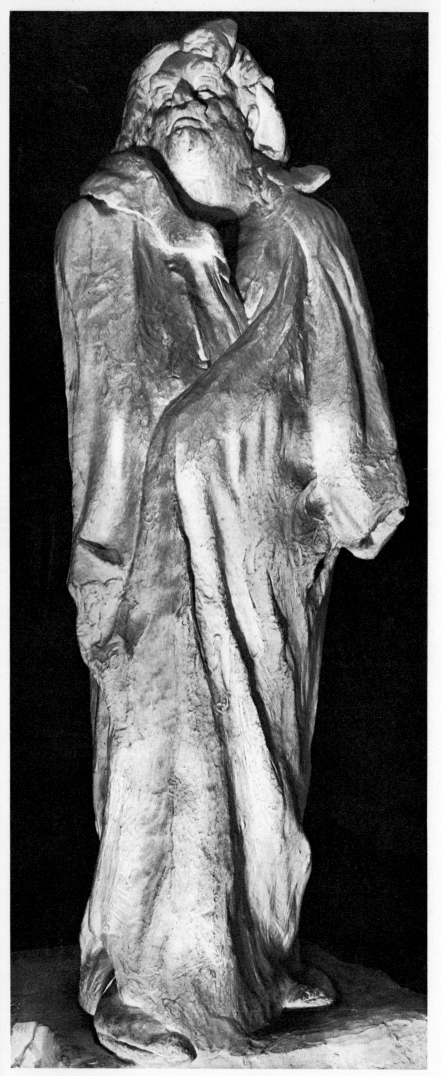

64. BALZAC. PLASTER. 1897.

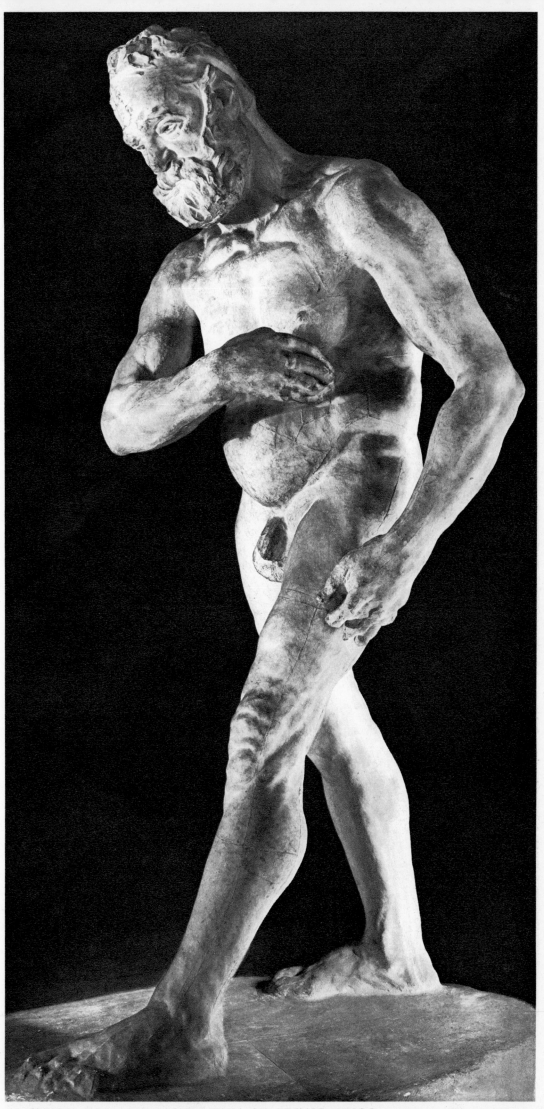

65. STUDY FOR THE MONUMENT OF VICTOR HUGO. PLASTER. 1897.

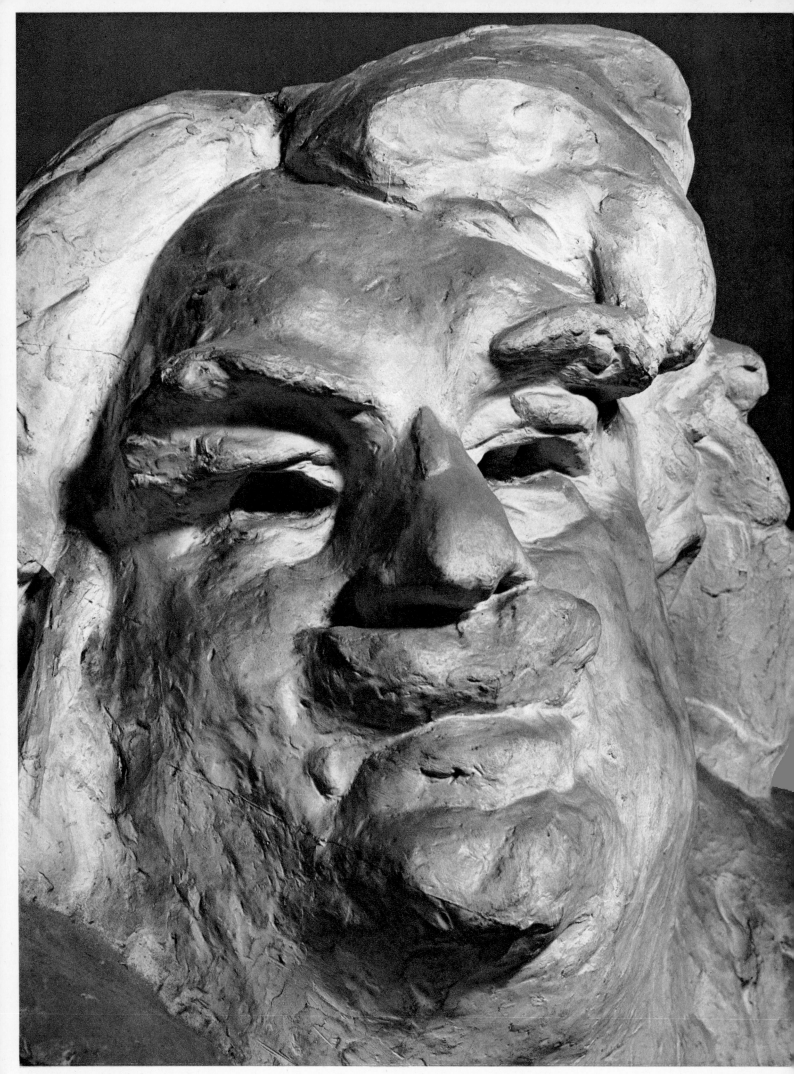

66. BALZAC. DETAIL.

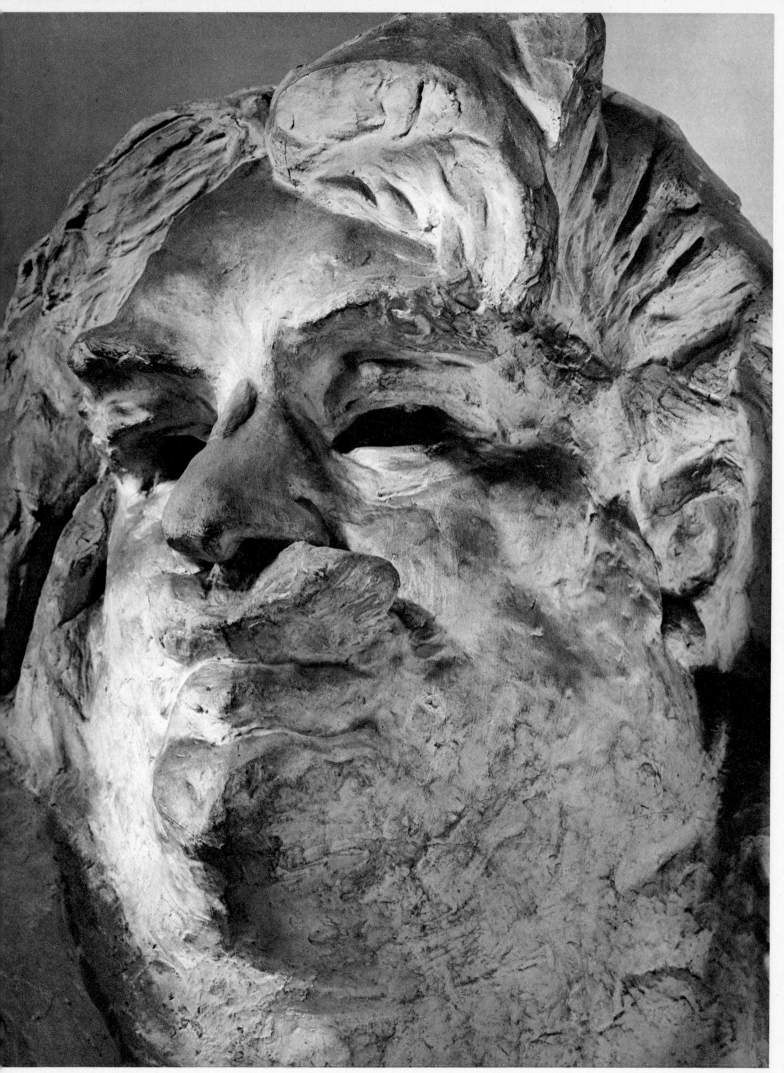

BALZAC. DETAIL.

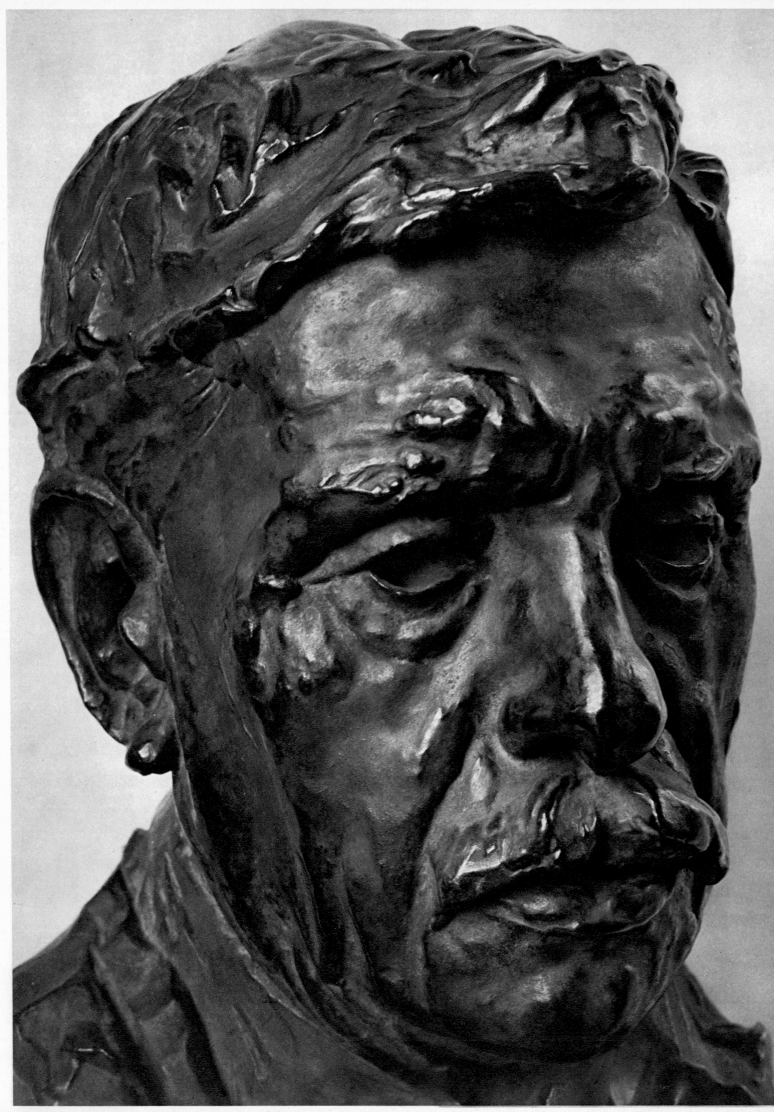

68. BUST OF THE SCULPTOR FALGUIÈRE. BRONZE. 1897.

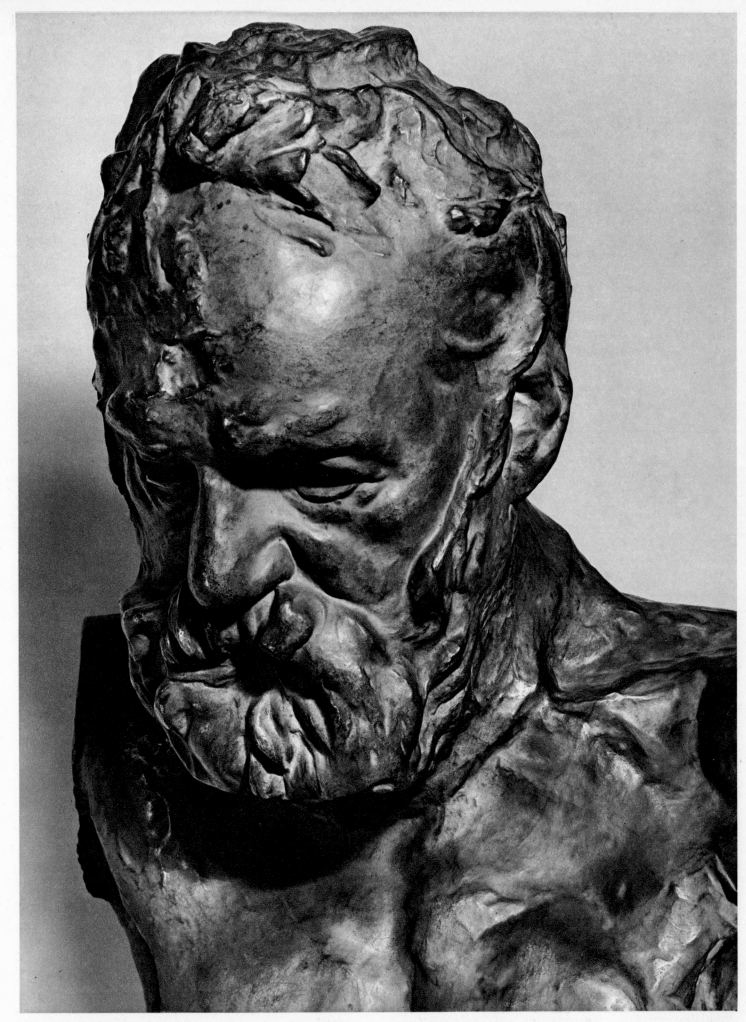

69. BUST OF VICTOR HUGO. BRONZE. 1897.

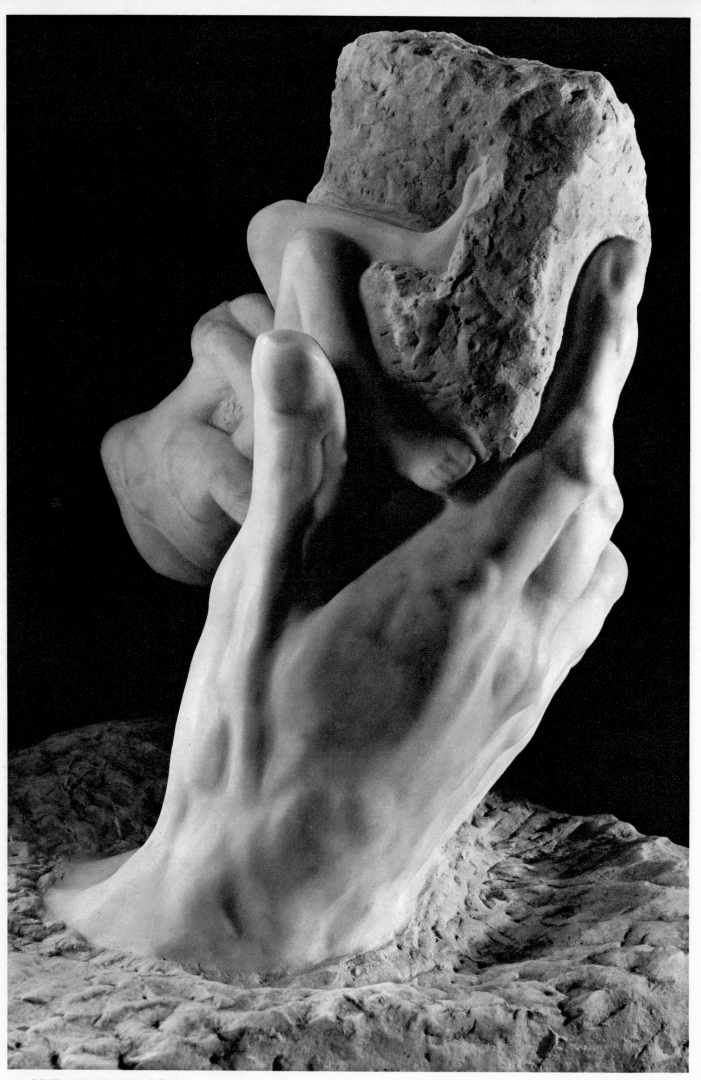

70. THE HAND OF GOD. MARBLE. 1897-98.

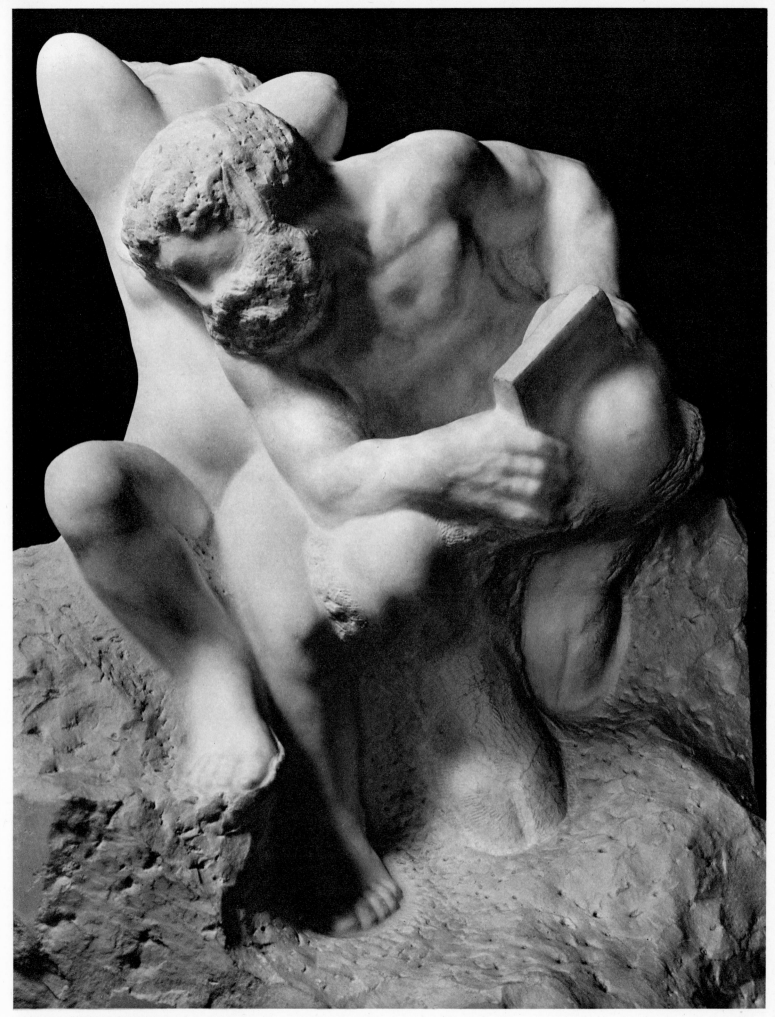

71. PAN AND NYMPH. MARBLE. 1898.

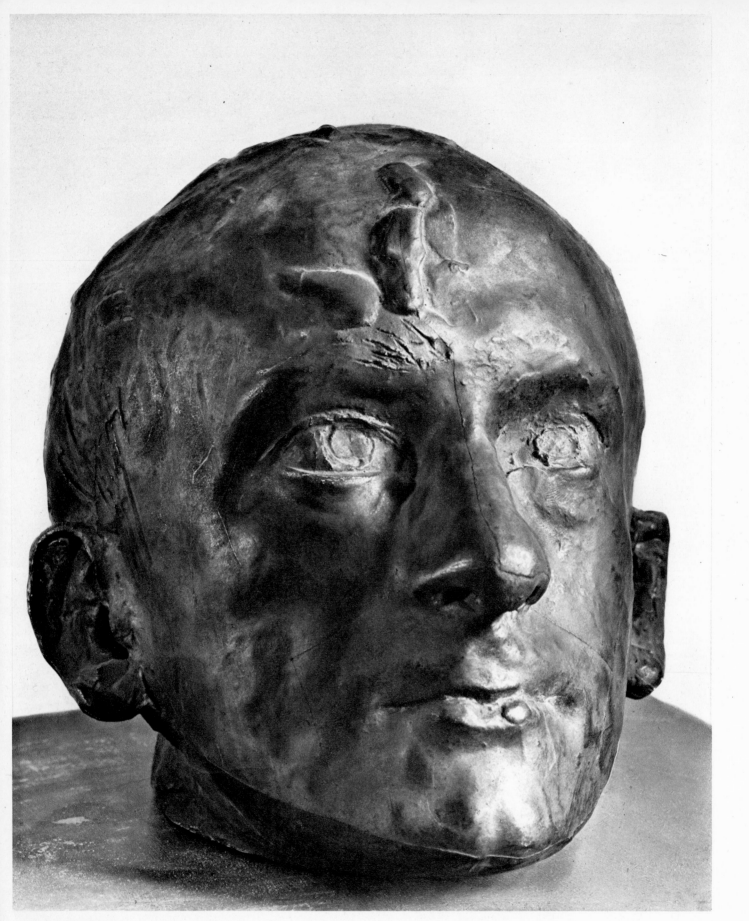

72. BAUDELAIRE. PLASTER. 1898.

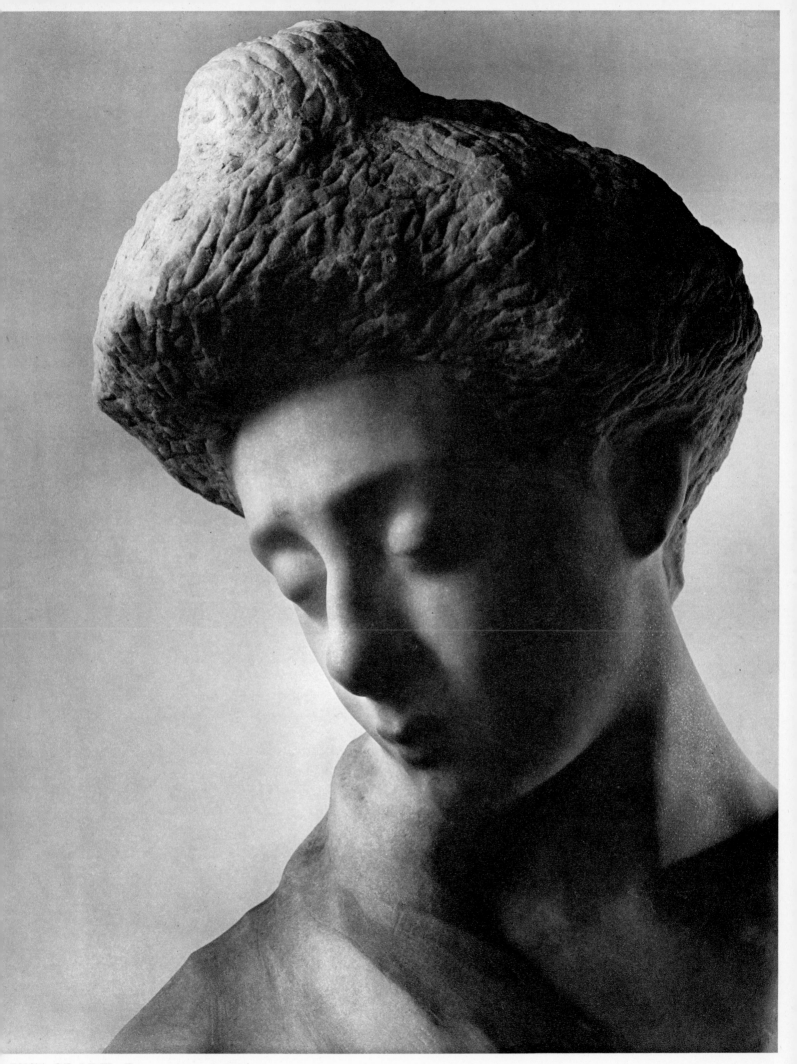

BUST OF MME. F . . . MARBLE. 1898.

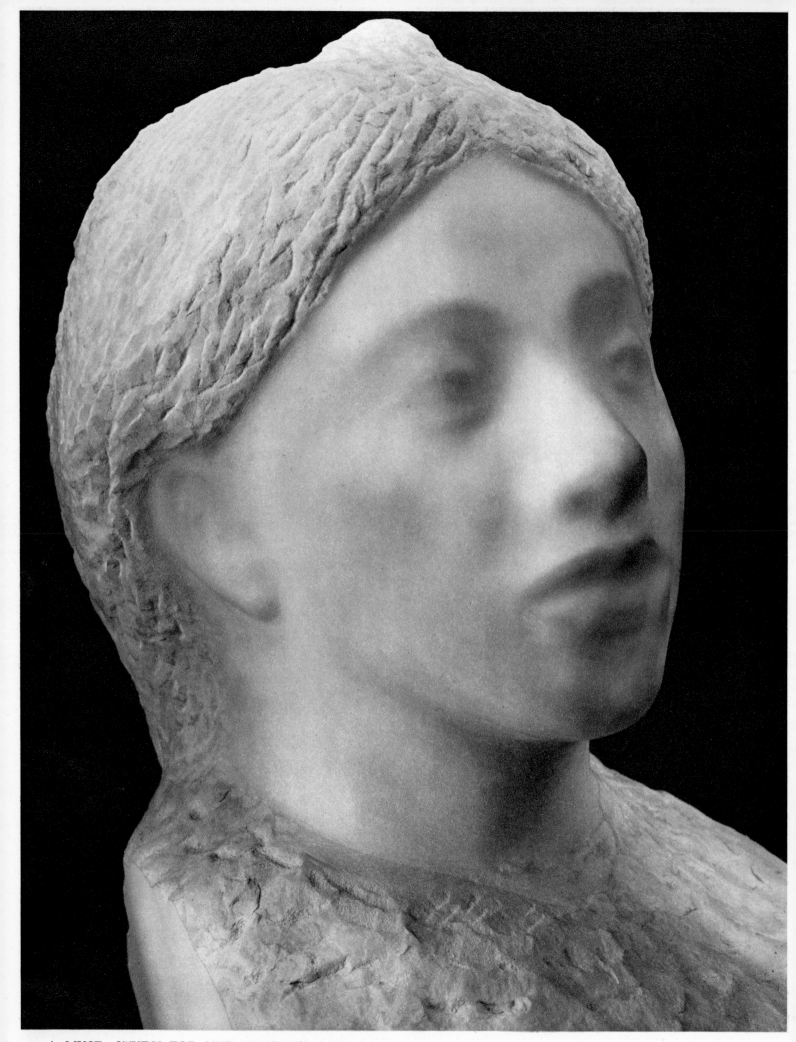

74. A MUSE. STUDY FOR THE WHISTLER MONUMENT. MARBLE. 1902–3.

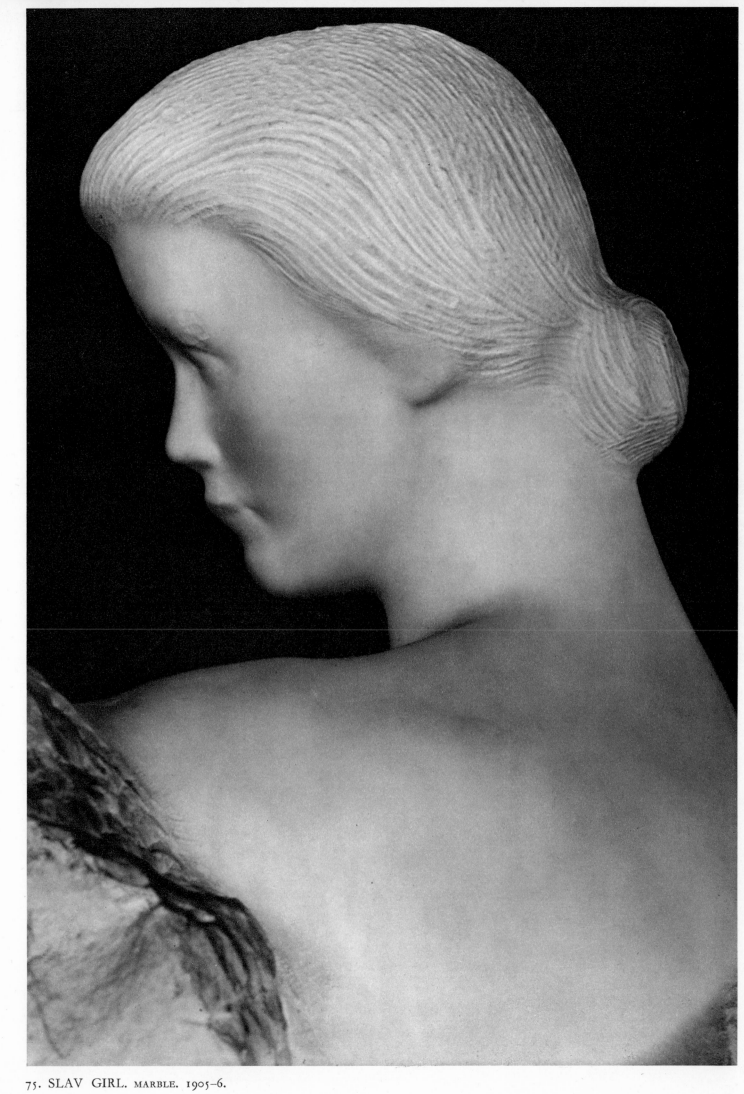

75. SLAV GIRL. MARBLE. 1905–6.

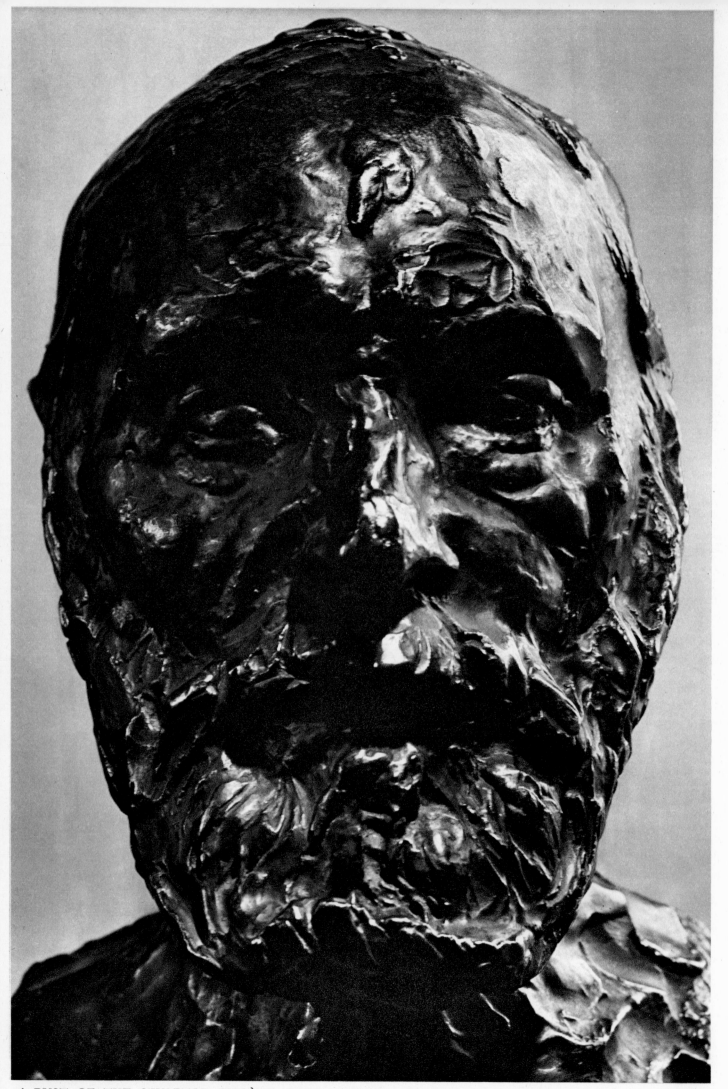

76. BUST OF THE SCULPTOR EUGÈNE GUILLAUME. BRONZE. 1903.

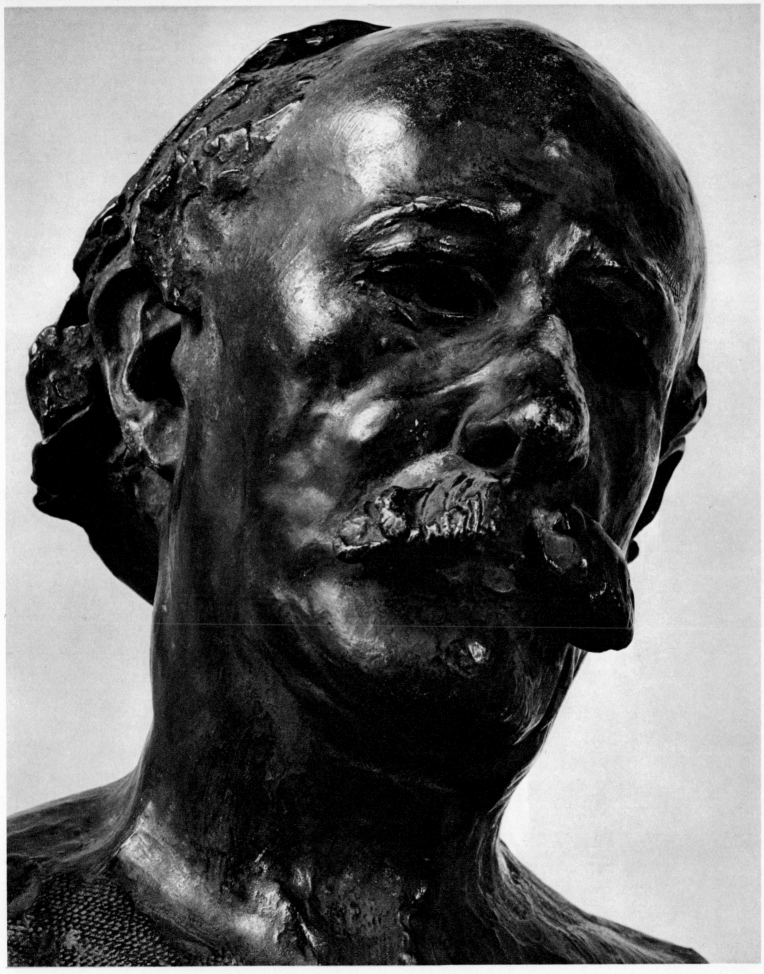

77. BUST OF MARCELIN BERTHELOT. BRONZE. 1906.

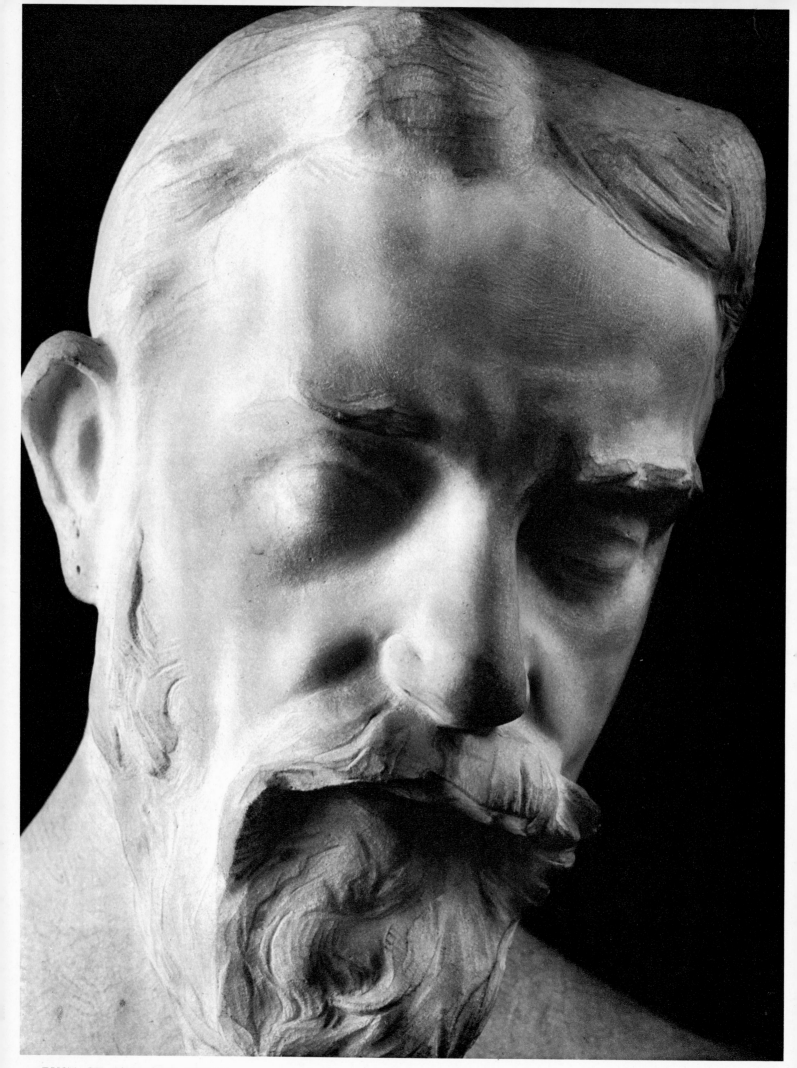

78. BUST OF BERNARD SHAW. MARBLE. 1906.

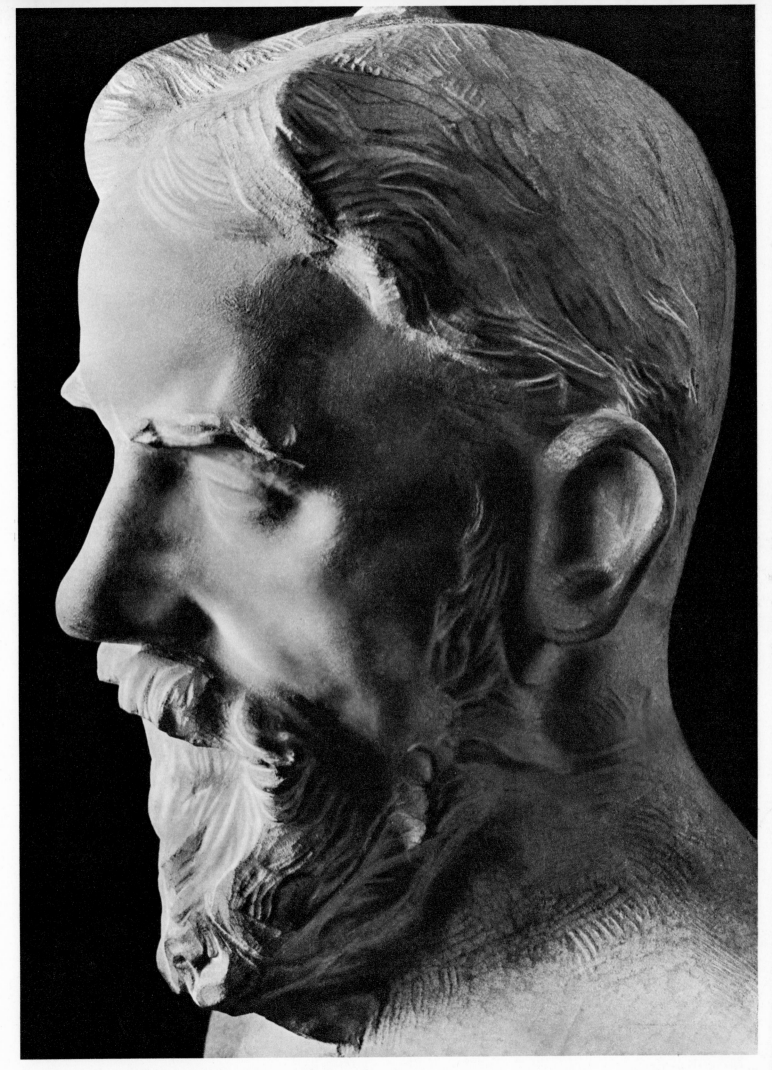

79. BUST OF BERNARD SHAW. MARBLE. 1906.

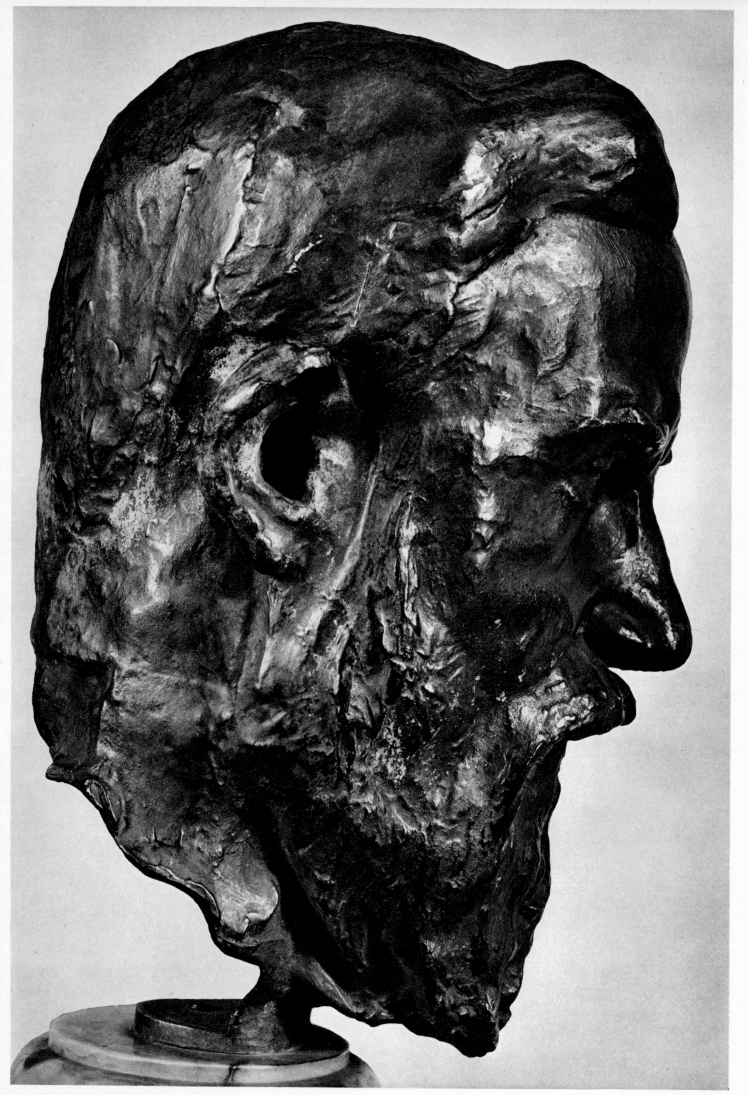

80. BUST OF BERNARD SHAW. BRONZE. 1906.

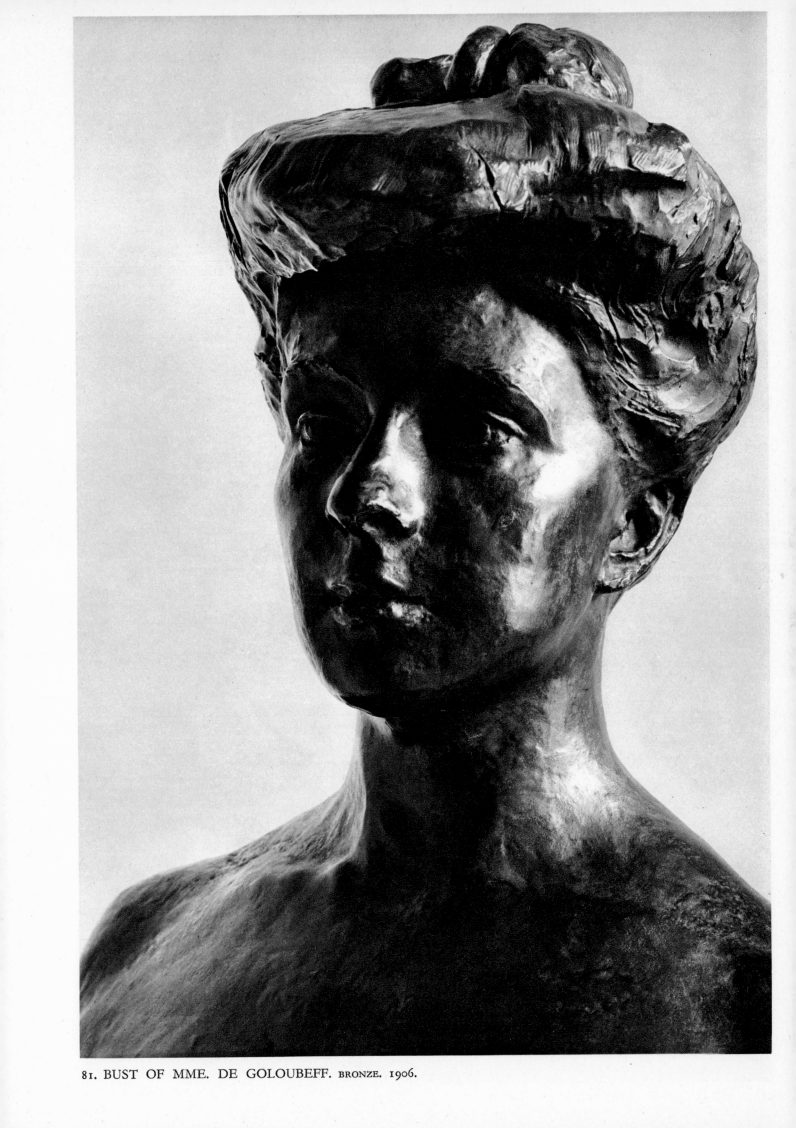

81. BUST OF MME. DE GOLOUBEFF. BRONZE. 1906.

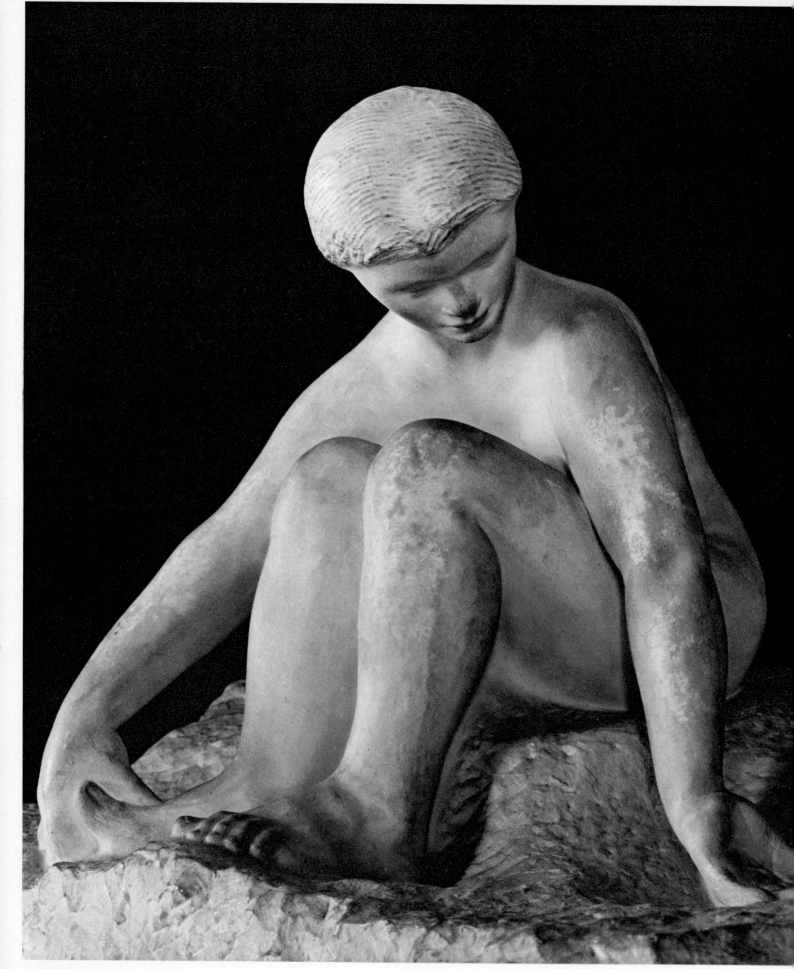

82. BY THE SEA. PLASTER. 1906-7.

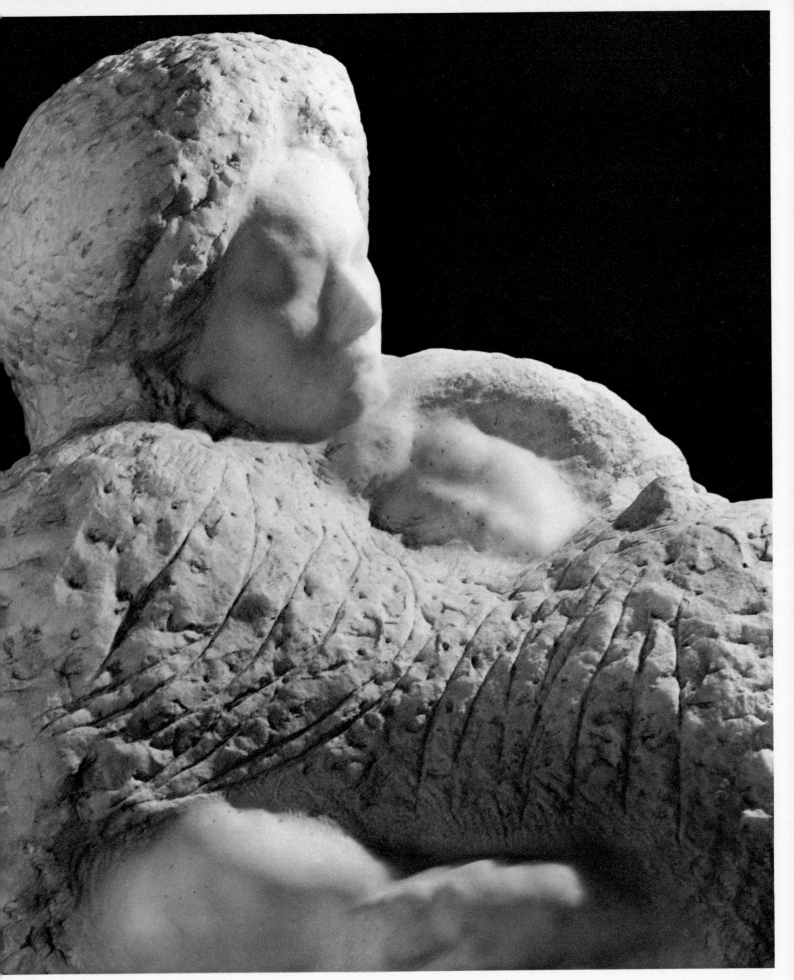

OTHER AND DYING CHILD. MARBLE. 1908.

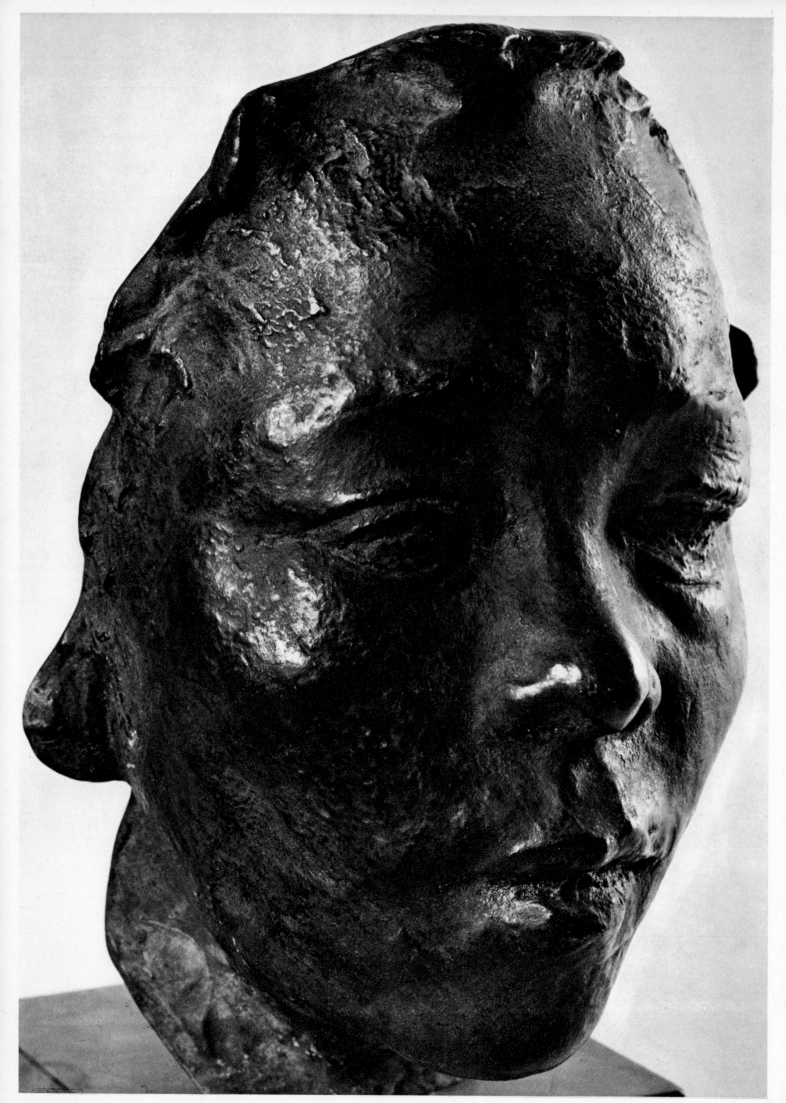

84. PORTRAIT OF THE JAPANESE GIRL-DANCER HANAKO. BRONZE. 1908.

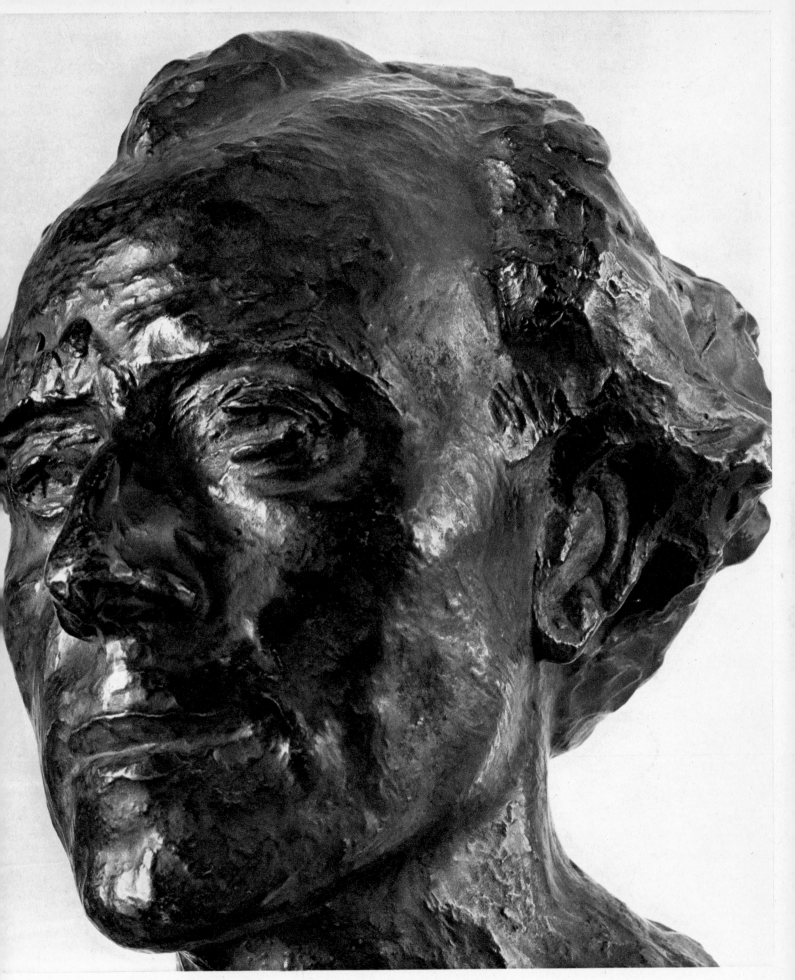

UST OF GUSTAV MAHLER. BRONZE. 1909.

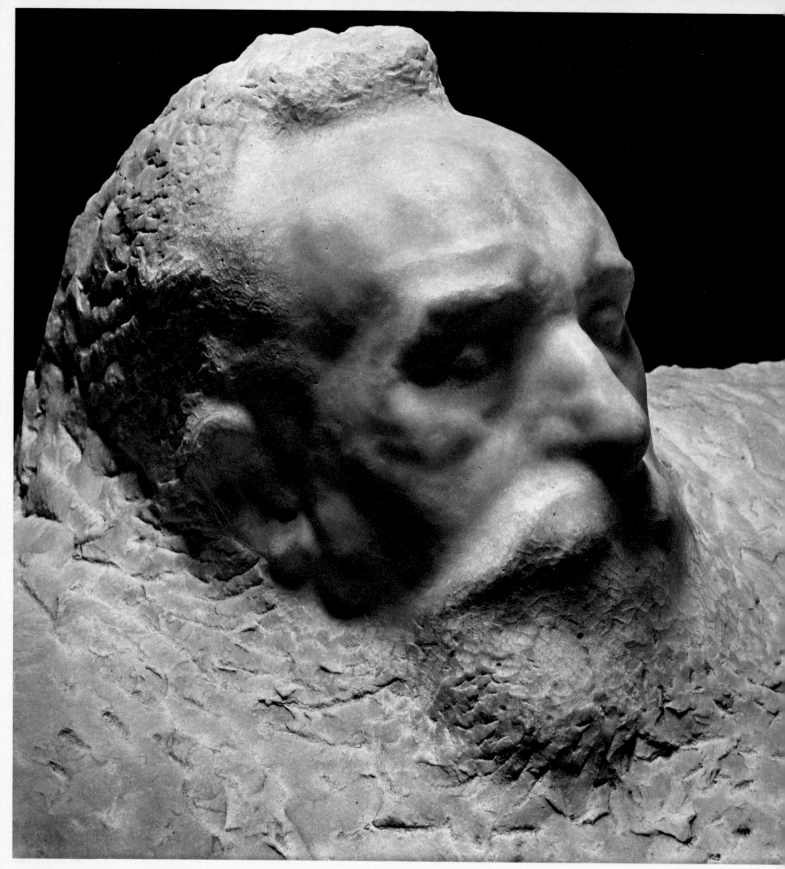

86. BUST OF THE PAINTER PUVIS DE CHAVANNES. MARBLE. 1910.

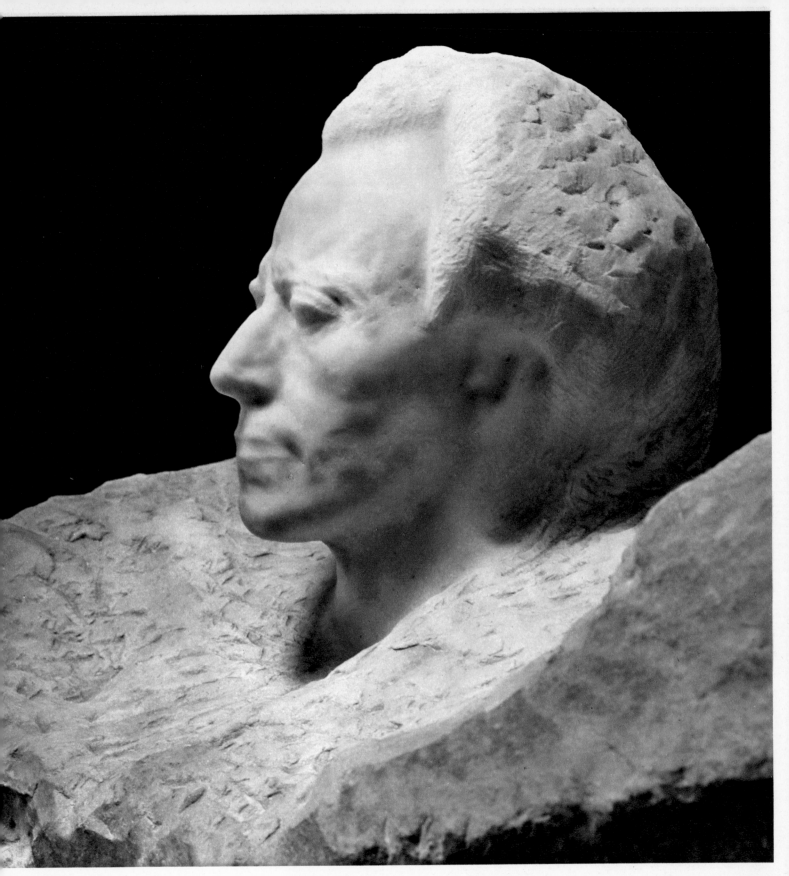

. MOZART. MARBLE. 1910.

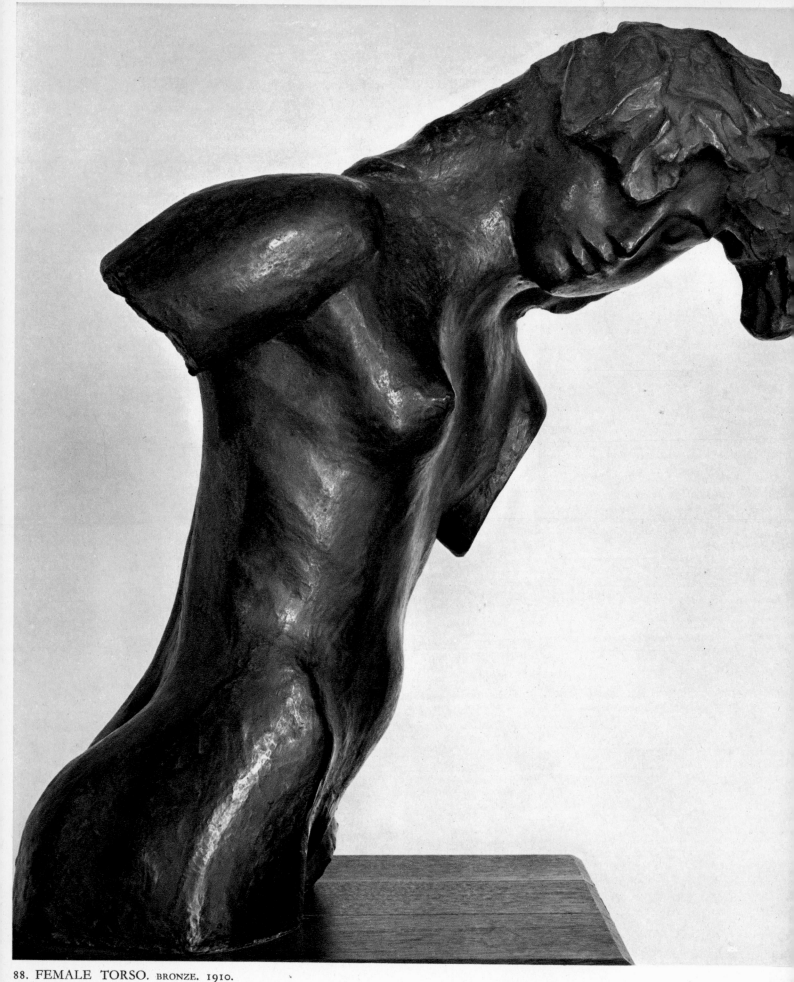

88. FEMALE TORSO. BRONZE. 1910.

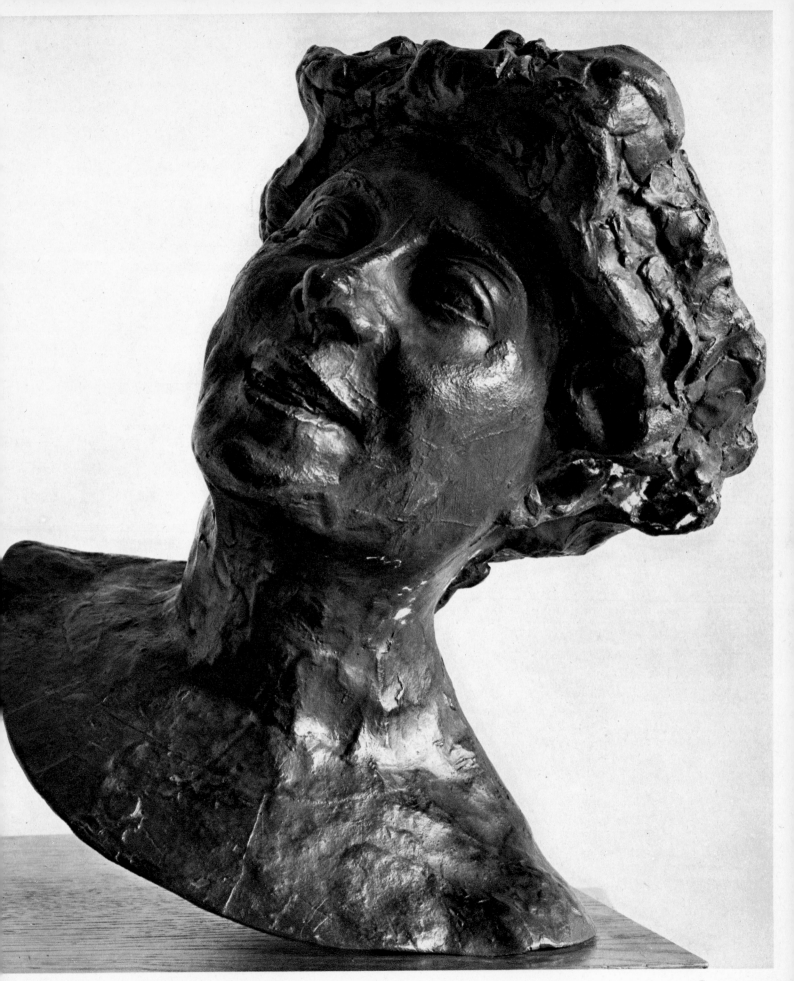

THE DUCHESS OF CHOISEUL. BRONZE. 1908.

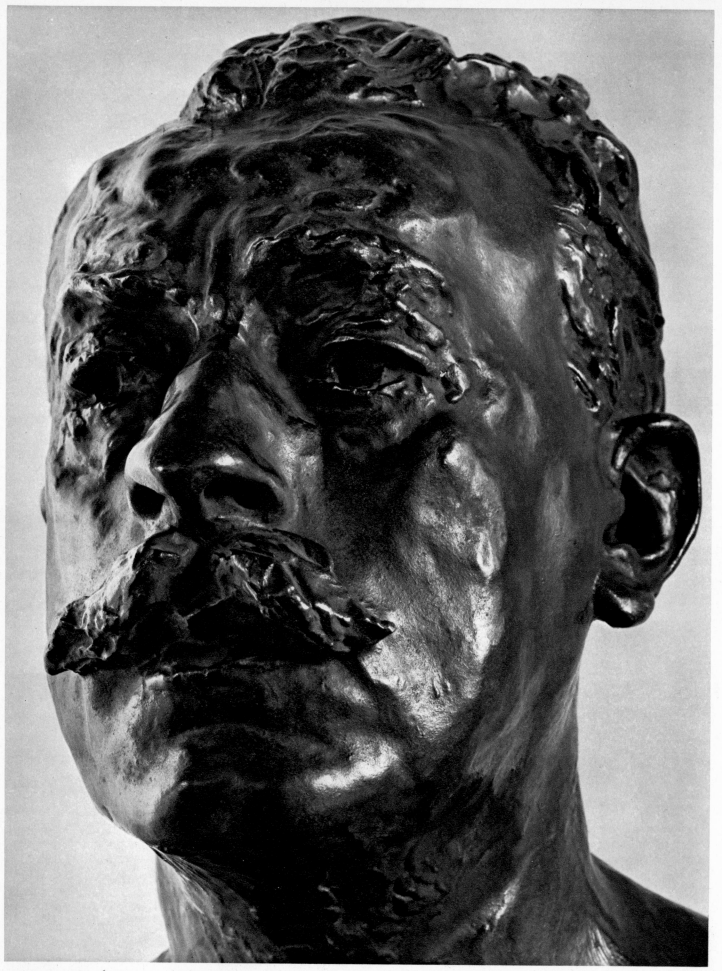

90. BUST OF ÉTIENNE CLÉMENTEL: BRONZE. 1916.

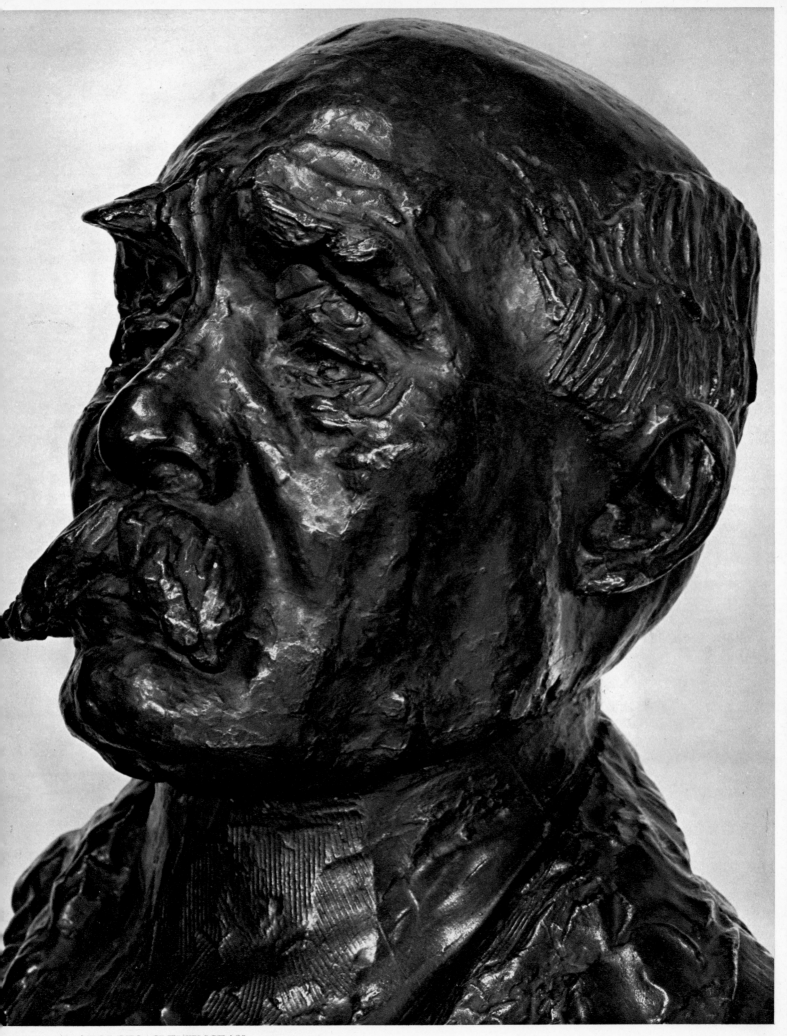

BUST OF GEORGES CLEMENCEAU. BRONZE. 1911.

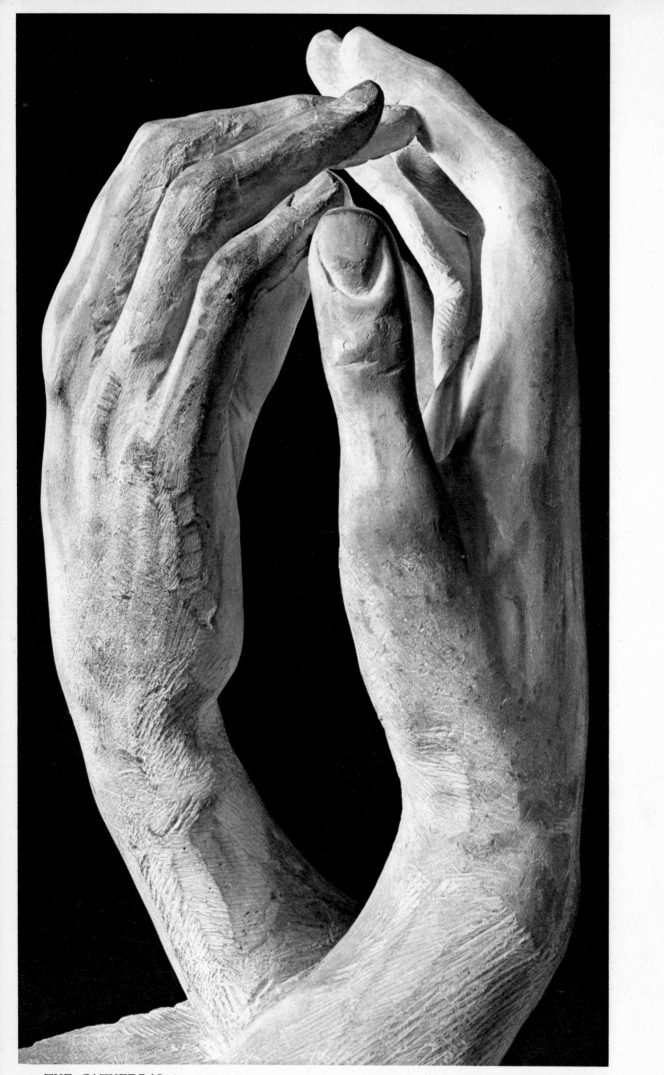

92. THE CATHEDRAL. STONE. 1908.

NOTES ON THE PLATES

NOTES ON THE PLATES

Measurements are given in inches, first height, then width, then depth.

1. RODIN'S FATHER. 1860. Bronze, 16½×11⅛×9½. This bust is the artist's first known work. J.-B. Rodin, who was a Norman, came to Paris in the reign of Charles X, and was engaged as office boy in the Prefecture of Police. He retired with the rank of inspector in 1861 and died in 1883. This bust, modelled in Roman fashion, recalls an effigy of Cato or of Minucius Felix. Although inspired by antique statuary, it already manifests a very strong personality and remarkable technical skill. This youthful work was built up by successive profiles according to the method Rodin was to adopt each time he executed a portrait.

2. THE BLESSED FATHER EYMARD. 1863. Bronze, 23¼×11⅜×11¾.
In 1863, Rodin's sister, who was a nun, died in the springtime of life. The young artist felt the loss so keenly that he sought admission to a religious order close to the family dwelling, rue St. Jacques, just founded by Father Eymard. On joining the Fathers of the Holy Sacrament, he took the name of 'Brother Augustine'. But Father Eymard, who was a rare psychologist, was not slow to realize that this vocation, prompted as it was by fraternal grief, was unlikely to prove lasting. He therefore requested his novice to sculpture his bust. While the monk was posing, he managed to persuade Rodin to return to the world, to fulfil his artistic destiny there. The Church has since beatified Father Eymard, and we are constrained to join in the homage paid to this holy personage, without whom, perhaps, we might not have had the magnificent work executed by Rodin and dating from this epoch.
The bust of Father Eymard, vital among all those the artist sculptured, is characterized by an intense and luminous expression which shows Rodin's growing mastery of statuary.

3. MASK OF THE MAN WITH THE BROKEN NOSE. 1864. Bronze mask, 9½×8¾×10¼.
This work has some affinity with the bust of the artist's father (Plate 1). It, too, breathes classical inspiration and reminds one of the Greek marbles. Thus we are advised that Rodin, although refused admission thrice to the School of Fine Arts, was working in solitude to acquire that classical education he was deemed unworthy to receive.
This mask is the more interesting as being that of an old Bohemian whom the young artist encountered on the slopes of the Rue Mouffetard, as busy a thoroughfare as one could wish, and close to the Horse Fair, where Rodin was fond of observing life. The work, refused by the Salon for being offered, with audacious simplicity, under the title 'Mask of Bibi' (the Bohemian's name), remodelled in 1872 as bust and in marble and sent in under the title: 'Bust of Mr. B. . . . ', was received this time with favour.

4-5. THE AGE OF BRASS. 1876. Bronze, 68½×23⅝× 23⅝.
The history of the conception and carrying out of this work is particularly interesting. It came after a period when the artist had been taking long country walks in the beautiful regions round Brussels, either alone or with his wife. This communing with Nature had made a deep impression on him, which was emphasized by the reading of Jean-Jacques Rousseau, who at the time and for long afterwards was his favourite author. Thus it was that the idea came to him to depict a purely natural man in the infancy of comprehension. He chose for his model a Belgian soldier who in private life was a carpenter. He was a physically perfect man, and, though not possessing much education, was very intelligent and able to understand the higher thoughts and ambitions of the sculptor. Rodin made a full size nude in plaster —a representation, as one critic put it, of one of the men who sprang to life from the stones cast behind him by Deucalion (the impressions of his visit to Italy a year previous were still very strong in the sculptor).
Completed early in 1877, the work was first exhibited at the Cercle Artistique in Brussels. Already charges were made against him of having taken a mould from Nature, though they attracted little attention. He was completely unknown. The work was then exhibited at the Paris Salon of the same year. The jury were quite unaccustomed to such realistic work. He was accused of imposture—of having taken a mould from the living subject. Such tricks were not unknown among inferior artists for small portions of the figure, but, as far as was known, had never been done for the whole body—and, as Rodin ultimately showed, could not possibly be done. The Ministerial authorities sided with the sculptor's critics, and the controversy was long and bitter. Rodin had moulds taken of the model's torso, and these were photographed to show that the procedure of which he was accused would have distorted the figure. Auguste Neyt, the Belgian model, offered to come to Paris to confound the detractors; and the controversy was not ended until a group of Rodin's fellow artists and a few critics, in a collective protest addressed to the Fine Arts Ministry, declared their faith in his genius, from other work which they had seen him execute.

As a compensation to the artist, the State, in 1880, acquired the bronze which had been shown at the Salon, and it was placed in the gardens of the Luxembourg museum. In 1890 it was removed inside the museum.

In contemplating this statue the student must bear in mind that originally the left hand held a stick on which the man was leaning heavily, as if to push himself up from the ground, on which his feet were still heavy. This staff was removed, as it threw a shadow on the moulding of the body on that side; but the position of the hand is only explained by imagining this staff still in position.

6–7. SAINT JOHN THE BAPTIST PREACHING. 1878. Bronze, 79×21⅝×38⅝.

The model was an Italian peasant who had never before been a model and knew none of the 'tricks of the trade'. The sculptor made him move about the studio, and when he was in an attitude that pleased him, he stopped him, saying simply 'Keep that pose'. This method was afterwards frequently followed by Rodin, as stated above. He himself repeatedly said he tried to interpret internal sentiments by the mobility of the muscles.

The Italian peasant afterwards became a well-known model. This work, so daringly original, and so different from the age-long religio-artistic conception of the Baptist, like so many other of the works of Rodin, aroused a storm of controversy. But, like the others too, it 'made its way', and the leading critics of several countries saw its greatness.

This St. John, said Grant Allen, is 'no seer of mysteries filled with prophetic fire, but a plain worn man of the people, an itinerant preacher.' He is 'marching ahead in a clumsy sort of way, ignoring the obstacles and the length of the road,' adds Gustave Geffroy. Edmund Gosse, in his speech at the dinner to Rodin in London in 1903, described the St. John as a 'wasted and bitter anchorite'.

Rodin worked arduously on this statue, which he first exhibited at the Ghent Exhibition in 1879, where it earned for him the great gold medal. The same year he sent to the Salon, in Paris, the bust of the Forerunner. Then he exhibited this statue in the Salons of 1880, 1881 and 1883, thereby enlarging the circle of his admirers. Sent to the Vienna and Munich Exhibitions by the Beaux-Arts, it scored a notable success there and assisted to spread the artist's fame in German-speaking countries. To-day still, in its decayed grandeur, in its wonderful simplicity, 'Saint John the Baptist,' in spite of the works of a more acute modernism later executed by the artist, remains one of his most moving creations, one of the most powerful.

8–10. THE GATE OF HELL. 1880–1917. Bronze, 248×157×34.

This monumental Gate, which was ordered by the State from Rodin in 1880, and was never finished, though he worked on it for over twenty years, was originally intended as a door for the Museum of Decorative Arts, which was then planned. Later it was proposed to place it in the disaffected chapel of the old Seminary of St. Sulpice, in the Place St. Sulpice, Paris, which was to become an annexe to the Luxembourg Museum.

Never since Michelangelo has a sculptor planned a work of such greatness and magnificence. His original idea was to make direct interpretations from the scenes in the 'Inferno' of Dante, while in the scheme of arrangement he adopted the plan of Ghiberti's door of the Baptistry at Florence, with symmetrical panels. By degrees Rodin departed from this plan, as he also drifted more and more from Dante's conception of 'Hell' and conceived symbolical figures of his own inspiration. The only actual groups taken from Dante's poem which are now left are 'Paolo and Francesca' and 'Ugolino', besides the representation of Charon's bark depositing the souls to be judged by Minos.

The other poet who greatly influenced Rodin as his ideas progressed for the 'Gate' was Baudelaire, the tragic and sensual author of 'Les Fleurs du Mal', but it may be said that most of the figures are due to his own keen sense of the tragic perversity of life and destiny.

As the Gate exists to-day it contains 186 figures, and, as has been said elsewhere, Rodin was continually adding, withdrawing or exchanging figures or subjects, so that it became a perfect repertory for his various works.

On the top of the Gate the three 'Shadows' look down into the abyss as if seeing or reading there the famous words of the poet:

'Lasciate ogni speranza, o voi ch'entrate!'

Below them, in the centre of the tympanum, the 'Thinker' also contemplates the tragedy. On the panels are represented all the passions and vices of humanity. Nearer to the ground the figures become more independent of the subject. Right at the bottom are the lost women, as Baudelaire conceived them, mingled with figures from pagan mythology—centaurs, faunesses, satyrs, and abstract vices, especially the remarkable 'Avarice and Luxury', representing a miser and a courtesan. On the cornice at the top are thirty heads showing varied characteristics, as if they were a summary or analysis of the whole. Rodin had said to the Fine Arts Minister Turquem, who gave him the commission, 'I will cover the door with a lot of small figures, so that nobody can accuse me of moulding from life'. Anatole France wrote of this wonderful collection of groups: 'Recall the damned who are placed on the left of God on the fine portal of Bourges cathedral. In those representations of the theological hell, the sinners are tormented by horned devils who have two faces, one of which is not on their shoulders. You will not find these monsters in the hell of Rodin. There are no demons there, or rather, the demons hide themselves in the damned. The evil demons through whom these men and women suffer are their own passions, their loves and hatreds; they are their own flesh, their own thought. These couples who 'pass so lightly on the wind' cry to us: 'Our eternal torments are in ourselves! We bear within us the fire that

burns us. Hell is earth, and human existence, and the flight of time; it is this life, in which one is incessantly dying.' The hell of lovers is the desperate effort to put the infinite into an hour, to make life pause in one of those kisses which, on the contrary, proclaim its finality. The hell of the voluptuous is the decay of their flesh in the midst of the eternal joy and triumph of the race. The hell of Rodin is not a hell of vengeance, but one of tenderness and pity.'
The actual size of the Gate was never decided.

11, 13. THE THREE SHADOWS. 1880. Bronze, $38\frac{3}{4} \times 35\frac{1}{2} \times 17\frac{3}{4}$.
These three statues together crown 'The Gate of Hell'. It was the author's first idea that in front of them should be an unrolled phylactery bearing the famous inscription from Dante; 'Lasciate ogni speranza, o voi ch'entrate!' This intention, which explains to some extent the attitude of the three men, was not carried out.

12. THE SHADOW. 1880. Bronze, $75\frac{1}{2} \times 44 \times 19\frac{3}{4}$.
The Gate of Hell' consists of three figures of half natural size, who with slow and weary gesture seem ready to enter into eternity. This work is, so to speak, the pendant of 'Adam', also in this trinity of brass, and which was conceived after Rodin's trip to Italy in 1875. The influence of Michelangelo is manifest, but the artist's personality was already too marked to be utterly overwhelmed by Buonarroti. 'The Shadow', modelled in 1880, was exhibited in the 1902 Salon and acquired by the State in 1910.

14-16. THE THINKER. 1880-1900. Bronze, $78 \times 51 \times 52\frac{3}{4}$. (Plaster model. 1880. $27 \times 15\frac{3}{4} \times 19\frac{5}{8}$.)
'The Thinker' also was part of the original conception of 'The Gate of Hell', of which it might be said that it constitutes the soul. Moreover, Rodin at first wanted his statue to be called 'The Poet'. In the artist's view, the poet was that Dante whose work he loved so passionately and whence he had drawn so many wonderful designs. But this Dante met the same fate as the 'Balzac' at a later date. Rodin went beyond his first conception and widened the theme he had thus first chosen until it became a universal symbol. 'The Thinker', executed in half life-size for setting up in 'The Gate' about 1879, was exhibited at a height of 6 feet in 1900 in the Alma Pavilion which Rodin had built in order to house his masterpieces. A subscription was raised in 1906 to present it to the people of Paris. It is under this bronze at Meudon that the great master rests to-day close to his wife.

17. THE PAINTER ALPHONSE LEGROS. 1881. Bronze, $11\frac{1}{2} \times 7 \times 9$.
In 1871 Rodin paid a visit to London, during which he ran against his friend Legros, whom he had known in 1854 at the School of Design in the Rue de l'École de Médecine, conducted by Professor Lecocq de Boisbaudran. Painter, engraver, sculptor, Legros had emigrated to England after

the Commune, and was to remain there until his death in 1911. The two artists resumed their friendship, which took on a more intimate character from this moment and proved lasting. Ten years later, in 1881, Rodin executed the fine bust of Legros, and, in the same year, Legros painted a vivid and precious portrait of Rodin, at this decisive epoch of his career. It was Legros who taught the sculptor the art of engraving, in which he excelled, and to this fact we owe the well-known masterpieces of Rodin in this medium.

18. THE PAINTER JEAN-PAUL LAURENS. 1881. Bronze, $22 \times 13 \times 12\frac{1}{4}$.
Very soon after his return to France, Rodin became intimate with J. P. Laurens, upon whose bust he started work in 1881. The model also attracted him by the classical type of his expression, thus giving him an opportunity to pursue the study of antique sculpture. This large-shouldered bust recalls a sage of Greece. By way of return, J. P. Laurens put his friend in the frescoes of the Panthéon under the guise of a personage of the Merovingian Court. In 1900 Laurens wrote to the art critic Arsène Alexandre: 'You know my admiration for the great sculptor. He is of the race of those who walk alone, of those who are unceasingly attacked, but whom nothing can hurt. His procession of marble and bronze creations will always suffice to defend him—he may rely on them.'

19. THE HEAD OF SORROW. 1882. Bronze, $8\frac{3}{4} \times 9 \times 10\frac{3}{4}$.
Rodin was often prompted to reproduce this or that fragment of one of his prior works, either singly or as part of a new composition. Thus this head, of striking intensity of expression, is a retaking of that of one of the children in the groups of 'Ugolino' and 'The Prodigal Son' (cf. pl. 21 and 56). Moreover, in 1905, having had a chance to meet 'La Duse' he was filled with such enthusiasm for her wonderful genius that he thought of adapting the head of 'Sorrow' to one of her passionate impersonations. He also thought of using it for the face of a statue of 'Joan of Arc at the Stake', which it was proposed in 1913 to remove to the United States.

20. THE FALLEN CARYATID CARRYING ITS STONE. 1880-1. Bronze, $17\frac{1}{2} \times 12\frac{1}{2} \times 12\frac{1}{2}$.
This statue was originally part of 'The Gate of Hell', where it figured above, in the left angle uncovered by drapery. It was exhibited from 1883 in a gallery and reappeared in 1892 in the Salon, where it was praised by Rodin's admirers, who henceforth grew ever more numerous.

21. UGOLINO. 1882. Bronze, $15\frac{3}{4} \times 17 \times 13\frac{3}{4}$.
This group was one of the subjects for the 'Gate of Hell'. Rodin's imagination seems to have been greatly stimulated by this incident which is one of the most terrific in the whole of the 'Divine Comedy'.

'The Pisans,' wrote the old Italian chronicler Villani, the contemporary of Froissart, 'who had imprisoned the Count Ugolino, with his two sons and two of his grandsons, the offspring of his son Count Guelfo, in a tower on the Piazza of the Anziani, caused the tower to be locked, the key thrown into the Arno, and all food to be withheld from them. In a few days they died of hunger; but the Count first with loud cries declared his penitence, and yet neither priest nor friar was allowed to shrive him. From then on the tower was called the Tower of Famine, and so shall ever be.' The incident depicted is related by Dante as follows, the old Count speaking to the poet in Hell:

> 'When a faint beam
> Had to our doleful prison made its way,
> And in four countenances I descried
> The image of my own, on either hand
> Through agony I bit; and they, who thought
> I did it through desire of feeding, rose
> O' the sudden, and cried, "Father, we should grieve
> Far less, if thou wouldst eat of us: thou gavest
> These weeds of miserable flesh we wear:
> And do thou strip them off from us again."
> Then, not to make them sadder, I kept down
> My spirit in stillness. That day and the next
> We all were silent'. (Hell, canto XXXIII; Cary)

Ugolino seems in this powerful group almost to have been changed into a beast by his sufferings and the gnawings of his stomach. He drags himself on his knees over the lifeless or scarcely living bodies of his descendants. Perhaps he is thinking of how the children urged him to appease his hunger on their own flesh, and a contest is taking place in his mind between the beast who would fain eat and the higher being who revolts at such a monstrous idea, as is shown by the violence with which his head is thrown to one side. At the same time the sculptor lets us see the wolf-like look in the eyes of the emaciated creature who is scarcely human any longer:

> 'Whence I betook me, now grown blind, to grope
> Over them all, and for three days aloud
> Call'd on them who were dead. The fasting got
> The mastery of grief.'

In the first rough model which Rodin did for this subject Ugolino was shown seated with one of his sons lying over his knees, and another standing by his side.

22. EVE. 1881. Bronze, $68\frac{1}{2} \times 25 \times 30\frac{1}{2}$.
This statue was executed during the period when the artist conceived his 'Gate of Hell'. It was intended to be placed by the side of Adam, but subsequently it was detached from the *ensemble* and offered separately to the 1899 Salon, in its natural size. For more than twenty years the work has been known in reduced copies, and has enjoyed great success. It is one of the most beautiful incarnations of the female form since the Greeks, full of robust life and in a natural attitude,

suggesting her presentiment of coming motherhood as well as her natural anguish at thinking of the sorrow to which the coming generation is destined. The face is beautiful and tense with thought; the arms are folded over the breasts, one hand being raised as if to shield her face, the other grasping her left breast as if in pain or anxiety.

23. THE THREE FAUNS. 1882. Plaster, $6\frac{1}{2} \times 11 \times 7$.
This charming group is often called 'The Three Bretons'. Its model is the same figure reproduced three times. It has its place in 'The Gate of Hell' under the tympan on a level with the left folding door. It may certainly be dated 1882.

24. HENRI ROCHEFORT. 1897. Bronze, $29\frac{1}{2} \times 22\frac{1}{4} \times 13\frac{1}{2}$.
A plaster model of this bust was executed in 1884 and first appeared at an exhibition at the Georges Petit Gallery, where it was much admired, both because of the quality of the work and the personality of the model, who was a famous journalist. The bust, which is considerably bigger than the plaster model, was exhibited at the Salon of 1897.

25. THE SCULPTOR DALOU. 1883. Bronze, $20\frac{1}{2} \times 15 \times 8\frac{3}{4}$.
This bust, one of Rodin's most famous, of which there are casts in many of the great museums of the world, is dated 1883. Dalou was one of his sculptor's youthful companions: in their student years they both frequented the same 'Petite École', which turned out so many fine artists. Rodin met him again in London, in Legros' circle, and, on returning to Paris, they continued to see each other frequently. It was at this period that Rodin decided to stamp his friend's image in a work that, despite its modern air, reminds one of the finest busts of the Italian Renaissance.

26–27. THE CROUCHING WOMAN. 1882. Bronze, $33\frac{1}{2} \times 23\frac{3}{4} \times 19\frac{3}{4}$.
At this period the majority of the works which Rodin conceived, and which were not imposed upon him by a competition or definite order, were, so to speak, commissioned by 'The Gate of Hell'. In this monumental creation those visions disported themselves which he had carried about with him until the age of 40, when he cast forth impetuously all the people of his dreams. 'The Crouching Woman', who at first glace startled the critics, was one of the crowd of the damned who writhe in the tympan, as they used to do on the portals of cathedrals. This magnificent bronze, on the back of a prodigious example of anatomy, is without doubt one of the most amazing fragments of the sculptor, who here delighted in difficulties.

28. MADAME LYNCH DE MORLA VICUNHA. 1884. Marble, $22\frac{1}{2} \times 19\frac{1}{2} \times 14$.
Quite at the commencement of his career, towards 1882, Rodin chanced to meet Madame Lynch de Morla Vicunha,

wife of a South American diplomat; and he became a friend of the household. The young woman, who knew the artist's passion for classic music, often played Mozart or Beethoven to him, and, by way of recompense, the latter executed her bust. Done in 1884, it was exhibited in the 1888 Salon, where it aroused real enthusiasm. The State then acquired it for the Musée National.

Not one of Rodin's busts is more filled with the living and subtle charm of female beauty. The look in the eyes, the pose of the head, and the set of the mouth, which seems just to have been speaking, are all characteristic. The moulding of the marble is exquisitely delicate. The nosegay of flowers on the base of the bust strikes a note of homage paid to a charming person.

29. MRS. RUSSELL. Before 1888. Wax, $18\frac{1}{2} \times 11\frac{1}{2} \times 10\frac{5}{8}$.

This young woman, who was of Italian origin, married an Australian painter, a friend of Claude Monet, affiliated to the Impressionists, and living most of his time in Belle-Isle en Mer, where he had a property. Herself a genuine artist, she probably became acquainted with Rodin through Monet, and the sculptor, struck by her classical beauty, requested permission to make her bust. In 1888, he executed the work, which later was even cast in silver. The young woman gave the Master numerous sittings.

30-31. SHE WHO ONCE WAS THE HELMET-MAKER'S BEAUTIFUL WIFE. Before 1885. Bronze, $20 \times 10 \times 12$.

Here Rodin has taken a text from the old French poet François Villon, whose poem 'Les Regrets de la Belle Heaulmière jà parvenue à vieillesse' ('Lament of the Old Helmet-Maker's Wife on Reaching Old Age') is one of the most remarkable of his works. The former courtesan, once radiant with youth and grace, is now repellent with ugliness and decrepitude. Once proud of her charm, she is now equally ashamed of her decay. Bent double, she contemplates her withered breasts, her abdomen in folds, her arms and legs which are knotted like vine-stalks, while the skin falls over the hardly veiled skeleton. Beauty is only skin deep, says the sculptor, echoing the 'vanity of vanities' of the preacher. The sculptor's work is perhaps even more grimly expressive, Grotesque as it is, the spectacle is ineffably sad, for it is the distress of a pour soul who, still so tardily yearning after youth and beauty, and powerless before its decay, is the antithesis of anything spiritual. There is a pendant to this statue (notes M. Paul Gsell) in a strange statue by Donatello now at the Baptistery at Florence, which represents an old woman, nude, or rather simply draped, with her long hair falling thinly and sadly over her withered body. It represents Mary Magdalen, who has retired to the desert, burdened with years, and now macerates her poor body, in honour of God and to punish it for the care she formerly bestowed on it.

But the sentiment of the two works is widely different. The Magdalen, in her desire for renunciation, is filled with the mysticism of the middle ages. The old woman of Villon and Rodin still longs for her lost beauty, and is horrified to find herself resembling a corpse. The original model of this statue was a withered old Italian woman who had come to Paris to seek out her missing son. Falling into want, some of her fellow country people advised her to go and ask Rodin for help, and he, struck with her appearance, invited her to pose for him.

At first he gave the subject the form of a bas-relief on the left doorpost of the 'Gate', but about 1885 he returned to this subject and gave it the moving and admirable form under which we see it here.

32. KNEELING FAUN. 1884. Plaster, $22 \times 8 \times 12$.

33. ERECT FAUN. 1884. Plaster. $24\frac{1}{2} \times 11\frac{3}{4} \times 10$.

These two figures bring us back to 'The Gate of Hell'. They were among the first which were placed in the tympan, but most certainly they were not slow to leave the crowd of the damned to lead an individual life. We know of a bronze cast of the 'Kneeling Faun' belonging to a Romanian collector, which is dated 1884.

34-35. DANAID. 1885. Marble, $13\frac{3}{4} \times 28\frac{1}{2} \times 22\frac{1}{2}$.

This splendid marble ranks amongst the most justly renowned works of Rodin. It represents one of the daughters of Danaus, King of Argos, condemned in Hades to fill perpetually a vessel full of holes, as punishment for the murder of her husband. What exquisite rhythm and beauty of contour there are in this slim girlish figure, who has thrown herself down, face downwards, beside the stream in despairing abandonment, with the bottomless vessel under her arm. It was sculptured in 1885, in view of 'The Gate of Hell', but was suppressed in its final state. Exhibited for the first time in the Salon in 1890, it could be seen in the following years in Venice and Oslo under the title 'The Spring', and excited the same enthusiasm in these cities.

36-45. THE BURGHERS OF CALAIS. 1884-1886. Plaster, $82 \times 94 \times 75$.

(Plates 36, 37, 39, 40, 41, 44, 45. Studies for Burghers of Calais. 1884. Bronze).

The episode of the Burghers of Calais and the patriotic sacrifice of Eustache de Saint-Pierre and his comrades has been related by Froissart and Jean le Bel, his Belgian predecessor as chronicler and troubadour.

British military annals furnish few cases of more determined and noble resistance than that maintained for eleven months (1346-1347) by the burghers of Calais, under the command of Jean de Vienne, a 'commander worthy of the commanded'. Famine attacked them even more fiercely than the soldiers of King Edward, and still they resisted. It was only when, after almost incredible fortitude, they saw their last

hope dashed to the ground, at the very moment that they anticipated relief—it was only when Philip the Sixth came towards Calais, and then, not liking the aspect of the English defence, turned and went back again, that they allowed themselves to think of submission. Philip's cruel desertion was the death blow. They sent to Edward, who, however, would listen to no terms except unconditional surrender. The noble Sir Walter Mannay, however, spoke for them; and at last mercy was promised to all but six of the chief burghers, who were to come to him bare-headed, bare-footed, with ropes about their necks and the keys of the town and castle in their hands. The people of Calais were sommoned by bell into the market place, and there the conditions of mercy were made known to them.

In 1884 the town of Calais opened a competition for a monument commemorating the heroic act of Eustache de Saint-Pierre. Rodin, struck by the narrative of the old chronicler, decided to make a composition which should commemorate the six hostages. The work occupied him some ten years, though the delays were not always his fault.

The Municipality, on inspection of the work, declared that the artist had not made 'the burghers sufficiently heroic'. It required all the persuasive powers of Dewavrin, the Mayor of Calais, who through seeing the sculptor at work had conceived admiration and friendship for him, the intervention of Alphonse Legros and of Charles Cazin—who had posed for the nude of Eustache de Saint Pierre—to quell the opposition. The work, inspired by the great masters of mediaeval sculpture and of Claus Sluter, was unveiled on June 8, 1895, in front of the Calais Town Hall and created a deep impression. Very fine replicas exist in London, Belgium and Copenhagen.

As with so many other of his works, Rodin was grieved at finding that many of his contemporaries did not understand his group, for a hot controversy again arose, as had been the case with the 'Bronze Age' and the 'Claude Lorrain' (to be repeated later with the 'Balzac'). 'They would have preferred,' Rodin said, in answer to some of his critics, 'gestures à la Marseillaise' (a reference to Rude's bas-relief on the Arc de Triomphe in Paris). 'I intended to show my burghers sacrificing themselves as people did in those days, without proclaiming their names.' Still there were more than sufficient admirers of the work to satisfy the artist.

The remarkable differences in character of these six hostages is evident to anyone who studies the group. The central figure is the aged Eustache, whose venerable head with its long hair is bowed, but not with fear or hesitation; he seems rather, in sorrowful resignation, to be in deep contemplation in the spirit of his own words, 'I have so good trust in the Lord God'. If his step is a little halting, it is from the privations of the long siege; his firmness is calculated to inspire his fellows. 'He was the one who said, "we must",' Rodin remarked.

The one next to him, who is probably Jehan d'Aire, holding the key which he is to hand to the King, also has no fear or hesitation, but his whole body is tense with the effort to get strength sufficient to go through the ordeal and humiliation. His face—a clean-shaven, lawyer-like face—is set in grim sorrow at the pass to which his city is reduced. Behind him is the figure known as the 'Weeping Burgess', whose face is covered by his two hands, as if he were indeed faltering or regretting his decision, and were thinking of wife and children. Just behind Eustache, one of the men looks back to the city, while he passes his hands before his eyes as if to drive away some terrible vision, for his resolution is evidently not so stern as that of the two leaders. Of the final two, who may be the two brothers, the one in advance, whose movement is more hasty and nervous that that of Eustache, as if he would fain have the ordeal over, may be encouraging by his gesture the one behind him, the youngest of the group, who hesitates at now leaving life and its sweetness behind.

The three figures in the second row are all of them less resolute and less brave than the three in front, as is shown by their attitude. Their act is no less heroic for all that. Their feet are heavy, but their wills urge them on.

In this great group the physical aspect is subordinated to the spiritual, and the composition is instinct with the shadow of the impending interview with the redoubtable King and the forfeit they are to pay. The greatness of the deed they are accomplishing pervades them with an atmosphere of august sadness, and eliminates all meaner sentiments. They move one by their simplicity and the absence of gesture.

Each one of the six is visible from any leading point from which one may look at them, and so one feels the crowd of sorrowful citizens, women and children gazing after them from the battlements of the stricken town.

Rodin had wished to have the group placed on a high pedestal, but as this would have entailed having the figures very much more than life size, the suggestion was not adopted. Failing that, he said he would have preferred the group to stand on the soil, so that they might seem to be part of the population, but even this plan did not seem practical and was not adopted.

46. AURORA. 1885. Marble, $22\frac{3}{8} \times 22\frac{3}{8} \times 13\frac{3}{4}$.
It was Mademoiselle Camille Claudel, Rodin's pupil and a sculptress herself, who posed for this radiant marble, worthy of the name given it. From this masterpiece emanates a light that once seen can never be forgotten.

47. THOUGHT. 1886. Marble, $29\frac{1}{4} \times 21\frac{3}{4} \times 20\frac{1}{2}$.
Again it was Mademoiselle Claudel who served as model for this head which, despite its unusual presentation, aroused deserved admiration from the start. Executed in 1886, 'Thought' was not exhibited until 1896 in the Salon.
'There is no disturbing strain,' says Grant Allen, 'but the calmness and the remote expression of one absorbed by the inward working of the mind'; and Paul Gsell says: 'Abstract thought blossoms out of the midst of inert matter and illumines it with the reflection of its splendour, though it tries

in vain to escape from the shackles of reality.' Such are the ideas which Rodin sought—and with what success!—to express in this work, which is at once instinct with spirituality, and yet in the lucidity of the eyes, beauty of features and charm of pose, is unmistakably feminine. There is an intentional suppression of any sensuous element, even to the absence of the hair, which is covered by a cap. It has justly been described as the very symbol of Rodin's art.

48. INVOCATION. 1886. Plaster, $22 \times 10 \times 9\frac{1}{4}$.

This fine figure belongs to a period when Rodin was working with ardour at the 'Gate of Hell', for which he had just received the commission. A certain resemblance to the 'Old Man Suppliant' suggests that it was a feminine adaptation of the same subject. Madame Abruzzezzi, the model whom Rodin employed several times, seems to have posed for this work.

49. THE KISS. 1886. Marble, $75 \times 47\frac{1}{4} \times 45\frac{1}{4}$.

This piece is considered by far the most important of Rodin's classical works. It was shown for the first time in Paris in 1887, and was later exhibited at the Salon of 1898 together with the statue of Balzac.

50. FAUN AND NYMPH. (THE MINOTAUR.) Before 1886. Plaster, $13\frac{1}{2} \times 10 \times 10$.

Once more it is to the remotest ages of mankind that we are transported by this group, to resonances as deep and mysterious as some lines from Racine's *Phèdre*. Certain critics re-christened it 'Jupiter Taurus', but Rodin, whose imagination was haunted by the images evoked by reading about the Mycenaean civilization, did not accept this new title. Moreover, the work seems to have been in the first, place a study for the group of 'Pygmalion and Galatea' excuted by the artist before 1886.

51. POLYPHEMUS. 1888. Bronze, $9\frac{7}{8} \times 5\frac{1}{2} \times 6\frac{1}{4}$.

Among the subjects which decorate the very fine Medici fountain in the Jardin du Luxembourg there is a statue of Polyphemus about to crush Acis and Galatea. This work of Ottin must have struck Rodin, who often had occasion to pass it during his youth, and when he conceived 'The Gate of Hell', there was an opportunity to introduce this mythological episode into his creation. But, after having modelled 'Polyphemus and Acis' in the right folding door, the sculptor realized that, plastically, the two characters, owing to their position, created gaps in the composition. The same year—1888—that he executed this group, he smothered the Acis in the plaster, and only preserved the Polyphemus.

52. THE METAMORPHOSES OF OVID. Before 1886. Bronze, $13 \times 15\frac{3}{4} \times 10\frac{1}{2}$.

Inserted in the 'Gate of Hell', in the right angle of the attique, the work, almost as soon as born, like many of its sisters, was detached from the monument to take on a life of its own. Two other titles that it bore, 'Volupté' and 'Les Fleurs du Mal', testify that it was conceived under the influence of the poems of Baudelaire, which, together with the 'Divine Comedy', were his bedside books.

53. FLYING FIGURE. 1889–90. Bronze, $20\frac{1}{8} \times 27\frac{1}{8} \times 11\frac{3}{4}$.

This figure, of an amazing audacity, in its agitating nudity, might well have been a study for the characters intended to surround the 'Victor Hugo seated', 'Meditation' and 'The Tragic Muse', a hypothesis which is equally valid for 'Iris, Messenger of the Gods', this prodigious creation of the artist. This 'Flying Figure', which is probably of 1889, was, however, utilized by Rodin, this time completed, in his group 'Avarice and Luxury'.

54–55. THE ETERNAL IDOL. 1889. Plaster, $29\frac{1}{4} \times 15\frac{3}{4} \times 20\frac{1}{2}$. (1889. Bronze, $6\frac{7}{8} \times 5\frac{7}{8} \times 3\frac{3}{8}$.)

A young woman is half seated half kneeling, with her head bending forward and a dreamy look in her face, while a man, kneeling before her, restraining his desire—his arms are behind his back—softly bends his head and plants a kiss under the left breast, over the heart. He has a restrained fervour that is at once mystical and amorous. She has a reserved sphinx-like expression. Is she, too, awakening to the current of love, or is she wondering at man's passion, which is unfathomable, for the beauty which he as yet hardly knows? The originality of the pose is unique in sculpture, rendering it one of the loveliest commentaries on the relations between man and woman that exist in art. Rodin is said to have adopted the title from the remark of a visitor, to whom he was explaining his idea. 'I see,' said the visitor—'the eternal idol!' And Rodin understood at once how suitable it was.

It certainly originated prior to 1889, for then it was known under the name of 'The Host'. It was exhibited in the 1896 Salon.

56–57. THE PRODIGAL SON. Before 1889. Bronze, $54\frac{3}{4} \times 41\frac{1}{2} \times 27\frac{5}{8}$.

This work, which figures in the right hand folding door of 'The Gate', was probably conceived between 1885 and 1887, for the subject is utilized in the 'Fugit Amor,' which is prior to 1887. It was first called 'The Child of the Age', and was exhibited under this title in the 'Salon de la Plume', to re-appear in 1905 in the Salon d'Automne, with an appellation invented by the critic, 'The Dying Warrior'. This interpretation of the Biblical episode reminds one, in the largeness and humanity of the conception, of Rembrandt's finest etchings.

58. OCTAVE MIRBEAU. 1889. Terracotta, $11 \times 7 \times 6\frac{5}{8}$.

Mirbeau was one of Rodin's oldest friends, and always defended him with his unsparing fire against the representatives of an obsolete academicism. He broke many lances in

the 'Balzac' controversy, and no one spoke better of the Master's water-colours than the author of 'Calvaire'. Moreover, Mirbeau, having prepared an édition de luxe of 'Le Jardin des Supplices', wanted it to be illustrated with his friend's works. For a copy of 'Sébastien Roch', belonging to Edmond de Goncourt, Rodin, as was his favourite custom, designed three profiles of the novelist on the cover. Mirbeau's bust, in terracotta, was done in 1889. There is also a medallion of the writer, which was exhibited in the 1895 Salon.

59. ROSE BEURET (MADAME AUGUSTE RODIN). 1890. Marble, $18\frac{5}{8} \times 15\frac{3}{4} \times 19\frac{3}{4}$.

Rose Beuret, born in 1845, of a humble family, became Rodin's companion at a very early age and shared his life in good times and bad, always keeping in the background. She died in Meudon shortly before Rodin, who had married her in his old age. Rodin made many busts of his wife, and was even inspired by her features for works of a more general character. This marble was placed by Madame Rodin, in 1916, at the disposal of her husband, for the Museum then being formed. Rodin had it cast in bronze.

60. BROTHER AND SISTER. 1890. Bronze, $15\frac{5}{8} \times 7 \times 7\frac{7}{8}$.

Perhaps under the influence of Carpeaux, which was stronger than is believed, Rodin always had a passion for sketching and sculpturing children. No doubt, 'Brother and Sister', the masterpiece of his maturity and dated 1890, is the most charming and affecting of the groups that inspired him with this taste from early youth.

61. DESPAIR. 1890. Bronze, $13\frac{1}{2} \times 10\frac{1}{4} \times 11\frac{3}{4}$.

Another figure originally intended for 'The Gate of Hell', where it is placed above the right folding door.

Retaken in the same part of the monument in three different settings, it shows how conscientiously Rodin worked at his subjects. This same year, 1890, Rodin detached the character to lend it a life of its own.

62. ROSE BEURET (MADAME AUGUSTE RODIN). 1890. Bronze mask, $10\frac{1}{4} \times 6\frac{3}{4} \times 6\frac{1}{4}$.

This portrait was done in 1890, in the full maturity of this fine woman's face, which had inspired the artist in the springtime of his union with more smiling images. The gravity of this face, combined with the sculptor's perfect command of his faculties, make this work an admirable and affecting creation.

63–64, 66–67. BALZAC. 1897. Plaster, $118 \times 47 \times 47$. (Plate 63. Study for Balzac statue. 1893. Bronze, $10\frac{5}{8} \times 11\frac{3}{8} \times 7$.)

The most remarkable incident in Rodin's career was that which was connected with this statue of Balzac. The Société des Gens de Lettres, the leading literary society in France,

after the Académie Française, had wanted a statue of the great romanticist, to be placed on a site in Paris. The work had, in 1888, been entrusted to Chapu, but he died in 1891, leaving only the commencement of his work, and having spent a portion of the 36,000 francs which was to be allocated for it.

Rodin then, at the suggestion of some of his literary friends, wrote to the Société (the president of which at the time was Emile Zola) offering to do the work, and the offer was accepted. Unfortunately he made the mistake of undertaking to deliver the statue in eighteen months. A great deal longer time than that went by, and no statue was delivered nor even a model submitted, so that the delay became the subject of popular jokes and quips. Relations between Rodin and the society became strained and some disagreeable correspondence passed. Zola among others grew inimical. There was a lawsuit, after which a new engagement was entered into, by which the commission was confirmed to Rodin, but without any time stipulation. He also returned the 10,000 francs, which had been advanced to him for the purchase of material, and agreed that he should receive nothing until the statue was delivered.

The material which Rodin had to work with was very meagre, but he set about a study of Balzac, his works, his habits and the country where he was born and lived, which was typical of the man but is probably very unusual in our days.

There is a bust of Balzac in existence by David d'Angers, and Rodin also had access to a daguerrotype of the novelist taken half-length standing, with his collar open showing his massive neck. But the best portrait of the novelist is the description by Lamartine:—

'It was the face,' he said, 'of an element; a big head, hair dishevelled over his collar and cheeks, like a mane which the scissors never clipped; very obtuse, eye of flame, and colossal body. He was big, stout, square at the base and shoulders —much of the ampleness of Mirabeau, but no heaviness. There was so much soul that it carried it all lightly; the weight seemed to give him force, not to take it away from him; his short arms gesticulated with ease.' Théophile Gautier added that the novelist's usual expression was of intense mirth—a Rabelaisian hilarity ennobled by great power.

So thorough was Rodin's preparation for his task that at Tours, where he found an old tailor who had made clothes for Balzac forty years previously, he got him to make a suit from the old measurements.

Rodin started by making several nude models (he nearly always began by making nude models, whether he intended to clothe his statues or not) and others which did not satisfy him. He found that this was the most difficult sculptural interpretation he had ever undertaken. He was puzzled by the elements of the strange, abnormal lineaments of the man, his complex character and extraordinary personality, beside which there was his prodigious literary production to

be considered. Rodin set himself, as usual, to incarnate the great thinker in action, but also to create a Balzac with all his idiosyncracies. For this he had to continue the Gothic conception which he had partially and successfully tried with the Burghers of Calais, the subordination of form to the main idea and spiritual meaning of the character, and the simplification of the trunk of the statue into large surfaces adapted to the play of light and shade, in order to concentrate all the vigour of expression on the head. The result was this huge man ('a very living Balzac') with the powerful head and bull's neck, who throws upon the crown that gazes up at him a look of deep but smiling irony tinged with sadness. His hands are crossed under the white gown, resembling a monk's garb, which he always wore when at work, the sleeves of which hang empty at his sides.

When the statue was at last exhibited at the Salon of 1898, side by side with 'Le Baiser', it is not too much to say that it was greeted with a chorus of scorn and ridicule. 'A cow,' said some of the people who went to see it, while critics with a choicer fund of expression talked of 'a snow man', 'formless lava", etc.

M. Roger Marx, that staunch friend, who wrote an interesting explanation of the work before the opening of the Salon, was unfortunately but little heeded. 'Rodin,' he said, 'has made it his business to seek for that which in this broad, frank, open face betokened will, power and genius.' He had got the man's personality—the height of the brow, the deep setting of the eyes and their keen brilliance, the bulky nose, and the sensuality of the thick lips. But besides all this, there was the complexity of the character—an indefinable smile made up of kindness and sarcasm, the defiance shown by the pose of the towering head, indifference to past insults, just satisfaction at the work he has accomplished, and faith in the judgement of posterity.

The Société des Gens de Lettres accepted the popular verdict and passed a resolution protesting against 'M. Rodin's rough model and refusing to recognize it as a statue of Balzac'! A split in the ranks of the society ensued, and Jean Aicard, the poet, who was then president, resigned with several others. The commission for a new statue was given to Alexandre Falguière. His seated statue is the one now to be found in the Avenue Friedland, Paris. Falguière's work should not be condemned so utterly as it has been by enthusiastic admirers of Rodin, and none who contemplate this statue can fail to note in it the influence of the great sculptor.

But the ridicule and contempt were by no means universal. Rodin was inclined at first to fight the society, but in face of the applause and admiration that came from other quarters he desisted. M. Auguste Pellerin, a wealthy art collector, asked him to sell the statue for 20,000 francs; and he received invitations from artistic bodies in London and Brussels to send the statue for exhibition to those cities. He replied to some of these friends in a charming letter acknowledging the encouraging testimonies of esteem and declaring that he had decided not to sell the statue—that it belonged to Paris and he would bide his time.

At the same time, it must not be forgotten that honest discerning criticism does not hurt, and that all those who criticized the 'Balzac' and thought that Rodin had carried his interpretation of the Gothic in sculpture to extremes were not mere scoffers and Philistines. Henri Rochefort, who could not be accused of being such, wittily said: 'To pretend to express the forty volumes which he (Balzac) left to the world in the contortions of the lips and the quivering of the nostrils, is carrying the *spirituel* a little far. It is the first time one has ever had the idea of extracting the brains of a man and putting them on his face! Let Rodin give us simply the nose of Balzac, his mouth, his forehead, with the structure of his powerful head, and in this transcription our own eyes will read the genius of Balzac. But for the love of art, let the sculptor spare us his commentaries.' Benjamin Constant, the artist, who passionately admired most of Rodin's work, was nonplussed at the 'Balzac', and it was the same with other distinguished critics and fellow artists. On the other hand, Octave Mirbeau prophesied that a day would come when the changing crowd, being more educated, would frantically applaud this work of genius.

An extraordinary thing is that there were not wanting some who accused Rodin of having voluntarily made his Balzac grotesque. His previous work should surely have supplied answer enough to such an absurd charge and proven the absolute and intense earnestness of the man. What! Rodin, whose eyes are like nothing else in modern sculpture, had made his Balzac with cavernous eyes as a joke! Rodin, who moulded hands as no others could do, had left the hands of Balzac (which are said to have been quite remarkable) out of sight, so that they should not draw attention from the spirit of contemplation in the face. Rodin replied to these charges in a few proud but scathing sentences: 'I shall fight for my sculpture no longer; it has for a long time been able to defend itself. To say that I patched up my Balzac as a practical joke is an insult that would formerly have made me writhe with indignation, but to-day I let it pass and go on with my work. My life has been a long course of study, and to accuse me of making fun of others is the same as to say I make fun of myself. If truth is to die, my Balzac will be torn to pieces by the next generation, but if truth is imperishable, I predict that my statue will make its way. . . .

'This work, which has been laughed at, which is being scoffed at because it cannot be destroyed, is the result of my whole life's study—the very pivot of my aesthetic feelings. I was another man the very day I conceived it. My evolution was complete, and I had knitted a bond between the old lost traditions and my own time, which every day will help to strengthen.

'By force or by persuasion, it will make its way in men's minds. Young sculptors come to see it here in the studio, and think of it as they descend the stairs again, to go in the direction whither their ideals call them. There are men of

the people who have understood—workers and those who, rare though they are in the crowd, continue the old traditions of the crafts in which each one did his work according to his conscience, and did not learn his art in the official catechisms.

'As to the public, they are not to blame. The fault lies with their educators. The sense of beauty and taste for reason are lost. There is no room for and no esteem among us for men who model their souls alone. And the huge majority are no longer interested in art, and see nothing more of art except through the eyes of a few elected judges. As for myself, knowing that life is short and my task is great, I shall continue my work far from polemics.'

Proud words—in the spirit of which he acted! How much of his own indomitable spirit Rodin put into his 'Balzac' it is not hard to see, for every artist puts into his work himself as well as his 'sitter'; and here Rodin had no sitter but an 'element', as Lamartine put it. Rodin's own words make one think of an English critic's judgement. 'No one in the intelligent world,' said Edmund Gosse, 'looks at sculpture to-day exactly as he did before Rodin put his mark on it.'

65. VICTOR HUGO STANDING. 1897. Plaster, $88\frac{3}{8} \times 35\frac{3}{8} \times 56\frac{1}{4}$.

As we have already had occasion to point out, Victor Hugo was one of the great subjects that preoccupied the genius of Rodin. Already in 1883 he had executed a first bust of the poet. When he received from the Beaux-Arts a commission for a statue for the Panthéon, the Director, M. Gustave Larroumet, was uncertain which position to assign to the hero; should he be seated or standing? It seems that there was some doubt upon this matter, since we have several studies of Victor Hugo standing. This one, the most important, shows how conscientiously Rodin grappled with his tasks. This nude, executed in 1897, is an enlargement of a plaster model done ten years earlier and shows that the sculptor thought of exhibiting the author of 'Les Châtiments' in front of the flood breaking on the shore.

68. THE SCULPTOR FALGUIÈRE. 1897. Bronze, $16\frac{7}{8} \times 9\frac{1}{2} \times 10\frac{1}{4}$.

When the Société des Gens de Lettres declined, in 1897, the statue of Balzac executed by Rodin, it commissioned Alexandre Falguière (1831–1900) to take the place of his illustrious colleague. But the latter bore no grudge against his friend, and to emphasize that he harboured no rancour for the substitution, he executed his bust, and had his own done by his happy and embarrassed rival. The two busts were simultaneously exhibited in the 1899 Salon.

69. BUST OF VICTOR HUGO. 1897. Bronze, $27\frac{1}{2} \times 19 \times 19$.

Rodin was introduced to the poet by his friend Roger Marx, who held an official post in the Fine Arts Ministry, and there is a letter in existence addressed to the 'dear and illustrious

Master' in which Rodin expresses in ardent terms his desire to perpetuate in marble or bronze the features of the greatest poet of his time. Victor Hugo, who was then living in the Avenue d'Eylau (near to the present Place Victor-Hugo), and was old and tired, was not at all enthusiastic at the idea, especially as he had just before been pestered by an inferior sculptor to whom he had given a number of sittings, the result of which had been unsatisfactory, or rather nil. However, Hugo consented to allow the sculptor to come to the house to lunch whenever he liked and make sketches of him, so long as he himself should not be disturbed in his habits. The Hugo family kept practically open house in those days, and there were always others to lunch. The arrangement lasted for several months, Rodin going to lunch not every day, but sometimes several days in succession, and sometimes leaving out a number of days. During the meal the sculptor would sketch the poet continually and feverishly, with the result that he himself rarely got any lunch, for when it was over he rushed off to his studio to transpose his rough sketches to the clay.

When Hugo saw the bust, neither he nor the family were pleased with it; they considered it not flattering enough.

In reality, the work is only a replica of the head and shoulders of the 'Victor Hugo Standing' (plate 65). It was exhibited in 1897, and in 1900 occupied the best position in the Alma Pavilion.

70. THE HAND OF GOD. 1897–8. Marble, $24\frac{3}{4} \times 31\frac{1}{2} \times 20\frac{5}{8}$.

This magnificent fragment of the great Master, almost contemporary with the 'Balzac', and which is perhaps a meditation in the margin of this famous statue, is like a symbol of the semi-divine creation of the prodigious sculptor. It seems that when he was struggling to express the supernatural gift of the writing genius, he was tempted to create the image of the genius of statuary.

71. PAN AND NYMPH. 1898. Marble, $53\frac{1}{4} \times 30\frac{3}{4} \times 27\frac{5}{8}$.

'Pan and Nymph' was done at about the time when Rodin, who was nearing his sixtieth year, returned to those themes of Greek mythology which had always captured his imagination. Perhaps he was influenced by a fresh reading of the 'Metamorphoses' of Ovid, one of the three most abundant sources, with Dante and Baudelaire, of his inspiration.

72. BAUDELAIRE. 1898. Plaster, $7\frac{7}{8} \times 7\frac{1}{2} \times 9$.

The admiration which Rodin entertained for Baudelaire was certain to prompt him one day to attempt to model the features of the great poet. Having made acquaintance with a young writer, now forgotten, M. Louis Malteste, an enthusiast for his sculpture, and who bore a curious resemblance to the author of 'Les Fleurs du Mal', Rodin sought to discover in his living countenance the physiognomy of the great master. The sculptor, however, never brought this attempt beyond the stage of a sketch, which was executed in 1898.

73. MADAME F . . . 1898. Marble, $25\frac{5}{8} \times 24\frac{3}{4} \times 20\frac{1}{2}$.
In the admirable gallery of feminine busts executed by Rodin, none is more delicately affecting than this. The model was the wife of a great amateur of the arts, who was one of the artist's most devoted friends, and who had supported his genius from the first. The work is dated 1898, and comprises several variations.

74. MUSE FOR THE WHISTLER MONUMENT. 1902–3. Marble, $19\frac{3}{4} \times 11\frac{1}{2} \times 11\frac{1}{2}$.
Rodin, who had the cult of friendship, projected several monuments to the glory of great artists with whom he had been associated. One of these was to Whistler, and about 1902 he carried out a certain number of studies from a model, Mary Jones. This marble is one of the finest fragments conceived for this design, which went no further.

75. STUDY OF A SLAV GIRL. 1905–6. Marble, $25\frac{1}{4} \times 28\frac{3}{4} \times 21\frac{5}{8}$.
Rodin made a marble bust about 1906 using as a model this young Slav girl, who has not been identified. The following year, still under the charm of her unusual face, he executed another graceful work in her likeness (plate 82).

76. EUGÈNE GUILLAUME. 1903. Bronze, $13\frac{3}{8} \times 12\frac{1}{4} \times 11\frac{3}{4}$.
The sculptor Eugène Guillaume was an 'official' artist, member of the Académie des Beaux-Arts, of the Académie Française, director of the École des Beaux-Arts and of the Académie de France in Rome. After having long resisted the aims of Rodin, he conceived in his old age a great admiration for the works of the great sculptor and became his intimate friend.

77. MARCELIN BERTHELOT. 1906. Bronze, $17\frac{3}{8} \times 9\frac{1}{2} \times 9\frac{1}{2}$.
Rodin was associated with the great chemist, as is proved by copies of the latter's works dedicated to the sculptor. But it was not until 1906 that he executed this bust, one of the most admirable that came from his hands. At this period of his career, the artist, having penetrated the secrets of his profession, like a Rembrandt, a Titian, a Goya or a Delacroix, thought only of expressing the essential in a work. He had neither desire nor need to multiply detail. He had reached the stage when detail appears useless and even harmful.

78–80. BERNARD SHAW. 1906. Marble, $23\frac{5}{8} \times 22\frac{7}{8} \times 15\frac{3}{4}$. 1906. Bronze, $11\frac{3}{8} \times 7\frac{7}{8} \times 4\frac{3}{4}$.
It was perhaps through Henley and the circle of English writers who supported him almost from the start that Rodin made the acquaintance of Bernard Shaw. The famous dramatist, hater of all poses, would allow none but the author of 'The Thinker' to make his bust. The work, executed in 1906, earned the artist the praise of the formidable satirist, and Mrs. Bernard Shaw, in her turn, wrote Rodin that the

resemblance of the work to the model was so faithful that it frightened her.

81. MADAME DE GOLOUBEFF. 1906. Bronze, $19\frac{3}{8} \times 16\frac{1}{2} \times 9\frac{7}{8}$.
Madame de Goloubeff was one of the musicians who supplied Rodin with some of the purest joys of his life. In interpreting for him in a pure and expressive voice the finest songs of classical art, she evoked the sculptor's gratitude, which was admirably expressed by this bust done in 1906.

82. BY THE SEA. 1906–7. Plaster, $22\frac{7}{8} \times 32\frac{3}{4} \times 22\frac{7}{8}$.
The model for this charming study is the young, unidentified Slav girl who sat as a model for the marble bust made by Rodin the previous year (plate 75).

83. MOTHER AND DYING CHILD. 1908. Marble, $41 \times 39\frac{1}{4} \times 27\frac{1}{2}$.
Rodin's glory had become so great that he received commissions from beyond the seas not only for busts but also for funereal monuments. In 1908, Mrs. Thomas Merrill, desiring art to perpetuate the memory of her daughter who had died in tender years, applied to the great Master. It is one of the most moving works of the artist, himself gradually nearing eternity.

84. THE DANCER HANAKO. 1908. Bronze, $6\frac{1}{4} \times 4\frac{3}{4} \times 3\frac{1}{2}$.
This dance theme could hardly fail to arouse the enthusiasm of a sculptor who was so interested in movement. In his latter days he grew fond of noting in their spontaneity all the gestures of his models left to themselves in his studios and he liked to paint all their attitudes in water-colours. On the other hand, about 1900, there was in France a prolonged infatuation for dancing and the admirable interpreters of this art, Isadora Duncan, Loie Fuller, the Javanese dancers, Hanako, and the chorus of the Russian ballet. This mask of the Japanese Hanako is contemporary—1908—with these important studies.

85, 87. GUSTAV MAHLER. 1909. Bronze, $13\frac{3}{8} \times 9\frac{5}{8} \times 8\frac{5}{8}$.
MOZART. 1910. Marble, $12\frac{5}{8} \times 37\frac{1}{2} \times 24\frac{1}{2}$.
It seems that it was through Madame de Nostitz, a German friend of Rodin, that the latter made the acquaintance of the Austrian composer, famous for his symphonies and his great work 'The Song of the Earth'. Rodin found that he resembled Mozart, and when he had made his bust in 1909, he was inspired by his face to execute a bust of Mozart in marble (1910).

86. PUVIS DE CHAVANNES. 1910. Marble, $29\frac{5}{8} \times 49 \times 23\frac{5}{8}$.
The painter of the 'Life of St. Geneviève' at the Panthéon, of the 'Summer' and 'Winter' at the Hotel de Ville, Paris, of

the decoration of the Amphitheatre at the Sorbonne, and notable works at Rouen, Amiens and other French cities, and the decoration of the library at Boston, Mass., was an aristocrat and religious mystic and the 'utterer' of 'sweet but pallid harmonies' showing great elevation of thought.

There was no modern artist for whom Rodin had a greater admiration. 'To think he lived amongst us!' he exclaimed to M. Paul Gsell (reported in the latter's book, already quoted from). 'To think this genius worthy of the most radiant epochs of art has spoken to us, that I have seen him and shaken hands with him! It is as if I had shaken the hand of Nicolas Poussin. He always bore his head high,' continued the sculptor. 'His skull, which was solid and rounded, seemed made to don a helmet. His round thorax might have been accustomed to wearing a cuirass. One could easily have imagined him at Pavia fighting for honour beside Francis I.' In 1891 Rodin exhibited in the Salon the bust of his friend, and, the following year, he presented to it the marble. In 1910 he intended to begin executing a new marble destined for the monument it was decided to raise to the great painter's memory. This latter bust, although no more than sketched (the war, then the sculptor's death, having suspended the work) is of impressive appearance and makes a strange impression, from the fact that the face emerges, like the sea, from the enormous block of marble.

88. FEMALE TORSO. 1910. Bronze, $29\frac{1}{4} \times 13\frac{3}{4} \times 23\frac{5}{8}$.

This bronze, in its fragmentary state, has all the grace of a mutilated antique excavated from the earth. It radiates, through its youthful and supple limbs, so much life and beauty as to give the illusion of a complete and charming statue of this young woman, apparently carried away in the dizziness of this sacred dance. This figure dates from 1910.

89. THE DUCHESS OF CHOISEUL. 1908. Bronze, $11\frac{3}{4} \times 9 \times 6\frac{1}{4}$.

Rodin made three busts of the Duchess of Choiseul, one in bronze, one in marble, and one in terracotta; all of them were executed in 1908. He was on intimate terms with this American lady, who through her marriage became one of the prominent members of the French aristocracy.

90. ÉTIENNE CLÉMENTEL. 1916. Bronze, $21\frac{3}{4} \times 14\frac{5}{8} \times 11$.

This bust, executed in 1916, the year before the Master's death, is the last work which he completed. Étienne Clémentel was a prominent politician, who was several times a minister. He became one of the sculptor's three testamentary executors. This work, particularly moving because it is the artist's supreme labour, shows that, even on the threshold of death, the artist rough-hewed with great facility and retained a clear eye and hand of incomparable firmness.

91. GEORGES CLEMENCEAU. 1911. Bronze, $18\frac{3}{8} \times 11 \times 11$.

Rodin was from an early date on terms of intimate friendship with the great statesman, who, both as an influential politician and as a journalist, always stoutly defended and supported him. In 1911, Clemenceau had become one of the most prominent parliamentary figures of the day, yet desired that in his spare moments the sculptor should model his features. Before achieving the amazing resemblance of this bust, Rodin made several studies of it, but it is manifestly this unique bronze which will supply posterity with the truest image of this noble spirit and great Frenchman.

92. THE CATHEDRAL. 1908. Stone, $25\frac{1}{4} \times 13\frac{5}{8} \times 12\frac{5}{8}$.

Rodin always had a passion for modelling hands, so expressive in his view, so capable of displaying in themselves so many human emotions. Still in this period of the opening century pre-occupied with symbolism, more and more attached to the history of the religious architecture of the Middle Ages, the idea came to him one day in 1908 of representing the high pointed naves by two tapering hands joined in a gesture of prayer. Perhaps to accentuate the relationship uniting the symbol to the reality, he executed this work in stone.